The Value of Aesthetics

Joe R. and Teresa Lozano Long Series in
Latin American and Latino Art and Culture

The Value of Aesthetics

Oaxacan Woodcarvers in
Global Economies of Culture

ALANNA CANT

University of Texas Press ◆ Austin

Requests for permission to reproduce material from this work should be sent to:
 Permissions
 University of Texas Press
 P.O. Box 7819
 Austin, TX 78713–7819
 utpress.utexas.edu/rp-form

All illustrations courtesy of the author.

⊗ The paper used in this book meets the minimum requirements of
ANSI/NISO Z39.48–1992 (R1997) (Permanence of Paper).

Library of Congress Cataloging-in-Publication Data
Names: Cant, Alanna, author.
Title: The value of aesthetics : Oaxacan woodcarvers in global economies of culture /
 Alanna Cant.
Description: First edition. | Austin : University of Texas Press, 2019. | Includes
 bibliographical references and index.
Identifiers: LCCN 2018055517 | ISBN 978-1-4773-1880-5 (cloth : alk. paper) | ISBN 978-1-
 4773-1881-2 (pbk. : alk. paper) | ISBN 978-1-4773-1882-9 (library e-book) | ISBN 978-
 1-4773-1883-6 (nonlibrary e-book)
Subjects: LCSH: Indian wood-carving—Mexico—Tilcajete. | Indians of
 Mexico—Material culture—Mexico—Tilcajete. | Wood-carving industry—
 Mexico—Tilcajete. | Aesthetics—Economic aspects—Mexico—Tilcajete. |
 Culture—Economic aspects—Mexico—Tilcajete.
Classification: LCC F1219.1.T46 C36 2019 | DDC 306.4/7097274—dc23
LC record available at https://lccn.loc.gov/2018055517

doi:10.7560/318805

Contents

Acknowledgments

Like Oaxacan woodcarvings, and all of the arts for that matter, no book comes into the world only through the efforts of the named author. The time, energy, inspiration, and ideas of all of the people who make up the social life of the book-in-progress are essential for it finally to be published. My own practices in crafting this text have been shaped by so many wonderful colleagues and friends; they have inspired, interjected, reviewed, and disagreed with my writing. For that I am very grateful indeed. Needless to say, any errors or infelicities are entirely my own.

First, I must express my gratitude to the artisans and their families in San Martín Tilcajete, especially the family that hosted me in their home. The work of Oaxacan artisans often places them in the eye of intense scrutiny from tourists, journalists, photographers, and many others, yet they still treated me with unending patience, generosity, and warmth. Many families opened their homes, workshops, and kitchens to me. I am always pleased when I get the chance to return to share stories, news, and food with them.

I owe special thanks to Alvin and Arlene Starkman, who have become my surrogate *padrinos* (godparents). Alvin facilitated many connections, both in San Martín Tilcajete and elsewhere in Oaxaca, and gave me so many important insights into the workings of the Oaxacan craft and tourism economies. The Starkmans' house remains my home-away-from-home whenever I am in Oaxaca. In and around Mexico and its world of anthropology, I would like to thank Scott Becker, Ronda Brulotte, Michael Chibnik, Jayne Howell, Nicholas Johnson, Walt Little, Antonio Mendoza Ruiz, Eric Monrroy Pérez, Martha Rees, Sandra Rozental, Lynn Stephen, Cindy Weill, Bill Wood, and Emiliano Zolla Márquez. All of these people have contributed to my understanding of Oaxaca, and I hope that this work reflects well what I have learned from them.

I certainly could never have produced this book, or the PhD dissertation it is based upon, without the boundless support of Matthew Engelke. I am very lucky to have had a supervisor who has continued to support and advise me well beyond my years as a student. More importantly, Matthew is a great friend. I would also like to acknowledge the impact that the late Olivia Harris had on this text. Olivia introduced me to Walter Benjamin's essays on art and modernity, which have since become a cornerstone of my thinking. Olivia insisted that ethnography is more than a methodology; it is an ethical mode of engaging with people that makes the researcher both vulnerable and open to the value of difference. This perspective is shared by Barbara Bodenhorn, who "adopted" me after Olivia's passing, and I am grateful for her attention to history and detail in her readings of my work.

This book has also benefited immensely from comments and discussions on my research with colleagues in the United Kingdom, Norway, Canada, and the United States: Max Bolt, Tom Boylston, Denise Brown, Geoffrey Gowlland, Penny Harvey, Yanina Hinrichsen, Ingjerd Hoëm, Martin Holbraad, Christian Krohn-Hansen, Sara Alejandra Manzanares Monter, Keir Martin, Marit Melhuus, Alicia Ory DeNicola, Daniela Peluso, Cecilia Salinas, Elisabeth Schober, Miranda Sheild Johansson, Astrid Stensrud, Dimitrios Theodossopoulos, Cathrine Thorleifsson, Clare Wilkinson-Weber, and Kimberly Wynne. I am deeply grateful for the feedback I received from three peer reviewers and my wonderful editor, Casey Kittrell, at the University of Texas Press, who has enthusiastically supported this project and expertly guided me through the publishing process.

Finally, I want to thank my family. Andrew Sanchez has the double role of being both husband and anthropologist, with all of the intellectual and emotional support that entails. He has read and reread every chapter of this book, and it certainly is the better for his comments and critiques. He has also been there for me through the difficult moments, encouraging me to keep writing and "just get it done." My parents, Douglas and Frances Cant, have always encouraged and supported me in my chosen field, though it is so different from their own. And I thank Adam Sanchez, who finally lets us sleep.

The funding for the research on which this book is based was provided by the Emslie Horniman Fund of the Royal Anthropological Institute of Great Britain and Ireland.

The Value of Aesthetics

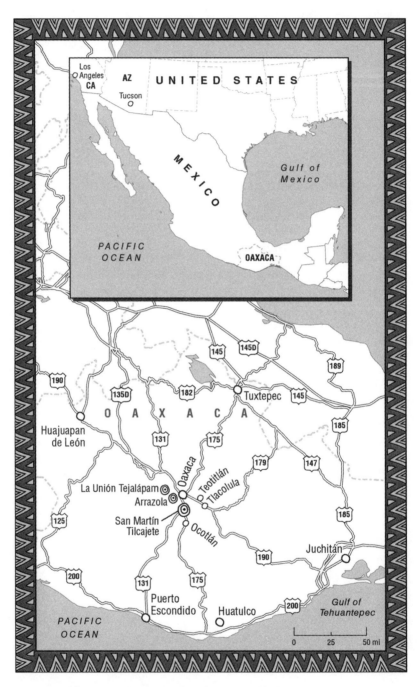

The state of Oaxaca, indicating key locations named in the text.

Introduction

Parallel to the way the expressive and practical cohere in the human mind and all social life, all art does work and all markets are art markets.
HARVEY MOLOTCH, "HOW ART WORKS" (2004)

In October 2007, as the southern Mexican city of Oaxaca began to fill with marigolds, sugar skulls, and tourists for the Día de los Muertos (Day of the Dead) fiestas, artisans in the city's nearby woodcarving villages were worried. As in most years, the busy period leading up to Día de los Muertos brought a range of concerns: Will we have many customers this year? Will we sell enough to get us through until Christmas? Have we remembered all of Grandfather's favorite foods to take to the cemetery? Will the shipment of carvings that we sent to Los Angeles arrive on time? That year, however, these commonplace concerns were overshadowed by a more ominous worry: what does it mean that replicas of Oaxacan woodcarvings have been made in China?

The short report on the discovery of the replicas that the newspaper *Las Noticias* ran at the time seemed to echo peasant folktales that anthropologists have been collecting in rural Mexico for generations. A year earlier, a mysterious foreigner had come to these small woodcarving villages and proposed a deal to select artisans that would make them money well beyond their immediate expectations. The stranger, who was identified only as "El Americano," had purchased five large Oaxacan woodcarvings, also known as *alebrijes*. In exchange for a signature on a contract, he paid their producers significantly more than their usual asking prices. When El Americano returned in 2007 to buy more pieces, the artisans and the reading public were horrified to discover that he had, in fact, taken the carvings to China to have them made into resin replicas, or "clones" as the newspaper put it,

which were now being sold in the United States and online. While the Mexican folktales usually end with the stranger—that is, the devil—tricking the local protagonists and leaving them with less than they began with, the newspaper story insisted that something must be done (Salanueva Camargo 2007).

The appearance of the devil—discursively or otherwise—usually signals points of social unease within local political landscapes. Devil stories throughout Latin America are allegorical social narratives that both describe and morally appraise the relations of power in contexts of visible inequality (Edelman 1994; Taussig 1980). It is not so surprising, then, to find that the style and form of such narratives work as a blueprint for public discussions of globalization in contemporary Oaxaca, a place of entrenched insecurity and inequality that is also undergoing rapid socioeconomic change (cf. Feinberg 2003). Indeed, while the newspaper story reported the artisans' immediate economic concerns, the thrust of the article was about the moral implications of the replicas themselves: what El Americano did with the carvings was *aviesa*: perverse, sinister, or evil. While this may seem like journalistic extravagance, objects can and frequently do embody moral and ideological power. Objects everywhere are socially active: they enable, resist, and transform the social worlds that surround them. While it is true that all material objects have this potential, certain kinds of things possess a particularly prominent social weight. The potency of saints and virgins may inhabit statues, pendants, and images in Catholic Mexico; objects described as "art" in galleries and museums in London, New York, and Santa Fe manifest the social, moral, and ideological power accorded to them by Western history, culture, and markets.

Woodcarvings and other forms of ethnic or folk art are especially potent social objects in Oaxaca, because in recent decades they have become an emblem of the region's economy and character. Oaxaca is considered a wellspring of cultural arts and craftwork throughout Mexico, and this material culture has become central to the state's identity: even the capital's *fútbol* (soccer) team is Los Alebrijes, named after the locally produced woodcarvings. Because of this, the resin replicas hit a nerve, not only for the artisans, but also for the state's cultural institutions and social elite. While there had been concerns about Guatemalan textiles in Oaxacan markets for quite some time, this was the first known incident of Oaxacan woodcarvings being transfigured into illicit replicas. In response, ARIPO (Artesanías e Industrias Populares del Estado de Oaxaca/Craftwork and Popular Industries of the State of Oaxaca) encouraged artisans from the prominent woodcarving communities of San Martín Tilcajete and San Antonio Arrazola to form

a *marca colectiva* (collective trademark union) to protect their work from imitations.[1] With organizational and financial support from Oaxacan and federal state agencies, the Unión de Talladores Productores de Alebrijes Tonas de Oaxaca, A.C. (Union of Woodcarver-Producers of Alebrijes and Animal Spirit Carvings of Oaxaca) was formally established in April 2008.

Some weeks after the union was founded, I was discussing the collective trademark over coffee with Antonio Mendoza Ruiz, a member of a well-known weaving family in Oaxaca City's vibrant artistic community.[2] As I described the resin copies and the artisans' trademark, he stopped me and asked: "But what I don't understand is, why do they care?" This question came as something of a surprise, and I found myself unable to answer; it had seemed to me self-evident that artisans would condemn the copying of their work. The newspaper story argued that their livelihoods were being put at risk while their culture was being unjustly appropriated. However, I came to realize that these particular factory copies actually posed little or no threat to local livelihoods; nor could they be accused of simply appropriating culture.

"Why do they care?" lingered in my mind as I continued my ethnographic research with artisans in San Martín Tilcajete, where I worked for twenty months in 2008 and 2009. My original intention for this research was to investigate how Mexico's politics of culture and identity were reproduced or resisted through artisans' everyday activities in their workshops and how the materiality of their work impinged upon these processes. While these themes continued to drive my activities in the field, Antonio's question drew my attention toward issues of authorship and value, in relation not only to the industrial replicas but also to artisans' relationships with their own work, with their clients, and with one another. In seeking to understand how artisans' and consumers' expectations of authorship and ownership played out in the production and marketing of Oaxacan woodcarvings as art objects, I was confronted by the fact that visual aesthetics were a powerful component of these processes.[3]

In this book I chart this complex relationship of visual aesthetics, power, and value in the making of art. I do this by considering the ways that the artistic and aesthetic qualities of art transform the political and economic features of production and marketing and therefore also the lives of art makers. In other words, this book is my answer to Antonio. To understand fully why Oaxacan artisans are worried about replication requires a detailed examination of their aesthetic practices and the aesthetic expectations of the markets in which their work circulates. While aesthetic practices are most visible in the moments of quiet solitude when a carver sits at his bench or

a painter sits at her table, the core argument of this book is that the visual aesthetics that form the bedrock upon which authorship, ownership, and artistic production develop are inherently social in nature. As I discuss in chapter 1, I draw on the theories of Pierre Bourdieu, Alfred Gell, and Walter Benjamin, to suggest that visual aesthetics are social-material practices that emerge through time, connecting people with one another and with the artworks that initiate and subsequently mediate relationships within larger art worlds. In the chapters that follow I link these aesthetic practices to the anthropology of craftwork and artisanship, which has connected discussions of materiality to debates about work, labor, and skill, and to the anthropology of cultural economies to show how aesthetics impinge on issues such as authorship, competition, and notions of cultural identity and intellectual property.

By viewing aesthetics in this way, I am able to make sense of a further ethnographic puzzle that my research with Oaxacan woodcarvers raised: how is it possible that just one of the many artisan families in San Martín Tilcajete has emerged as the true winner in the woodcarving market? The Garcías, as I call them (see the appendix), are now extraordinarily successful, not just compared to their neighbors but by general standards in southern Mexico. In addition to their large workshop, which is located in their beautiful two-story home in San Martín, they currently own two restaurants and two large galleries where they sell their own work and the products of other Mexican artisans. Although some of their financial success is certainly due to their "middleman" position between some producers and consumers (cf. Cohen 1999, 52–54; Milgram 2016), as I explore throughout this book, the Garcías have also used a number of aesthetic strategies that make themselves and their artwork significantly more desirable to tourists, collectors, wholesalers, and other important actors in the Mexican craft market. Through the story of their success, I show how they use different features of aesthetics, materiality, and authorship to produce monetary and cultural value for their own work. At the same time, I show how their approach to woodcarving both requires and contributes to a diverse yet conventional field of perspectives on Oaxacan woodcarving held by various kinds of art-world actors, including tourists, collectors, dealers, museum and gallery curators, state officials, and other artisans. As these individuals make, view, judge, buy, and sell Oaxacan woodcarvings, they produce competitive fields of power, wealth, and prestige, which are inseparable from their aesthetic practices and beliefs. In the next section I address why the case of Oaxacan woodcarving, and the Garcías' position within it, is especially useful for understanding how aesthetic practices intervene in relations of economy, power, and value.

Why Oaxacan Woodcarving? Why the García Family?

In many ways the woodcarvings that are made in small Oaxacan villages are ideal for investigating how art objects, makers, and viewers together produce aesthetic practices and expressions. Unlike many other handicrafts in Oaxaca, which have long cultural and historical trajectories, Oaxacan woodcarving began in the second half of the twentieth century and has always been done for the commercial market. This makes the carvings a particularly useful case, for example, for understanding how concepts like authorship and ownership intersect with aesthetic practices, as artisans are less likely to be bound by strong cultural norms of design and relations of production. As I discuss below, their novelty and the conditions in which they are made also mean that they cannot be readily placed within the dominant and often taken for granted categories of Mexican visual culture: *arte* and *artesanía* (art and craftwork). This indeterminacy means that the carvings are susceptible to markedly different interpretations of their meanings and value by different viewers, allowing the conceptual tensions inherent in art worlds and markets to be more easily observed.

Oaxacan woodcarving came about relatively recently and was essentially the invention of a single person. In the 1950s Manuel Jiménez, a peasant farmer and laborer from the village of San Antonio Arrazola, began selling carved masks and small sculptures to vendors in Oaxaca City's market. By the 1960s, with the help of investment and guidance from two wholesalers with whom he worked, he had developed his style of carving and painting. Taking inspiration from local folktales and other Mexican craftwork, his pieces generally referenced classic motifs of Mexican popular art: devils, skeletons, saints, and the Virgin of Guadalupe as well as real and fantastical animals. In time, others in his village saw that this new form of work offered the potential for greater economic security and began to produce pieces of varying quality and price for wholesalers and later for the tourist and collector markets (Brulotte 2012:28–49; Chibnik 2003:23–26). The woodcarvings did not begin to be produced in San Martín Tilcajete until as recently as the early 1970s, when Isidoro Cruz, a villager who occasionally made masks for Carnival, had a chance encounter with a director in Mexico's Secretariat of Tourism (SECTUR). They became friends and associates. Through this connection, Cruz eventually became a manager of the craft-purchasing program in Oaxaca for the National Fund for the Development of Artesanías (FONART). Cruz convinced some of his neighbors in San Martín to try woodcarving and was able to arrange sales of their work through FONART and its connections with other cultural institutions. By the 1990s woodcarving was established as a major source of income for many families in the vil-

lage (see Chibnik 2003:23–34, for a detailed history of Oaxacan woodcarving).[4] Although all forms of visual culture constantly undergo processes of reinterpretation and change (Fabian 1998:48–51), the short history of Oaxacan woodcarving has meant that the ways that people interpret and categorize these objects and their producers have been highly variable and the subject of constant negotiation.

This conceptual variability is also reinforced by the diversity of actors in the woodcarvings' art world itself. Artisans in San Martín must constantly manage a diverse assortment of government patrons, wholesalers, collectors, tourists, and other consumers, so they need to position themselves and their work according to their audience of the moment. As a result, artisans are often intentionally ambiguous about what the woodcarvings "mean," opting for suggestive explanations of the carvings that they hope will satisfy their interlocutors. This openness of meaning allowed me to see when, how, and to whom different kinds of explanations were articulated and to connect these articulations to different formations of value within the larger market. Needing to position themselves flexibly meant that some artisans could also critically appraise the role that such actors played in the market for Oaxacan woodcarvings, which allowed them to share their insights with me about the different social imaginaries and desires that these people brought to their interactions.

Of all the artisans that I worked with in San Martín Tilcajete, Miguel and Catalina García were the most insightful and articulate about the ways that different kinds of actors in the woodcarvings' art world impacted their work and the market. Their perceptiveness about the nature of North American markets for ethnic art and craft has allowed them to turn woodcarving into a highly lucrative activity. They have also benefited from ongoing relationships with key individuals in the art world of Oaxacan folk art and craft. As their renown has grown, they have increasingly become de facto ambassadors of Oaxacan woodcarving and of Oaxacan artisans in general. At the same time, they have become patrons to other artisans as they mediate between their powerful connections and local producers and also purchase the work of others to sell in their own galleries. Their success is plainly evident to their neighbors, clients, and patrons: they command significantly higher prices than any other woodcarving workshop in Oaxaca, including the family of Manuel Jiménez, the recognized inventor of the carvings. While small souvenir-quality woodcarvings generally cost between 5 and 50 US dollars, the Garcías frequently sell theirs for over 100 dollars. Their more expensive work now can fetch over 5,000 dollars, a significant amount of money in southern Mexico.

While the Garcías in no way can be described as typical Oaxacan artisans, focusing on their very successful workshop offered a number of advantages to this research. The stark contrasts that exist between themselves and their neighbors raise a series of questions that reveal important features of the relationship of aesthetics, value, and power. First, as I discuss in chapter 4, the aesthetics of their work have changed dramatically since they began making carvings in the 1990s, in ways that have rendered it distinct from the established general style of Oaxacan woodcarving in which most others work. This prompted me to ask how they developed their current styles of carving and painting; why this new aesthetic has proven so appealing to consumers; and what impact the appearance of a new style of work has had on the market more generally. Second, the large scale of their workshop produced forms and relations of production distinct from those found in other workshops in San Martín, allowing insight into how changing aesthetic practices produce and redefine social and political relationships in working life: how do relations of production and employment in their workshop relate to the aesthetic practices and changes that take place there? What consequences do these workshop relations have for considerations of authorship and ownership? What are the social and professional implications for artisans who work for the Garcías? Finally, the aesthetic and productive changes that the Garcías have initiated in San Martín have impacted larger issues of politics and identity in the village, raising questions about the relationship between personal authorship and apparently cultural forms of expression and the implications of a reified notion of "culture" for expressions of identity in San Martín Tilcajete and Oaxaca more broadly.

While these issues are central to my own academic theorizing of the connections of aesthetics, value, and power, they are also of immediate concern to artisans themselves, as many in San Martín struggle to make sense of the ongoing changes in the markets and larger cultural landscapes in which their work circulates. By paying close attention to the aesthetic, productive, and entrepreneurial activities of Miguel and Catalina García, I can chart the ways that these changes are generated both from within and outside of the locations of artisanal production.

It is worth pointing out that no matter how exceptional the Garcías' circumstances are, many of my observations about their work apply to some degree in other workshops in San Martín Tilcajete. Focusing on the larger and perhaps more dynamic workshop of the Garcías allows the details of these processes to emerge distinctly, where they might be harder to glimpse ethnographically in the smaller workshops of their neighbors. Because

Oaxacan woodcarving is organized through households and families, and around larger art-world ideologies of authorship and cultural production, the aesthetic practices and features that I observed at the Garcías' workshop impact all artisans who produce Oaxacan woodcarvings. Everyone works within Mexico's distinct but overlapping economies of culture, each of which seeks to materialize and commoditize particular aspects of cultural forms according to its own logics and visions.

Oaxacan Woodcarving in Mexico's Economies of Culture

All Oaxacan woodcarvers find themselves working at the intersections of various cultural and material categories that operate in southern Mexico. These categories, such as "Mexican," "indigenous," "art," and "craft," structure the markets and cultural discourses that drive the circulation of their work throughout Mexico and North America more generally. Like other cultural producers around the world, artisans' views are colored by such perspectives that legitimate them as the makers and bearers of authentic local and national culture. At the same time, they increasingly work within social and economic conditions that encourage principles of market rationality, individual rights, and personalized success. The everyday blending of these ideologies of "extraordinary authentic culture" and "common-sense entrepreneurship" is a hallmark of the connections that now link nation-states and their citizens to global markets for cultural products, a condition summed up by the term "neoliberal multiculturalism" (Gershon 2011; Hale 2005). As many authors have shown, the work of such markets and institutions does more than simply bring cultural and commodity forms into coexistence. Neoliberal multiculturalism profoundly transforms the relationship between people and their cultural identities by recasting groups and individuals as the *owners* of culture in order to produce economic value at the boundaries of cultural difference (Comaroff and Comaroff 2009; Coombe 1998; Gershon 2011: 539–543). This economic value is the central mechanism of what I am here calling "economies of culture": those multiple fields of economic practice that depend on a reified culture concept and repackage the diffuse practices of everyday life into commodified objects, places, and events.

It is worth distinguishing this "economies of culture" approach from what Scott Cook (2004, 2006) has described as "commodity cultures," not least because his analysis is also based on research with artisanal producers in Oaxaca's Central Valleys region. As an extension of his earlier inter-

jection into the "formalist-substantivist" debate in economic anthropology, Cook proposes the "commodity cultures" concept as a way to account for both the discrete characteristics of the economy and the "socio-cultural matrix" in which it exists, without subsuming one into the other.[5] He argues that the economy is an inherently autonomous space that is relationally constituted by the cultural forms that surround it and that each commodity generates, and in turn is engendered by, its own culture or subculture. It is these commodity cultures that produce the multiple values (use, exchange, and symbolic) of a given commodity, as well as affecting the ways that economic actors behave in relation to these values (Cook 2004:8–10). Interestingly for the topic at hand, Cook also expands this approach to consider the role that commodity cultures played within the development of Mesoamerican civilizational processes. He shows how commodity cultures interpenetrated the various forms of social organization and governance that developed in the Mesoamerican culture area from pre-Conquest times through the colonial period and into the Mexican republic, including the implementation of NAFTA (the North American Free Trade Agreement) (ibid.:165–172).

Like Cook's commodity cultures, my "economies of culture" approach recognizes the productive tension between the social and political structures that govern economic life and the acts of commerce and competition in which individuals and groups engage (which can also be understood as the tension between "structure" and "agency"). It is also interested in parsing the multiple factors that make up a commodity's value. However, I diverge from Cook first in his certainty that the economy is indeed an autonomous space that can be clearly demarcated from the culture and politics that surround it. Second, and more to the point, where Cook seeks to clarify the relationship between culture and *all* commodities, the "economies of culture" concept captures the particularity of markets for those commodities that depend on a reified notion of local culture: those goods, practices, and performances that are believed to "contain culture" in and of themselves and are bought and sold as such.

While artisanally produced bricks made in Oaxaca indeed can be analyzed in order to show how extraeconomic factors impact their production and sale (Cook 2004:224–229), bricks are not locally understood as being intrinsic representations or a chief ingredient of Oaxacan culture. However, other artisanal objects that are made through similar relations of production and labor in Oaxaca's Central Valleys, such as pottery, textiles, and woodcarvings, are profoundly affected by the idea of Oaxacan culture and their place within it. These objects move almost exclusively within "econ-

omies of culture"—systems of exchange focused on goods and services in which their supposed cultural content is an important component of their value. As such, although the economies of culture approach focuses on a specific kind of commodity, it is a move toward holism, as it emphasizes that the various objects of anthropological knowledge, such as economy, culture, property, and identity, are never autonomous from one another.

In developing this concept throughout this book, I build upon the insights of the many anthropologists who have also worked on such cultural commodities in Oaxaca's Central Valleys region, in particular research on textiles by William Warner Wood (2001a, 2008) and on Oaxacan woodcarvings by Michael Chibnik (2003; 2006). Both have interrogated the relationships of production, marketing, authenticity, and value. As they have shown, rather than being an ancillary frame or lens through which audiences interpret locally made carvings and textiles, ideas and discourses about Oaxacan or indigenous cultures have become intrinsic elements of these crafts. Chibnik's meticulous analysis of the history and development of the Oaxacan woodcarving market emphasizes the importance of wholesalers, journalists, and collectors in influencing the styles that artisans work in. At the same time, Chibnik (2003:19–59, 174–234; see below) highlights the importance of the material and labor conditions of artisans and the way that particular material and environmental characteristics of woodcarving impact these issues.

Wood (2000) has explored in detail the implications of what he calls the "weaving production complex" of the Tlacolula arm of the Central Valleys, emphasizing that the economic and social relationships between smaller weaving communities and the more dominant town of Teotitlán del Valle are not merely incidental to the character and form of textile production but rather directly shape it. He also expands this observation to argue that the cultural institutions of the state and the North American tourism and museum industries should also be considered *part of* the communities that produce textiles, shifting the object of analytical attention from geographical communities such as Teotitlán to a more conceptual "community of practice" (Wood 2008). Both Chibnik's and Wood's insights have been invaluable to my own understanding of the relationship of aesthetics, production, competition, and property, and I return to them many times throughout this book.

In conversation with Chibnik and Wood, I argue that culture is itself an essential element of the value of these kinds of commodities and that this "culture value" recasts the use, exchange, and symbolic values of such goods and therefore dramatically impacts the entire social-economic form. In Oa-

xaca the most significant economies of culture through which such arti-
sanal objects are produced, circulated, and sold are cultural tourism, na-
tional markets for *artesanías*, and international markets for ethnic art.

Oaxacan Cultural Tourism

All contemporary economies of culture have developed from much older
notions of culture, history, and belonging. This is particularly evident in the
case of Oaxacan cultural tourism. Since the late nineteenth century, differ-
ent renditions of Oaxaca's ethnic diversity have been used to make claims
for the state's unique status, and even superiority, as a font of authentic cul-
ture within the Mexican nation (Lomnitz 1993:221–241; Poole 2004). By the
1930s this Oaxaqueñismo (Oaxacan exceptionalism) was firmly grounded
in the minds of the urban elite in Oaxaca City through state-sponsored cul-
tural activities designed to construct a strong and distinct Oaxacan identity
(Smith 2009:46–51).[6] One famous example is 1932's Homenaje Racial (Racial
Homage), a cultural performance in which "embajadoras raciales" ("racial
ambassadresses") from the state's different indigenous regions gave hom-
age to the mestizo city of Oaxaca through displays of clothing, dance, and
song (Poole 2011: 188–189). This event served to galvanize elite interest in
Oaxaca's diverse aesthetic and material cultures and at the same time estab-
lished political, administrative, and territorial boundaries between cultures
and races in the state (ibid.).

Oaxaqueñismo also reworked representations of the pre-Hispanic past.
Rather than celebrating the Aztec or more generalized Mesoamerican cul-
tural antecedents of Mexico, as nationalists of the period did, elite Oaxacans
in the 1930s pointed to the extraordinary discoveries being made at the ar-
chaeological site of Monte Albán as the foundation for an identity connected
to local Zapotec and Mixtec pre-Hispanic civilizations (Poole 2004:72–73;
Smith 2009:46–51). While this state-sponsored Oaxaqueñismo depended on
the presence of distinctive indigenous cultures, histories, and traditions, it
is important to note that, like other similar projects of *indigenismo* in Mex-
ico, it was driven by elite political and economic interests.[7]

Under the governorships of Francisco López Cortés (1928–1932) and
Anastasio García Toledo (1932–1936), the apparent celebration of aestheti-
cized indigenous cultures was used to construct a political corporatist struc-
ture that integrated power-holders from various political parties, classes,
and regions. At the same time, the government began to build Oaxaca's tour-
ism industry. As early as 1930 López Cortés established the first state tourism
commissions, laying the foundations for today's dominant tourism economy

(Smith 2009:50–51). The Homenaje Racial itself was the forebear of today's Guelaguetza festival, an annual official celebration of the culture and history of Oaxaca's eight geographic-cultural regions (Poole 2011). With its fanciful representations of regional dress, dance, and music, the ticketed spectacle of the Lunes del Cerro (Mondays on the Hill)—as the main Guelaguetza event is known—epitomizes the ideals of neoliberal multiculturalism: a commodified and folklorized cultural form that indisputably belongs to the place of Oaxaca.

Indeed, the belief in Oaxacan exceptionalism continues to ground tourism activities. While it has a number of small but popular beach destinations, state and private investment has been focused on the promotion of cultural tourism centered in the Central Valleys region where the state capital is located. In productive tension with the marketing of Mexico's large beach resorts, Oaxaca sets itself apart as an opportunity to experience authentic Mexico, which it often implies has been lost elsewhere. As with the emergent Oaxaqueñismo of the 1930s, contemporary tourism is focused on three main arenas: the colonial historic center of Oaxaca City, pre-Hispanic archaeological sites and artifacts, and traditional Oaxacan culture, which can be experienced through activities like visiting markets, sampling mezcal and other local cuisine, and viewing the artisanal production of textiles, pottery, ceramics, and woodcarvings. As Wood (2008, 32) has observed, the photogenic character of these sites is not the spontaneous effect of ordinary people going about their daily lives; the Oaxacan state has gone to great lengths to produce, control, and disseminate this image of picturesque authenticity through marketing, through urban planning interventions, and by directing funds toward specific kinds of businesses, museums, and events (see also Lira Vásquez and Calderón Martínez 2009). Although tourism in the Central Valleys may appear less commercially developed than in Acapulco or Cancún, it is in fact big business. The archaeological zones alone attract more than 600,000 visitors annually, and in 2016 Oaxacan hotels and guest houses registered over 5.2 million arrivals, generating about 12.25 billion pesos (USD 661.5 million) (SECTUR Oaxaca 2016; INEGI 2012).[8] Mexicans make up the largest percentage of tourists, a majority of whom are from Mexico City and Puebla (SECTUR Oaxaca 2016). Although the state also invests heavily in the development of natural resources through mining, forestry, wind electricity, and hydroelectricity, tourism is the public face of Oaxaca's economy. As a representative from the Secretariat of Tourism told me in 2009, it now lags behind only the undocumented and untaxable economies of drug trafficking and migrant remittances in the state.

Despite the appearance of strong tourism and service sectors in the capital, Oaxaca is characterized by high levels of poverty: the 2010 national cen-

sus found that 67 percent of Oaxacans live in either "moderate" or "extreme" poverty and a further 24 percent are "economically vulnerable" (CONEVAL 2012:11–12). This is compounded by Oaxaca's economy, ranked the third weakest in the country: it is the second-to-worst state for labor productivity, generating only 66 pesos (USD 3.19) per working hour, and 75 percent of the population works in informal employment, the highest rate in the country (México: ¿Cómo Vamos? 2017; Morales 2017).[9] This poverty is strongly correlated with the fact that Oaxaca is home to one of the largest populations of indigenous people in Mexico; historical and contemporary structures of exclusion prevent indigenous groups and individuals from attaining the levels of economic and social security that mestizo Mexicans may expect (de la Peña 2005, 2011). From a tourism perspective, Oaxaca's underdevelopment contributes to its attractiveness. Its lack of industrial infrastructure, such as the factories and refineries that sprawl around other midsized Mexican cities, means that it has retained the aesthetic charm that tourists seek (see Murphy and Stepick 1991 on the history of poverty and inequality in Oaxaca).

Although a certain kind of aestheticized underdevelopment has been useful for Oaxaca's tourism industry, it also generates tensions within the local political landscape. In the context of popular dissatisfaction and distrust of the government, tourism has become both a target for political action through demonstrations and blockades and a subject of social critique in itself (Arenas 2011; Lira Vásquez and Calderón Martínez 2009). Tourism and the Guelaguetza festival in particular have become the focus of political action by particular industrial unions and protest groups, including teachers, students, transport workers, and indigenous peoples protesting the actions of mining companies on their lands (to name a few). Sección XXII, Oaxaca's radical arm of the national teachers' union, has been the most publicly visible of these groups, staging an annual occupation of the *zócalo*, the main square at the very heart of Oaxaca's historic center (Howell 2009; Magaña 2017; Norget 2010). While this move allows the union to put pressure on the government, it can also justify force against social movements. At the height of protests in 2006, UNESCO (the United Nations Educational, Scientific and Cultural Organization) threatened to revoke the city's World Heritage designation. Graffiti and encampments were held to be harming the colonial architecture for which the status was granted. This threat was used rhetorically in the conservative media to justify governor Ulises Ruiz Ortiz's use of the federal police and army against the demonstrators in October of that year (Eisenstadt 2011, 21–24; Esteva et al. 2007).

More prosaically, tourism has provided a convenient excuse for successive governments to carry out unpopular activities, potentially allowing

them to channel funds to private interests (Aguiar 2007; Esteva et al. 2007; Olvera 2010:100). A recent example is a project initiated by governor Gabino Cué Monteagudo (2010–2016), to develop a culture and convention center on green space adjacent to the Guelaguetza Auditorium in Oaxaca City. Cué's election in 2010 was perceived by many as the commencement of real political change, as he was the first governor who was not a member of the Institutional Revolutionary Party (PRI), the corporatist political party that held uninterrupted power in Mexico for seventy-one years—eighty-one years in Oaxaca.[10] Many Oaxacans became disillusioned as Cué's government tried to strong-arm the development, despite opposition from citizens' groups and prominent social activists like the artist Francisco Toledo.[11] While the center was eventually relocated, the incoming government of Alejandro Murat, himself a member of the PRI and the son of former governor José Murat, has accused Cué of criminally diverting 290 million pesos intended for human development projects to the convention center, in addition to larger accusations of poor governance and corruption (García 2016; Zavala 2017). Such political pressures have also taken place within the context of larger strains on Mexican tourism, most significantly the global economic crisis, which began in the middle of my research in 2008, and high-profile drug-related violence. This violence is widely covered in the international media, in both news and fictional dramas, and has contributed to a popular perception that Mexico's tourism sector is at risk. However, 2017 recorded an 8.4 percent increase from the year before in the number of international tourist arrivals, a trend that seems set to continue (SECTUR México 2018).

Despite such issues, tourism remains one of the most important economies of culture for the marketing of craftwork in Oaxaca, precisely because tourists are directly immersed in the cultural setting that makes this work desirable. Whether in galleries, marketplaces, or their own workshops, artisans' works fit neatly into the ambiance of authenticity and tradition that the Oaxacan state and tourism sectors promote. The turnover of tourists means that the market is constantly revitalized with new customers looking for souvenirs. While some Oaxacan artisans depend entirely on the tourist trade, most are also simultaneously engaged in Oaxaca's two other significant economies of culture: Mexican *artesanías* and the international market for ethnic art.

Mexican *Artesanías*

While cultural tourism's tropes of authenticity and tradition are the most immediately visible in Oaxaca City, artisans from the region's craft villages

must also engage with cultural experts such as museum staff, gallery owners, civil servants, and even journalists and anthropologists (Chibnik 2003; Wood 2008). Rather than viewing Oaxacan woodcarving exclusively as the material expression of a local culture, as tourists are often inclined to, these actors view Oaxacan woodcarvings as examples of the larger genre of *artesanías*, characteristically Mexican craftwork. While the word *artesanía* is generally translated to English as "handicraft," the two terms carry quite different historical and cultural connotations. Contemporary usages of the English word "craft" are inflected by its history with regard to labor relations since the Industrial Revolution. In particular, the Arts and Crafts movements in England and the United States in the late nineteenth century, and their subsequent revivals, have influenced the ways that English speakers use the term today (Greenhalgh 1997:32–35; Mascia-Lees 2016). The Arts and Crafts movements, broadly speaking, were holistic intellectual, social, and artistic projects that emphasized the aesthetic and moral superiority of hand-produced objects to both industrially produced consumer goods and figurative high art. This perspective is reflected in contemporary ideas that something handcrafted is inherently authentic and of high quality, as in the current fashion for "craft beer" or "artisanal cheese" (see Paxson 2012; Terrio 2016).

Current understandings of Mexican *artesanías* are less concerned with questions of quality or innate genuineness per se and instead are about distinguishing national categories of visual culture, marking the line between the cultures of the elite and subaltern classes (Bakewell 1995).[12] As in other postcolonial contexts, Mexican folk cultures have been the focus of a romantic fascination by national elite groups and played an important symbolic role in Mexico's postrevolutionary moment (cf. Field 1999; Graburn 2004; Makovicky 2010; Venkatesan 2009). The configuration of *artesanías* as a basic category of Mexican material culture was not directly in response to modernist anxieties about industrial production but was rather formed as the political and intellectual elite worked to consolidate a national identity immediately after the Mexican Revolution (1910–1920). Prior to the revolution, elites in New Spain and independent Mexico looked to Europe for cultural legitimacy and aesthetic taste. Although the content of the art in those periods was often influenced by New World experiences, it was executed in decidedly European styles: baroque, neoclassical, and Romantic (Bargellini 2005:81–91; Ruiz Gomar 2005:76–77). Once the dust of the revolution settled, those in power sought simultaneously to distance themselves from Europe and to bridge the country's great divides of class, ethnicity, and politics by cultivating a coherent nationalist ideology that celebrated the unique-

ness of the Mexican culture and character. It was grounded upon the idealized figure of the mestizo, a person of mixed Spanish and indigenous ancestry.[13] *Artesanías* were symbolically important to this project, as they could represent the indigenous and subaltern's contribution to Mexican culture without opening the door to demands for real social justice and inclusive citizenship. The promotion of *artesanías* was also seen as a way to extend economic development to the countryside and to curb the rush of unskilled laborers to the cities (García Canclini 1993a, 1995:118–120; Hernández Díaz and Zafra 2005:17; López 2010; Novelo 1976).

Today the category of *artesanías* continues to reify indigenous and peasant groups as recognizable and distinctive units within the nation. They remain symbols for the reproduction of both Mexicanness and Oaxacanness at official levels. For Mexico City elites, *artesanías* are firmly established as collectible objects, as they evidence connections between the "cosmopolitan" capital and the "provincial" towns and countryside, where the root of national authenticity is believed to reside (Alonso 2004:467–469; López 2010:65–94; Mraz 2009; Poole 2009; Shlossberg 2015). However, while *artesanías* are often highly prized, they also remain conceptually subordinate to the fine arts in Mexico's larger hierarchies of art and culture (Bakewell 1995). This has implications not only for how pieces are valued and received in art markets and museums but also for their makers, who may be viewed by their clients and others through racialized beliefs about class, naiveté, and backwardness (Brulotte 2009:469–470; Shlossberg 2015).[14]

Visual aesthetics are crucial to how *artesanías* work as symbols of national belonging: in order to be legitimately perceived as *artesanías*, handmade items must be recognizably Mexican outside of the contexts where they are made. In her study of the Mexico City art world, Liza Bakewell (1995:20) observes that art can take almost any form, while *artesanías* should be "typically Mexican in palette, shape and sentiment." As one artist explained to her: "Mexican artesanías embody the real truthful culture, the authentic personality of America—all of Latin America, but especially Mexico. I learned about color from Mexican artesanías. All of it has a lot of color, texture, form. It is a special characteristic of Mexico" (ibid.).

Artesanías are thus expected have a characteristic aesthetic that is easily recognizable to all Mexicans and many foreigners, especially US Americans (hereafter "Americans") and Canadians.[15] They must utilize what Mary Coffey (2010:302) calls "the fiesta palette": "cobalt blue, terra-cotta, hot pink or sunny yellow . . . which [recall] stereotypical ideas about Mexico's colorful people and culture." It is this specific aesthetic approach and a certain combination of color and form that distinguish *artesanías* from other

kinds of Mexican material production and from the material culture of non-Mexicans (Bakewell 1995:19–20; D'Ascia 2007:20). As we shall see, while this aesthetic allows artisans to readily connect their work to particular formulations of value and desirability, it is also aesthetically constraining for almost everyone.

The International Market for Ethnic Art

The final economy of culture that has a significant effect on current aesthetic forms of Oaxacan woodcarving is the American and Canadian market for indigenous art. As I discuss in chapter 4, this relatively recent development has had a significant local impact. By viewing woodcarvings as indigenous art, the experts and consumers in this economy of culture simultaneously cast the carvings as the material representations of named indigenous groups while also connecting them to generalized ideas about Native American aesthetics and culture. This ethnicization of Oaxacan woodcarvings has had important consequences in Oaxaca, both in terms of how the woodcarvings' aesthetics have shifted through time and (as I discuss in chapter 5) in terms of how residents of San Martín Tilcajete now articulate ideas about identity and belonging.

American interest in Mexican arts and crafts has a long legacy, dating at least to the 1920s, when prominent collectors like Dwight D. Morrow and Frances Toor began to promote them. This interest intensified with the beginnings of mass tourism in Mexico in the 1950s (Delpar 1992; López 2010:95–126; Zolov 2001:234–243). While Oaxacan woodcarvings can now be found in galleries, markets, and shops throughout Canada and the United States, the American Southwest is the region where they are most successful. This is not very surprising, as the Southwest's regional identity is partially grounded in its history as a part of New Spain and independent Mexico before its cession to the United States in 1848. Furthermore, like Oaxaca within Mexico, it is often associated with indigeneity in the US national imagination. It is home to many different and well-known Native American groups, including the Hopi, the Diné (Navajo), the A:shiwi (Zuni), and the Ndé (Western Apache), whose arts and material culture have also been collected by outside individuals and institutions for generations.[16] As a result of this historical and contemporary interest in these works, a particularly robust art world and market for indigenous art exists in the Southwest, focused on Santa Fe, New Mexico (Mullin 2001; Rodríguez 1997).

Shelly Errington (1998) locates the emergence of "ethnic art" as a concept in the United States in the 1970s: objects previously considered "primitive

art" by ethnographic museums, collectors, and others needed reclassification, as the word "primitive" was finally losing its social acceptability. Like *artesanías*, ethnic arts are concerned with aesthetic authenticity, but the role that authenticity plays in the ethnic arts market is to establish cultural exoticism, rather than national inclusion. In the United States and Canada, as in many other postcolonial settler nations, the most popular ethnic arts tend to be those made by a country's own indigenous, aboriginal, or First Nations artists (Dubin 2001; Graburn 2004; Townsend-Gault 2004). Also like *artesanías*, indigenous arts cannot be understood as spontaneous forms of cultural production that happen to make their way into commercial markets. Various actors and institutions are central to the development and authentication of specific indigenous art forms and styles over time. In the Canadian Arctic, for example, well-known forms of Inuit printmaking and sculpture are the direct result of initiatives by the Canadian state to promote art production as development policy in order to reduce welfare expenditures in the North. While Inuit artists have themselves appropriated and transformed the concept of "Eskimo Art" for their own purposes, the established aesthetic continues to reproduce stereotypical and nationalist imaginings of the North and of the Inuit throughout Canada (Graburn 2004).

Official representations of distinct cultures—Inuit, Haida, or Navajo, for example—circulate and interact with popular imaginings of indigeneity, producing a generalized native aesthetic that blurs differences among indigenous groups. Native peoples with diverse cultures and historical experiences have become subsumed into a generic indigenous ethnicity, resulting in the repackaging of distinct cultures as "styles" and therefore making the aesthetics and content of indigenous cultures eligible for use by nonindigenous people and corporations (Coombe 1998; Townsend-Gault 2004). As Charlotte Townsend-Gault (2004:192) observes, the unrestrained circulation of indigenous aesthetics "insinuates aboriginality" into public and private spheres, making "indigenous art" a commonsense category of material culture that North American white middle-class consumers can easily identify. While the aesthetics of indigenous art in the United States and Canada also reference their respective nations, they do so in different ways than *artesanías* do. Because the Mexican nation was built on an ideology of *mestizaje* (the idea that authentic Mexican culture and identity has emerged from the providential blending of Iberian and indigenous cultures), the makers of *artesanías* are incorporated into the ideal of the Mexican people, rendering *artesanías* the product of the national, if subaltern, self. Indigenous art in the United States and Canada is not the product of the self but a product of others who are geographically and historically within the nation but not ethnically or culturally part of the national subject.

It must be noted that the appreciation and promotion of *artesanías* and indigenous arts as representations of Mexico, Canada, or the United States rarely do much for demands for social justice or political recognition. Differences of culture and class are often valued only when they take the form of aesthetic and consumable cultural expressions (Shlossberg 2015). Nevertheless, Chicano, Mexican, and indigenous artists have been central to many social movements in all three North American countries (Arenas 2011; McCaughan 2012). The involvement of art producers in movements for justice and change indicates that the aesthetic processes described in this book are not static, apolitical, or uncontested and that the aesthetic practices of others working in these art fields also help to shape and transform the aesthetic processes that Oaxacan artisans work within.

While I have schematically presented the contemporary economies of culture at play in Oaxaca as forming distinct spheres of activity, they of course are not so clearly separated in reality. Particular individuals and institutions in the art world of Oaxacan handicrafts simultaneously work within the cultural economies of tourism, *artesanías*, and ethnic art, producing an interdependent and synergetic field of cultural production (Wood 2008). Likewise, these three perspectives are also not exclusively related to one group of consumers or another but are instead aesthetic categories that consumers and producers alike utilize in order to understand, talk about, and position Oaxacan woodcarvings vis-à-vis other kinds of material production. Because of this, no single term—handicraft, material culture, or art—analytically captures the multiple and sometimes contradictory concepts that Oaxacan woodcarvings embody. As such, the terms I use throughout this text to describe Oaxacan woodcarvings frequently shift as I draw attention to how each of these perspectives intermingle with artisans' own aesthetic sensibilities and practices in their workshops in the woodcarving village of San Martín Tilcajete.

Carvers and Carvings in San Martín Tilcajete

San Martín Tilcajete is an ideal location for selling authentic Mexico. Its dusty streets stretch in a neat Spanish colonial grid past brightly painted cement walls, the tidy garden of the main square, and the imposing seventeenth-century church, dedicated to the village's patron saint, Saint Martin of Tours. Old adobe walls return to the earth behind the new concrete facades, and goats and donkeys wander through the streets, inadvertently providing opportunities for photographs laced with nostalgia and bucolic charm. Dark *tienditas*, little shops selling sodas and *cervezas* (beers), provide a welcome

retreat from the bright sun. Children run along the main street, offering to take tourists to their families' workshops.

Located about fifteen miles south of Oaxaca City, San Martín is the head (*cabecera municipal*) of its own small municipality in the Ocotlán district. From 1891 it was a council (*ayuntamiento*) under the municipality of Ocotlán, but it gained political independence in 1905 and for some time controlled its smaller neighboring communities (*agencias*) (Serrano Oswald 2010:123). An etymological catalogue of Oaxacan place-names from 1883 reports that an earlier Zapotec name for San Martín was Tilcaxitl, meaning "black *cajete*" (earthenware pot) (Martínez Gracida 1883). However, many older residents of San Martín reported to me that the "Til" refers to the red cochineal dye, which was an important export from Oaxaca during the colonial period. Some residents also explained that Tilcajete had been once known as Zapotitlán (place of the sapodilla tree) in Nahuatl, the language of the Aztec Empire, which dominated the region in the fifteenth century.[17]

The center of the village proper is divided up into private plots, where Tileños (people from San Martín Tilcajete) have their homes and workshops, keep animals, and plant kitchen gardens. The arable land surrounding the village is communally owned and is cultivated by households. Families are allotted a portion to work, where they grow the traditional crops of corn, beans, and squash. San Martín Tilcajete holds both forms of communal land titles in Mexico: *terreno comunal* (communal land) and ejido land titles. As part of the postrevolutionary agrarian reforms in the twentieth century, *terreno comunal* titles were granted where communities could claim a "primordial connection" to the land, and ejido lands were redistributed from the former holdings of large landowners and the Catholic Church (Bartra 1993:94–97; Eisenstadt 2011:29). Tileños claim primordial title through their occupation of the land since time immemorial, evidenced by the remains of ancient Zapotec settlements on the ridge above the village, which indicate occupation from at least 500 BC (Flannery and Marcus 2007: xi). Its two ejido parcels are relatively small and of poor soil quality, so agriculture mainly takes place on the *terreno comunal* lands.

San Martín's municipality is currently governed under the system of *usos y costumbres* (uses and customs), which was legally sanctified under reforms to Oaxaca's constitution in 1995. These reforms were intended to give legal recognition to political practices already existing in Oaxaca and to grant further autonomy to indigenous communities. For example, political parties are barred from participation in municipal elections. Leadership positions are generally elected or appointed within the structures of the "*cargo* system" (Durand Ponte 2007:20). The cargo system, common in indigenous

and rural communities throughout Latin America, is a form of community organization constituted by a hierarchy of roles and committees, which are (mostly) occupied by men who work their way up through the ranks (see Chance and Taylor 1985 and Cohen 1999:107–133 for analyses of the history and current forms of this system, respectively).[18]

Although the recognition of *usos y costumbres* appears to be a liberalizing move toward indigenous autonomy in Oaxaca, it has been critiqued by activists and intellectuals. As many have observed, although it is supposed to be free of political party influence, it often functions as a de facto mechanism for the PRI party to consolidate its power in rural municipalities (Anaya Muñoz 2005:601–608; Eisenstadt 2011:53–54; Hernández Díaz 2007:50–52). Furthermore, questions have been raised about human rights within *usos y costumbres* communities. During my fieldwork at least one family in San Martín Tilcajete had their electricity cut off for many months during a dispute with the municipality over participation in the cargos. When individuals or families run into such troubles with the authorities, they can appeal to the state government's Commission for Human Rights Assistance (Coordinación para la Atención de los Derechos Humanos de Oaxaca) for adjudication, although this often takes many months.

Officially, the population of San Martín Tilcajete is just under 2,000, but it varies throughout the year as migrants come and go from the United States. Jeffrey Cohen (2004:153–154; see also INEGI 2010) reports that over 50 percent of San Martín's households are economically dependent on remittances. A survey I conducted at the beginning of my fieldwork in 2008 found that 68 percent of San Martín's households were involved in making woodcarvings and that 43 percent considered woodcarving a full-time occupation. Most artisan households combined woodcarving production with other kinds of income-generating or subsistence activities. This often was agricultural production but also included running small shops or employment in Oaxaca's service and government sectors. The Garcías and one other family also ran restaurants on the highway and hired staff from the village. The woodcarvings are really the only things that draw tourists, collectors, and journalists to San Martín, which did not have a market, a museum, or even a *comedor* (eatery) in the center of town for visitors at the time of my research.

Oaxacan woodcarvings are intriguing and diverse. Many are small enough to be tucked into pockets or attached to key chains, while others are so large that they must be shipped to their final destinations. While a majority represent animals—both real and imaginary—the carvings also take the form of human characters and religious figures that are common in

Mexican popular culture. On the shelves of San Martín's workshops Mexican fauna like iguanas, jaguars, and coyotes share their space with giraffes, dragons, saints, and devils. While their forms are diverse, Oaxacan woodcarvings' stylized manner and bright and elaborate paintwork cast a spell of regularity. Fine lines, dots, flowers, chevrons, and swirls in vibrant reds, sunny yellows, and fresh greens seem to spill from one piece to the next, creating a landscape of color and form that stretches between shelves and between workshops. While individuals do incorporate their own stylistic flourishes, the majority of carvings are similar. Some visitors even told me that they found them indistinguishable from one another. Yet, due to their recent invention, there are few fixed norms for making woodcarvings and learning the craft. This is not to say that Oaxacan woodcarving is an unconventional or avant-garde genre or that people engage with their work only as individual artists. As I discuss in chapters 2 and 3, expectations from the economies of culture through which carvings gain their value mean that production tends to be household-based and aesthetically conservative.

Tileño artisans colloquially use three basic divisions when describing woodcarvings, which I use throughout this book. These can be understood as evaluative descriptions of styles within the larger genre: (1) *piezas comerciales* (commercial pieces; plate 1); (2) *piezas típicas* or *rústicas* (traditional or rustic pieces; plate 2); and (3) *piezas finas* (fine pieces; plate 3). These categories are based on lines of stylistic or visual qualities that relate to the way the finished pieces look and also encompass evaluations of the quality of execution and the price that might be achieved. *Finas* are generally thought to be of higher quality in execution than *comerciales*, but they are not thought to be categorically of higher quality than *rústicas*. While *finas* might appear more elaborate or difficult to produce, *rústicas* are understood to be valued by collectors, who prize them for their simple, authentic look.

Comercial pieces make up the majority of woodcarvings that are sold in San Martín and in Oaxaca more generally. This style was consolidated during the early 1990s, when woodcarvings came to be seen as a viable livelihood and many people began producing them (Chibnik 2003). Workshops where *comerciales* are produced often have a display area full of hundreds of pieces of different forms, where tourists and wholesalers can view them. They are small to medium pieces, mostly animal forms, like cats, iguanas, and armadillos, usually carved in simplified or stylized poses. *Rústica* pieces, in contrast, are more often the stock characters of Mexican folktales and popular culture, including saints, devils, skeletons, and peasants. Unlike the *comerciales*, animal forms are more likely to be animals found in the Oaxacan countryside. They are carved in more organic modes with the

intention, according to some, of achieving a level of realism and often depict scenes of everyday life, such as agricultural work and fiestas. Many *rústica* carvers also carve masks that are used in San Martín Tilcajete's annual celebration of Carnival just before the beginning of Lent, which are also considered highly collectible by folk art connoisseurs. As a descriptor, *fina* was used with much less frequency by Tileños than the other two categories. My sense is that this is because some artisans have only recently begun to be distinguished by themselves and others as producing "high-end" work. More often people would comment that *su trabajo es muy fino* (his or her work is very fine). These descriptions are not exclusive or necessarily precise at all times. Pieces may be evaluated differently by various people. These words are not generally used as abstract categories but rather to describe the work of an artisan or an individual piece. The works of many artisans in general might not fall clearly into one category or another but might be described at the same time as "quite *típica*" but also "very *fina*." Despite this ambiguity, when I asked artisans about *fina*, *típica*, or *comercial* pieces, they could immediately give me an example of each kind of work.

The carvings are generally purchased by three overlapping groups of consumers from Canada, the United States, and Mexico, which loosely correspond to the economies of culture outlined above. Tourists buy carvings directly from artisans in their workshops or from the many galleries and markets in Oaxaca City and other Mexican destinations. Ethnic and folk art collectors from Canada and the United States often pride themselves on buying only directly from artisans, although they also purchase work in upscale galleries. Finally, museums and state institutions purchase work directly from artisans for their shops and permanent collections. The character of these markets means that Oaxacan woodcarving is for the most part aesthetically conservative. As Christopher Steiner (1999:101) has argued for African sculpture, this is a hallmark of art markets that depend on essentialized views of culture: repetition and not originality gives these works their authenticity, because "anything that deviates too far from the accepted canons of a particular ethnic style is judged as inauthentic."

In his ethnography *Crafting Tradition*, Michael Chibnik (2003) charts the development of the production and marketing of the woodcarvings from their beginnings in Arrazola, when Manuel Jiménez first started carving in the 1940s, until the late 1990s, when he conducted his initial ethnographic research in the three main woodcarving communities: Arrazola, La Unión, and San Martín Tilcajete. Since the publication of his book in 2003, the production and marketing of Oaxacan woodcarving have changed dramatically. In particular, increasing economic and sociopolitical instability in the

region and the current precarious legal and security situation for migrants in the United States have made artisans less certain that their current forms of livelihood will be open to their children. At the same time, the changing aesthetics, ideologies, markets, and labor practices that I chart throughout this book have resulted in increased stratification among artisan families, which was not present (at least to the same degree) in the 1990s (Chibnik 2017:301–319). As I discuss in chapters 4, 5, and 6, these changes have dramatically impacted relations among artisans in San Martín Tilcajete, both in terms of competition and cooperation and in more general understandings of identity and belonging.

In discussing the ways that woodcarving articulates with the multiple economic goals and activities of individuals and households, Chibnik's analysis delineates three main strategies of artisans: those who combine woodcarving and agriculture; those who combine woodcarving and wage labor; and those who focus exclusively on woodcarving. Chibnik (2003:82–92) notes that the strategy a family adopts often has as much to do with household composition as it does with relative success. When I began my research in San Martín Tilcajete in 2008, these strategies remained the main ways that artisans organized their work. Chibnik's observation that household composition was a key factor certainly remained true. What had changed since the 1990s, perhaps, was the form and significance of these strategies, within the larger shifts in the woodcarving market and in southern Mexico more generally. For example, the relationship between carving and agricultural production had changed since the 1990s because the price of corn crashed dramatically with the removal of protective tariffs under the requirements of NAFTA (see Wise 2011). Many artisans I worked with no longer felt that selling their surplus harvest was worth the effort, although cultivating staple crops for household consumption remains a key way that they can shore up their incomes from carving (Chibnik 2003:88). Because access to communal land is dependent on its cultivation, even artisans who are relatively secure continue to grow food on their family's allotment. In fact, the Garcías hire neighbors to cultivate their own parcel so that they do not lose access to it. As elsewhere in rural Oaxaca, Tileños view the ability to cultivate this communal land as their basic security against the uncertainties of the world.

Chibnik (2003:114–119) describes the labor relations between workshop owners and hired employees, who work for wages or piece rates in "factory-like workshops," which often also sell carvings made by other independent artisans. He notes that this organization exists in both Arrazola and San Martín and that many households in the 1990s that used no hired labor were

as well off as those who ran the large workshops. By 2008, however, there was a discernible difference in San Martín Tilcajete between workshops that sold only their own work without using hired labor and those that hired employees and/or resold the work of others. Those independent artisan families who had successfully established themselves in the 1990s and early 2000s were able to continue to sell their work consistently, but a large number of people who had more recently entered the trade struggled to sustain themselves.

At the same time, the scale of some factory-like workshops in San Martín had increased significantly, especially in the case of the Garcías. When I conducted my research, they employed about thirty artisans with full-time wages and a large number of casually employed people who worked on piece rates in their own homes. The workshop also employed a few auxiliary staff who managed the office and finances, ran errands, and cooked two meals a day for the entire workforce. The Garcías' restaurant on the highway and the two small galleries that they owned in Oaxaca City also employed people from San Martín. In a village of about 2,000 people, the increasing scale of the Garcías' business effectively meant that a significant proportion of Tileños who worked in wage labor were working for them. This has consequences for relations among families and in the community as a whole (see chapter 3).

I hope that this book can be read as a continuation of the story of Oaxacan woodcarving that Michael Chibnik began in *Crafting Tradition* (2003). The production processes, material considerations, and economic decision-making that he analyzes remain important to woodcarving production today. Likewise, his descriptions of the organization of woodcarving markets continue to reflect current conditions, especially the role of dealers, shop owners, and popular authors in setting the parameters for sales. His observations about the ways that Zapotec and indigenous identities were becoming a key trope through which online wholesalers advertised the carvings in the 1990s also foreshadowed some of the processes that I describe here. At the same time, this book details the significant changes that have happened in the world of Oaxacan woodcarving since the 1990s. Indeed, these changes have continued at a great pace. In the new Spanish-language edition of *Crafting Tradition*, Chibnik (2017:304–308) notes that these changes have impacted San Martín Tilcajete much more dramatically than the other carving communities, due especially to the dramatic success of the family that I call the Garcías. As I address in the conclusion, the Garcías' business has continued to expand well beyond what I witnessed in 2008 and 2009. The place of Oaxacan *alebrijes* in the popular imagination has changed as well.

This book also charts a new course in the study of Mexican ethnic art and craftwork by bringing current concerns from the anthropology of art to bear on the classic questions of production and marketing. As I discuss in chapter 1, a focus on aesthetics provides a better view of the interconnections between objects and materials on the one hand and the multiple ways that value is constructed on the other. Attention to aesthetics therefore allows us insight not only into the nature and function of works of art but also into how economies of culture work to structure the lives of those who make, sell, and buy things like Oaxacan woodcarvings.

Outline of Chapters

Throughout the chapters, I investigate how the aesthetics of Oaxacan woodcarvings are both a central feature of their economic and cultural value *and* the mode through which artisans in San Martín Tilcajete experience, interpret, and enact change in their working lives. By considering various aspects of woodcarvers' aesthetic practices within the varied and often contradictory discourses and expectations of the three overlapping economies of culture described above, I show that the aesthetics of Oaxacan woodcarving are more than just a symbolic or ornamental outcome of economic life. They are a practice and a technology through which Tileño artisans engage with the economies and politics of culture.

Chapter 1 initiates an analysis of how competing ideologies of aesthetics, materiality, and authorship interact in a given context and how these perspectives produce monetary and social value. Based on ethnographic data about how different kinds of viewers engage with and interpret Oaxacan woodcarvings, the chapter suggests that Walter Benjamin's notion of the "aura" of works of art can help us to understand art's allure for viewers and how it relates to the production of value within art markets.

In chapter 2 I explore the social, artisanal, and aesthetic processes through which woodcarvings are made in San Martín Tilcajete. Rather than being just descriptions of skills, traditions, and expertise, these forms of productive and aesthetic decision-making constitute particular aesthetics of work, which are not necessarily collective or shared by all. Drawing on artisans' own explanations of "skilled" and "unskillful" work, I analyze the concrete, affective, and sensory experience of doing their work and how this experience relates to diverse feelings of satisfaction, dissatisfaction, and desires about their workday.

Chapter 3 starts to move conceptually outward from the immediate relations of art objects, viewers, and makers to consider how art-world ideolo-

gies of authorship now affect the intimacies of daily life in San Martín Til-cajete. By considering how authorship reconfigures relations of kinship and neighbor into relations of employment and competition, the chapter argues that aesthetic practices produce particular forms of attachment and detachment between people and the objects they produce and with one another.

In chapter 4 I continue to explore artisans' aesthetic practices through an investigation of the aesthetic genre of Oaxacan woodcarving. In order to understand the nature of the competition discussed in chapter 3, artisans' own practices must be placed within the economies of culture in which they work. The chapter shows that the Garcías' enviable success is due to their ability to reposition their work as "indigenous art" rather than "Mexican craft," a move that has allowed them to tap into the more lucrative North American ethnic art market. I argue that in doing so the Garcías have fundamentally changed the aesthetics and meaning of Oaxacan woodcarving as a genre and have moved the goal posts, so to speak, for all other Oaxacan woodcarvers in the process.

Chapters 5 and 6 can be read together as an analysis of the consequences of aesthetic change in contemporary Oaxaca. Chapter 5 considers the implications of the new "aesthetic of indigeneity" in Oaxacan woodcarving for processes of identity and belonging in San Martín Tilcajete. Although most villagers do not straightforwardly identify as Zapotec, their history, work, and personal experiences allow them to make particular kinds of connections to an imagined indigenous belonging. In contrasting the ways that two individuals articulate their ideas of indigeneity, the chapter suggests that the kind of indigeneity produced by participation in economies of culture may be essentially personalized, aestheticized, and depoliticized. Despite some individuals' positive perspective on indigenous belonging, I show how artisans cannot avoid the structures of race and racism that are still conspicuous in Oaxaca today.

In chapter 6 I return to Antonio's provocative question of why artisans care about replicas of their work if they do not seem to threaten them culturally or economically. In discussing the process through which artisans in San Martín Tilcajete and the other carving communities attempted to form a collective trademark for Oaxacan woodcarving in 2009, I argue that the resin replicas provoked anxieties because they made visible all of the conceptual contradictions and tensions of their work that I explore in earlier chapters. I suggest that intellectual property is alluring precisely because it seems to offer the possibility of reconciling the contradictions of competition, authorship, and aesthetic production in a way that the market and the politics of culture do not seem to be able to do.

Together, these chapters trace the contours of aesthetic experience and

practice in artisanal lives in contemporary Oaxaca. Although this book is not an exhaustive survey of the forms and styles of Oaxacan woodcarvings, its fundamental idea is that aesthetics themselves are key generators of activity and change within art worlds. While this may seem evident, given that works of art are what art worlds are premised entirely upon, the analysis of aesthetics and their social effects has not always been taken as a central theme in anthropological studies. So I begin by discussing exactly what I mean by aesthetics.

Notes

1. In 2004 ARIPO changed its name to the Instituto Oaxaqueño de las Artesanías, but most people in Oaxaca continue to refer to it as ARIPO.

2. Except for well-known public figures and Antonio Mendoza Ruiz, Manuel Jiménez, and Isidoro Cruz, all personal names and the organizations Artesanos del Pueblo and Artistas Artesanales are pseudonyms. See the appendix, "A Note on Names," where I discuss why I have used pseudonyms in this study.

3. The word "aesthetics" (with the *s* ending) is primarily treated as a singular in most English-language dictionaries. However, this grammatical feature is a consequence of it being the name of the branch of philosophy concerned with beauty and judgment. As that is not generally the concern of this book, I follow the colloquial form of using "aesthetics" as a plural, except when discussing philosophy, in order to retain the manifold nature of what these aesthetics entail (color, form, style, sensibility, and so forth).

4. The development of *barro negro* (black pottery) in nearby San Bartolo Coyotepec is strikingly similar to the historical trajectory of Oaxacan woodcarving.

5. The "formalist-substantivist" debate was a discussion among economic anthropologists primarily in the 1960s and 1970s. Formalist scholars, including Scott Cook, argued that the formal rules of neoclassical economic theory were essential for understanding precapitalist economies, whereas substantivists inspired by the works of Karl Polanyi insisted that the particular cultural character of such economies determined the distribution of goods, services, and labor (see Wilk 1996 for a summary).

6. A strong Oaxacan identity was desired by the state, as Oaxaca was considered unmanageable due to deep divisions of language, ethnicity, geography, and politics (Smith 2009:46–51).

7. *Indigenismo* is a nationalist ideology that emphasizes the celebration of indigenous culture as a part of Mexico's history and the attempt to integrate indigenous populations under the authority of the nation-state.

8. All exchange rates between Mexican pesos and US dollars are based on the monthly average rate for June of the year in question. If no year is given, the monthly average rate for June 2009 is used.

9. The national average for labor productivity is 134 pesos/hour; the national level of informal labor employment is 53 percent (México: ¿Cómo Vamos? 2017).

10. Cué had previously been a member of the PRI but joined the newly formed Partido Convergencia during his successful campaign to become mayor of Oaxaca

City in 2001. In 2010 he was elected governor through a coalition of various parties on the political right and left that opposed the PRI.

11. See Holo (2004) and McCaughan (2012) for detailed discussions of Toledo's political activities in Oaxaca.

12. This corresponds to common usages of "craft" in English before the Industrial Revolution (Graburn 1976).

13. See Gutmann (1992) and Lomnitz (1993, 2001) for full analyses of lo mexicano in the historical development of Mexican nationalism.

14. However, large numbers of the middle classes are not interested in artesanías at all, preferring to own "modern" items that showcase their tastes and upward mobility.

15. Unless otherwise stated, "Americans" refers to people from the United States; "North Americans" refers to people from Canada, the United States, and Mexico. While acknowledging the problematic (and unfair) use of the term "Americans" to describe people from the United States, the term is the most straightforward demonym in English.

16. For further information about Native American cultures in the Southwest, see the American Indian Heritage Foundation's website, http://www.indians.org.

17. I have not found any historical evidence to back up this claim, although many communities in Oaxaca's Central Valleys do continue to have Nahuatl names, such as nearby Coyotepec and Ocotlán.

18. In San Martín Tilcajete men begin their cargos when they turn eighteen or marry, and those in full-time education are not allowed to take on positions. Unlike some other villages, all men in San Martín must start at the lowest cargo (topiles [the village police force]) and work their way up through the positions in the hierarchy. While women are allowed to vote in the municipal assemblies for elections and other decision-making processes, they cannot hold cargos. However, a large number of them work with the school committee (said to be because of their responsibilities for child care within the household) and are able to hold the position of municipal secretary.

CHAPTER 1

The Alluring Thing Itself

One quiet afternoon I was walking along the sunny and peaceful main road through San Martín Tilcajete, lined on either side by workshops and *tienditas*, small corner shops that sell everything from lollipops flavored with chili and tamarind to chilled beer, fresh fruit, and household staples. Suddenly I heard Lázaro Ramos, a woodcarver who produces inexpensive *comercial* carvings for tourists and wholesalers, excitedly call to me from across the street. I went over and ducked into his shady workshop, where he normally sat at a small table near the doorway, so he could keep an eye out for passing tourists. "Come in! Come in!" he exclaimed as he clanged the metal door shut behind me, which startled me since his door was always left open when I visited him. "I'm going to turn off the lights," he warned me, as he directed my gaze toward a table where thirty or so woodcarvings were lined up against the unpainted concrete wall. "Look." As he turned off the light, he flicked another switch and I finally understood what was happening: the thirty carvings jumped to life in the eerie glow of a black light. Opening the door again, he asked, smiling, "What do you think?" I was uncertain how to respond, as I wondered to myself whether tourists and folk art collectors would really be interested in glow-in-the-dark Oaxacan woodcarvings. To my relief, Lázaro did not wait for an answer; his eyes glittering with humor, he told me: "Like the conquistadors and Cortez, who were enchanted by the gold of the Aztecs, these will enchant the tourists." He speculated that this might be his new big opportunity—a way to distinguish himself from the many other workshops along San Martín's main street, where his neighbors and relatives were also his direct competition. Lázaro's clients were not enchanted, however, and I noted a few weeks later that he had given up on the fluorescent paint.

Lázaro's mistaken prediction about the ability of the fluorescent glow of

black-light paint to enchant his clients indicates a serious question faced by Oaxacan artisans and by myself as an anthropologist interested in the relationship between art and value: Why do people *want* to buy Oaxacan woodcarvings in the first place? When I asked artisans outright why they thought customers wanted to buy their work, many seemed uncertain and resorted either to generalized explanations of Oaxaca's traditions or, more often, to simple descriptions of colors, forms, and sentiments. Because they are *muy alegre* (very cheerful) was one of the most common answers. The pressing issue is not why tourists desire a souvenir—it is not surprising that visitors want to take home something to remember Oaxaca by. However, as a place deeply embroiled in cultural tourism, Oaxaca offers boundless opportunities to buy souvenirs: its many marketplaces and galleries literally overflow with locally made textiles, pottery, glassware, silver jewelry, and foodstuffs prepared for export. In such a market, where authenticity is everywhere, what attracts customers to Oaxacan woodcarvings specifically and to the work of certain individuals in particular?

In this chapter I propose an analytical approach that will allow insight into two core questions of this book as a whole: how do different, even competing, ideologies of aesthetics, materiality, and authorship interact with one another in a given context? And how do such perspectives produce value—both monetary value in markets and social value in the sense of the respect and attention that we grant to art? Current scholarship on aesthetic commodities suggests that we cannot accurately understand the ways that value accrues to such objects without considering how their symbolic and material qualities condition the experiences of both producers and consumers.

Since the late 1990s anthropologists have generally approached this issue either by looking at how "authenticity" is produced in a given locale or, following Alfred Gell (1992), by approaching artworks as "technologies of enchantment" that appear to have agency in their own right. While both of these approaches tell us something important about the social and material relationships induced by the circulation of artworks, I maintain that they do not give us the full picture. They tend to present overly neat illustrations of the "artistic encounter" where producers and consumers have a shared understanding of what the artwork is supposed to be and do. During my research in San Martín Tilcajete, I found that the artistic encounter was frequently very different than what was expected by those involved, including myself. In order to truly understand the value of artistic objects like Oaxacan woodcarvings, and therefore the conditions of work and life of their makers, we need to be able to account for the multiple and often contradictory ways that people experience a piece of art. I maintain that these

multiple experiences cannot be understood without also paying attention to aesthetics. However, the term "aesthetics" has not been consistently used or even wholeheartedly accepted in the discipline of anthropology. Therefore, I begin by addressing the trajectory of anthropology's relationship with aesthetics and some of the main criticisms that have been raised against its use as an analytic device, before turning to my proposal of how we might include such aesthetic concerns when researching the production of value in art markets and economies of culture.

Aesthetics as an Anthropological Subject

In these pages I discuss how value and power are produced through the making and circulation of art within what I have termed "economies of culture." However, the arguments I develop here have larger implications for our understandings of economic life and social life more generally. Aesthetics are by no means auxiliary to current forms of economics and politics: regimes of contemporary capitalism, citizenship, and governance *and* the ways in which people seek to transcend them take place through aesthetic practices and experiences (Das and Randeria 2015; Mascia-Lees 2011; Winegar 2016). As the sociologist Eduardo de la Fuente (2013:169) argues, aesthetic forms materialize the emotional force of human relations, making them visible and allowing them to become sites of transformation: "There is an art-like dimension to all human activities—including supposedly rational or instrumental activities like science, economics and work." This art-like dimension of social life can be understood as the result of the intermingling of human emotion and sensory experience ("perception") within a social and physical environment (Ingold 2000). As such, economics, politics, and even society itself are never prior to or apart from aesthetic experiences, as they can exist only through people's visual, haptic, auditory, olfactory, and gustatory experiences of the physical world (de la Fuente 2013; Ingold 2000:157–171; Le Breton 2017). Moving beyond symbolic and sociological approaches to art, then, such reasoning indicates that style, color, form, materials, rhythm, composition, and their transformations *always matter* (Bateson 1972:103–118; Young 2011).

Yet acknowledging the fundamental impact of aesthetics does not mean that they are easily captured or explained through traditional social scientific enquiry. In previous decades anthropology struggled to decide how—and even whether—to use "aesthetics" as a term of analysis (see Svašek 2007 and Morphy and Perkins 2006 for detailed histories of the anthropology of

art). Influenced by Franz Boas and later Claude Lévi-Strauss, early attempts to develop a practicable approach to visual aesthetics were focused on cataloguing "ethnoaesthetics," local systems of classification and knowledge that connect the symbolism in material culture to other social institutions (e.g., Carpenter 1973; Dark 1966). While this approach increased understandings of material culture cross-culturally, its primary interest in linking symbolic meaning to extant cultural features meant that ethnographers struggled to take social and aesthetic change into account. In response, a focus on "aestheticization" emerged, investigating how social processes persuade people to frame and value particular objects and experiences in terms of their sensory qualities (Morphy and Perkins 2006; Svašek 2007:9–11). In the late 1980s anthropologists began to be concerned with how objects become classified as art. James Clifford (1988) and Sally Price (1989) produced groundbreaking studies that interrogated activities of collection, curation, and the power to define "culture." Slightly later, Jeremy Coote (1992) and Howard Morphy (1989) emphasized how particular visual characteristics—such as the color patterns and sheen of the hides of the Nilotic peoples' cows or the quality of brilliance in Yolngu painting—relate to particular forms of moral and ritual value. Their work moved beyond the older ethnoaesthetic approaches, which emphasized symbolism and meaning, by showing how aesthetic experiences are fundamental human experiences that become localized through cultural systems.

Despite these varied and insightful approaches, by the late 1990s anthropology had all but rejected "aesthetics" as a term of analysis. Many argued that the concept itself was too entangled with Western European philosophical thought—in particular Immanuel Kant's preoccupations with transcendental beauty and disinterested judgment—to be of any analytical use at all (see Morphy et al. 1996; Sansi 2015:67–69). This uncertainty led to a general disengagement with art and aesthetics, marginalizing their study in the discipline in that period (Townsend-Gault 1998:425). Another palpable shift has occurred in the past decade: a new disciplinary interest in "affect" has prompted some scholars to reconsider aesthetics as a useful analytic (see Richard and Rudnyckyj 2009; Rutherford 2016). Indeed, affect and aesthetics can be seen as two sides of the same coin, as both are concerned with embodied responses to experience. This shift has resulted in a kind of renaissance in the discipline, and a concern for the aesthetic has been brought to bear on topics as wide-ranging as nationalism, religion, and corporate and public institutions (e.g., Meyer 2009; Mookherjee 2011; Rowlands 2011; Sharman 2002, 2006).

At the same time, anthropologists have begun to work closely with con-

temporary artists, many of whom have themselves been engaged in critical, often "ethnographic" thinking and exposition about aesthetics and their relationship to society, politics, and research (Sansi 2015; Schneider and Wright 2013). What this new, more critical, interest in aesthetics shows is that anthropology requires a way to conceptualize and interpret the relationship between aesthetic experience—seeing, hearing, touching, and so forth—and the social and cultural relations that are the discipline's main object of study, as such experiences cannot be separated from the ways that people live their lives.

Rather than start from the point of Kant's preoccupations with high art, beauty, or the sublime, new approaches to aesthetics have sought to reinvigorate earlier formulations, such as those by the eighteenth-century philosopher Alexander Baumgarten, who introduced into European thought the concept of "aesthetics" (which he developed from the Greek *aisthesis*, meaning sensation or perception) in order to describe the study of the things in the world that we know through our sensory, rather than intellectual, faculties (see Sansi 2015:67–86). Fran Mascia-Lees (2011) usefully suggests that anthropologists should look to Maurice Merleau-Ponty to understand human aesthetic experience. For Merleau-Ponty, aesthetics describes a form of embodied knowing or a mode of being-in-the-world through which "humans respond to forms, shapes, and color . . . in ways that take on a life of their own and open themselves up to metaphoric meaning" (Merleau-Ponty 1964:123, quoted in Mascia-Lees 2011:6).

Reconceptualizing aesthetics as a culturally inflected and socially induced response to visual forms allows us to move beyond the impasse of earlier decades. In considering how people engage with and react to visual elements, aesthetic practices can be firmly located within their cultural, political, and economic contexts without confining our analyses to discrete artworks, genres, or judgments of beauty, as the Western tradition of art history and critique often does.[1] However, while visual aesthetics are intrinsic to all social life, their effects are perhaps rather easier to observe in the case of artistic objects and aesthetic commodities. This is because the linguistic and conceptual categories that we use to think about such objects—such as art, souvenir, curio, and craft—draw our attention to their alluring aesthetic attributes. Oaxacan woodcarvings are a particularly interesting case in this regard, because they do not fall neatly into any one of such categories. Because of their recent history and various circuits of movement they easily slip between different classifications of material culture.

The title of this chapter was inspired by a short essay by Arjun Appadurai (2006) entitled "The Thing Itself," in which he implores us to consider

all of the ways that art objects shift and change as they move through time and space: how changes of commodity or gift status or physical condition and location affect what he calls the "objecthood" of art (ibid.:15). In contrast, here I want to hold Oaxacan woodcarvings momentarily still in order to consider what is actually happening in the precise moment when someone—a maker, a buyer, a viewer—gives an art object full attention. I suggest that we can begin by thinking about the interactions between viewers and art objects through the analytical device of the "aura of works of art" as developed by the twentieth-century critical philosopher Walter Benjamin (2008 [1936]).[2] This may be surprising to some readers because tourist arts, like the woodcarvings made in San Martín Tilcajete, seem not to fit Benjamin's description of the aura, the essential "genuineness" of true works of art. They are aesthetic commodities produced entirely for consumption outside the culture and society that imagined them into existence. However, I have found that the engaging and affective qualities of aura that Benjamin describes are helpful for understanding the allure of Oaxacan woodcarvings, precisely because his notion of genuineness is much more flexible than concepts like authenticity and agency seem to allow. This flexibility not only accounts for a wider variety of experience but also allows for the emotive and alluring power of artworks to be directly connected to a theory of value and competition in art worlds, which I address in the final sections of the chapter.

Authenticity, Agency, Aura

Since the mid-twentieth century, authenticity has become an increasingly desirable and therefore marketable quality that is believed to attach to objects, food, people, and places (cf. Bruner 2005; Lindholm 2008; Terrio 1999). Like many other classificatory processes within modernity, labeling something as "authentic" links it to contradictory definitions of value: while authenticity is a perception of tradition, history, and simultaneity, it also references uniqueness and singularity. However, the "trap" of authenticity is more problematic than mere inconsistency in usage. For anthropologists and cultural actors who seek a full explanation of its rationales and consequences, authenticity always reveals itself to be *inauthentic* at heart by its own definition (Theodossopoulos 2013). Although distinctive formulations of authenticity underwrite the economies of culture currently at play in Oaxaca, I suggest that the concept in and of itself is an inadequate analytical tool for anthropologists dealing with art. While the various ways that people

construct, challenge, and reconstitute authenticity provide an interesting set of research problems, to focus only on the authenticity question might obscure other important features in the formation of value (Bruner 2005:5). As a term of analysis, authenticity draws our attention to *public explanations* for cultural expressions. For something to be discussed as authentic—however that is locally understood—other people need to acknowledge, critique, or challenge its claims to authenticity. Even when considered at the personal level of the individual, authenticity is always a public discussion because it is a *claim for recognition* (Lindholm 2008:65–71). While this publicness is in fact appropriate to many objects and situations, it does not represent all of the ways that people can and do engage with art (Bruner 1996:172–179; Graburn 2004; cf. Hansen 2008:343–344).

Recently, the experience of viewing art has been described by many anthropologists as an "encounter" rather than a one-way act of looking. This emphasis on intersubjectivity both draws our attention away from the public discourses that seek to recognize or deny the authenticity of objects and forces us to consider the affective and psychological (perhaps even cognitive) yet profoundly social experiences of art making and viewing. The initial terms of the discussion were largely set out in Alfred Gell's seminal text *Art and Agency* (1998), which dominated anthropological thinking on artworks throughout the 2000s and continues to be extremely influential. Gell famously uses Trobriand canoe prow-boards to illustrate his understanding of art-like objects. Trobrianders see the intricate carving on their canoes as fundamental to their exchanges of *kula* ritual objects because they are believed to demoralize the opposing party, which loses the capacity to drive hard bargains. The more intricate and elaborate the carvings, the more demoralized the opposition becomes, because they are evidence of the superior magical and practical skills of the canoe makers; hence, the canoe prow-boards are what Gell (1992, 1998: 23–24) calls "technologies of enchantment."

Gell argues that all art objects work like Trobriand canoes; their power is due to the viewer's inference of the art-maker's own power or intention. Drawing on C. S. Peirce's semiotics, he suggests that the relationship between an artist and a work of art is similar to the relationship between an object and an "index." For Peirce, an index is something that directly signals the presence of the object: his commonly cited example is that smoke indexes fire, as smoke is a consequence of fire.[3] Following a similar logic, Gell suggests that artworks index artists and therefore that viewers are necessarily provoked by them to reflect on the artists and their intentions. Gell describes this process as the viewer's "abduction" of the creator's agency,

which leads to the impression that the artwork itself carries the agency of the artist, whether that is understood to be an individual, a commissioner of a work, a collective authorial body, or something of divine or other non-human origin. As art objects move independently of their authors, they carry and distribute this apparent agency throughout the social world, enchanting their viewers along the way (Gell 1998:12–24).

Gell's formulation of the art encounter has made his text both inspiring and problematic for anthropologists working on art. The notion of a person's agency being distributed through space as objects circulate resonates well with the idea that artists can shape their world through their work, a perspective expressed by many contemporary art producers themselves (Driscoll-Engelstad 1996; Finney 1993; Graburn 2005). Gell (1998:16) defines agency as the power to cause events to happen by acts of intention, but this formulation is problematic. While he acknowledges that the events that transpire might not necessarily be those intended by the artist, this caveat is not enough to account for the fact that the desired reception of artwork often differs from its actual reception or interpretation (cf. Hoskins 2006; Layton 2003). Roger Sansi (2015) proposes that the "abduction of agency" model may fall short because it is premised on a limited reading of Peirce. For Peirce, the index and object do not stand in a merely dyadic, causal relationship but are always mediated by a third element, which could be described as "context." As Sansi (2015:55) argues:

> This does not mean simply that the meaning of the index changes after its context—that the index is an empty vessel whose meaning is simply subject to interpretation, depending on the point of view. The index is not determined by the context, but rather the opposite, the index *determines* the context. . . . [It is] a shifter, not just something that "changes" in relation to things, but something that makes things change. (emphasis in original)

This third element of context is highly relevant to artwork. The context may be taken as the larger circumstances of the art encounter, which itself is necessarily conditional on the existence of the art object in the first place: without the work of art, there would be no encounter, no social effect. Rather than being seen as endpoints that refer back to their origins, artworks should instead be viewed as relational objects that mediate agency, intentions, and effects within multiple frames of reference (ibid.:55–65).

Following Sansi's lead, I suggest that in order to account for the allure of particular art objects, we must begin by acknowledging that agency not only occurs as art is produced and sent out into the world but also materi-

alizes in a multiplicity of ways as art is encountered and beheld by viewers. I argue that Benjamin's conception of the aura of works of art can be remade into an incisive analytical tool that allows us to account for the public weight and authority of art objects while also allowing us to take the art viewer seriously, so to speak. This is possible because Benjamin's description of the aura of works of art leaves room for more flexible explanations of what art objects are and do, allowing multiple and simultaneous readings of the same object in ways that diverge yet are equally meaningful for the different actors involved.

Benjamin (2008:5–10) ambiguously describes the aura as "genuineness," "singularity," or "the here and now of the work of art." But the idea of uniqueness does not fully characterize his vision, for it is also the aura that gives works of art their inexplicable allure or desirability; what Gell (1996, 1998:69, 80–82) calls their "trap-like" effect. We might say that it is the aura that makes artworks a particular *kind* of technology of enchantment, similar to, but not the same as, the paraphernalia of ritual and magic. In Benjamin's view, this ability to enchant is due to the intersubjective nature of artworks at all times—their aura is dependent on the relationship between object and viewer, is unstable and relational in character, and therefore is contingent on "acts of reading and interpretation" (Hansen 2008:359). It is this aspect of the aura concept that offers purchase on my observations from Mexico in a way that Gell's agency cannot. For Gell, the viewer is necessarily focused on the creator of the artwork. However, in many cases the viewers and consumers of Oaxacan woodcarvings are not entirely concerned with the agency of artisans but rather with how the object metonymically stands in for other things, such as the place of Oaxaca, the nation of Mexico, or the viewer's own identity as a cosmopolitan and well-traveled person. Rather than objects impressing the agency of their creators upon consumers, a synergetic relationship exists between maker and viewer, one that is always mediated by materiality and aesthetics.

The essay in which the idea of the aura is most fully developed is *The Work of Art in the Age of Mechanical Reproduction*. Written in 1936, it was explicitly concerned with the consequences of modernity for the authority and legitimacy of works of art, as copies of artworks and photographs had become easily mass produced and circulated by that time. Benjamin was concerned with fine-art production in the industrialized West, so the question of whether the aura is an appropriate tool for the study of Mexican craft objects, which are not necessarily valued for their originality, might legitimately be raised. Christopher Steiner and Christopher Pinney have drawn on Benjamin's notion of the aura in their analyses of African tourist art and

Indian printed religious imagery, respectively. Their work shows that auras of artworks can be found outside of the conditions of Western modernity that Benjamin was concerned with and that they need not be tied to singular originality. Steiner (1999:101) argues that in certain art contexts, especially those oriented toward cultural tourism in postcolonial settings, repetition and *not* singularity is what gives an artwork its desirability. Pinney (2002) pushes further, showing that repetition can produce aura in its own right. As his Indian informants engage with mass-produced images of gods through their senses and emotions, he argues, each particular image builds up a patina of auratic divinity over time through its use. Authenticity, in the sense of legitimate production or authorship, is of no concern to them: Pinney reports that people were blankly indifferent to information about the sources of the images or the nature of their execution. He argues instead that their power came from their "visuality or the [ongoing] mutual relationship between the image and the devotee" (Pinney 2004:189–191). By suggesting that objects can become "sensorily emboldened," Pinney (2004:357) shows that the allure of images can change over time by virtue of their relationships to their viewers. As these affective relationships may not be articulated publicly, and do not necessarily need public recognition in order to exist, they are much more susceptible to idiosyncratic or creative interpretation, which can be seen as acts of reading the object (cf. Hansen 2008).

Focusing attention on the "reading" of art objects necessarily raises issues of differential power in the ability to describe, classify, and consume. Readings may not always be stable or consistent between different viewers or indeed different viewings by the same person. The multiple ways that objects may be read are necessarily conditioned by the contexts in which they are encountered, by the cultural or discursive frames in which they are understood, and by the viewers' motivating desires behind the attention given to the object (Errington 1998; Price 1989).

To be clear, by using the word "reading" to describe the affective, creative, and often interior processes through which people encounter artworks, I do not mean to suggest that the analysis of visual arts can proceed as if they are texts. I use "reading" metaphorically to highlight the affinities between an art encounter and the way that readers may become thoroughly absorbed in their books: they bring their own experiences, thoughts, and imaginations to the encounter. Furthermore, it is worth noting that while the quality that I call "aura" relates to the appeal of artworks, this allure is not necessarily synonymous with beauty. Beauty, which can be loosely understood as that which aesthetically elicits attractive pleasure, is indeed at the heart of the aura of *some* artworks; in fact, this may be the case generally for Oax-

acan woodcarvings. Yet it is important to retain the idea that works of art frequently are "technologies of enchantment"—alluring, engaging, and captivating objects—without being attractive, pleasurable, or beautiful. One need only to look at images like Francisco Goya's *Saturn Devours His Son* to see that captivating artworks may also elicit feelings of repulsion, horror, and fear.

In the next section I examine some of the ways that different kinds of viewers read Oaxacan woodcarvings in order to highlight how these events can be remarkably different, even when the artwork is encountered in an identical context. I compare three kinds of visitors to the same workshop: tourists, a collector, and old friends of the artisans. I am not offering these examples as the definitive ways that woodcarvings are rendered authoritative and genuine in Oaxaca, but they illustrate the processes through which such readings take place and the consequences for the meaning of the art encounter. I also describe the aesthetic and productive practices that Miguel and Catalina García put to work to generate what we might call an auratic potential for their work. Throughout this discussion I show that the auras of woodcarvings are read in ways that are not wholly dependent on culturalist conceptions of authenticity but instead are polyvalent and contingent on the social contexts in which objects are made and encountered and the kinds of people who produce and consume them.

Reading Woodcarvings

Miguel and Catalina García are now the most well-known and economically successful artisans in San Martín Tilcajete. Their success is evident to their neighbors as well as to the many collectors, gallery owners, museum curators, and tour guides with whom they work. They command significantly higher prices than any other woodcarving workshop in Oaxaca, including the family of Manuel Jiménez, the recognized inventor of the carvings. While their own explanations link their success to their cultural traditions and the dealers and tour guides chalk it up to Miguel García's entrepreneurial spirit, neither of these answers seemed satisfactory to me or to their neighbors and competitors. Although the Garcías' carvings are made from the same materials, using the same tools and within the same cultural context as those of the other artisans, it is clear from even a cursory glance that their work is very different from other Oaxacan woodcarvings. The figures are executed in a more naturalistic—what might even be called neo-Romantic—mode, with emphasis on organic rounded shapes. Attention is

paid to anatomically correct morphology and proportions and poses that evoke the natural movements of the animals. They are painted in muted, natural-looking colors, and the Garcías avoid the high-gloss paints that are favored by some other artisans.

As can be seen in plate 4, the painting is finely detailed and consists of interlocking lines of geometric patterns and symbols that overtly reference indigeneity: feathers, arrows, and the cardinal points, which the Garcías have elaborated into their own system of meaning (see chapter 4). The skills and material knowledge required to produce such work are obviously an important component of the success that they now enjoy; as Alfred Gell (1998:68–72) describes, one source of an art object's power, and therefore its value, is the inability of viewers to imagine producing such work themselves. However, I suggest that visually aesthetic conventions, expectations, and practices are perhaps even more important than talent and skill, particularly within markets for cultural goods, in which products need to be recognizable as being *from* a particular place. It is not incidental that some of the folk art collectors I interviewed found the Garcías' pieces too skilled and refined, explaining that they lack the expressiveness or rustic folk-art sensibility of other artisans' work. In the three examples presented here, we see an interplay between the Garcías' attempts to present their work as desirable and the different ways in which visitors to the Garcías "read" the woodcarvings. I begin with a group of tourists, who represent the most common way that visitors encounter woodcarvings in San Martín Tilcajete.

One morning in July, a large group of American and English tourists arrived at the Garcías' workshop. As they emerged from their air-conditioned vans, they found themselves in a tranquil and sunny courtyard, painted in a terracotta hue, with accents of cerulean blue and bright *rosa mexicana* (Mexican pink). This group was a part of a large organized tour that focused on the major archaeological and historical sites in the state. Half of the group was spending the day visiting artisans in three craft villages, including San Martín Tilcajete, while the other half elected to remain in Oaxaca City to visit museums.

The tourists filed into the sunny workshop space, which was open to the courtyard. As they took their seats on the series of benches tucked along the right-hand side, Miguel García stood up from where he had been painting to greet the visitors. "Welcome to my home and our workshop, amigos," he began, taking his place behind a small table, laden with powders and plant materials. "Today I am going to tell you about our work here and our beautiful village of Tilcajete." On the walls behind him about forty unpainted, highly technical carvings sat drying. As Miguel began to explain the history

of the town and its name, he produced a machete and started peeling the bark from a small piece of copal wood. As he explained how its sap had been used for incense for thousands of years in southern Mexico, he held the bark to his nose, deeply inhaling, then passed the clean, fresh-smelling wood to the tourists, indicating with a gesture that they should do the same. After describing the wood, he moved on to Oaxaca's pre-Hispanic and colonial heritage of natural inks and dyes. As he spoke, he began mixing different powdered minerals and plant materials with liquids in his palms, producing a surprising variety of hues and opacities from seemingly dull everyday materials. The peak of the demonstration came as Miguel crushed deep red pomegranate seeds into bright white powdered zinc with his thumbs. The resulting turquoise color surprised everyone: the tourists eagerly leaned forward, uttering a few "oohs." Then, with the addition of just a dash of dried *anil* (an indigo-producing plant), the bright turquoise transformed into a deep, inky blue.

After explaining the stylistic inspirations of his work, Miguel introduced each of the painters by name, highlighting when someone was a member of his large extended family. As the demonstration wound to a close, two or three of the tourists rushed up to Miguel to take pictures of his palette-like hands. A few others leaned over the painters' shoulders to get a better look at their intricate work. At the end of the demonstration, as he answered a woman's question about where the wood is grown, Miguel began to wander to the front of the courtyard, drawing the tourists to the small gallery, where their own carvings sat on well-lit glass shelves, along with the work of other artisans from San Martín and Arrazola. Miguel's nephew David was already waiting for them. He informed them that he could also take orders for pieces if anyone wanted something different from what was available. Of the twelve people, six bought medium-sized, relatively expensive pieces made in the workshop; five purchased smaller pieces by other artisans. Only one man decided not to purchase anything. He told me while we sat on the sofas outside of the gallery that his suitcase was already too full of "artifacts" that he had bought in the neighboring state of Chiapas.

The performance by Miguel García is a clear example of "staged authenticity," as Dean MacCannell (1976) has described other similar tourism practices. Miguel does not refer to the recent origins of Oaxacan woodcarving but instead connects the craft to much longer histories of natural pigments and incense that have been used in the area since pre-Hispanic times. He never describes Manuel Jiménez as the inventor of the craft, which would undermine his claims that the woodcarvings are the material expressions of an autochthonous culture, but instead refers to him as a *gran maestro* (great

master or teacher).[4] Interestingly, this "staged authenticity" is cross-cut in the Garcías' workshop by the amenities that they provide for their visitors: the glass shelving and spotlighting in the gallery display the woodcarvings as pieces of art rather than rustic craft. Customers can pay using an electronic credit card machine. The sofas, chilled sodas, and modern washrooms with running water made available to their visitors are unheard of in other carvers' workshops and would seem to undermine the workshop as a "real" place of campesino (peasant) craft production. Most tourists did not seem bothered by this inconsistency, though—I suspect that they were grateful to avoid a visit to an outhouse.

For the majority of tourists, viewing the woodcarvings being made in workshops in traditional-seeming villages adds greatly to their desirability. Through the pedagogical processes of the demonstration, tourists are provided a frame through which they can imagine production of the woodcarvings as part of a long cultural history. The seemingly magical transformation of dull powders into bright paints also imparts a sense of aura to the work of contemporary painters, whose finely detailed brushwork is impressive to watch. The tourists' introduction to Oaxacan woodcarving in the artisans' workshop makes these carvings seem especially authoritative and genuine: as one Canadian man said during a tour at the beginning of my fieldwork, "I'm not sure I would have bought one of those things in a store, but once you see where they're made, you just want one!"

The experiences of these tourists can be contrasted with another American visitor who arrived at Miguel and Catalina's just a few weeks later with his private tour guide. Greg described himself as an avid collector of Mexican folk art and crafts and was well versed in the language of collecting. After an introduction from his guide, whom I had met on other occasions, Greg invited me to spend the rest of the day with him as he scoured the villages for pieces. We discussed the merits and difficulties of using published collectors' guidebooks about Oaxacan craftwork as well as what kinds of things Greg looked for when searching for pieces. He emphasized a combination of "uniqueness" and "tradition," saying that he was not fond of artisans who produced large amounts for export: "What's the point of finding something that I can just as easily buy in L.A.?" At the same time, he wanted something that he saw as consistent with the established genre of Oaxacan woodcarvings: as a collector, he wanted "the real thing."

When Greg arrived at the Garcías' workshop, David went over to greet him, as someone always did when tourists and other visitors arrived. However, Greg brusquely interrupted, indicating that he was not interested in a demonstration but wanted to see what kind of work they were producing at

the moment. Instead of showing him the powdered pigments, David took Greg directly to the workbenches and informally showed him what different people were working on. As Greg wandered around the workshop, something caught his eye: a small, rather old looking carving of a man sitting on the workshop's altar, off to one side. Many artisans in San Martín construct their family altars in their workshop spaces, where they spend the majority of the day. Icons and plastic figures represent the saints, Jesus, and Mary; offerings are made in the form of candles, flowers, incense, and bread. In addition to Saint Martin, the village's patron saint, images of Saint Jude the Apostle are frequently found. His symbol is the carpenter's rule, so he is closely associated with woodworkers.[5]

When Greg asked if he could look at the carving, David assented. After a moment or two Greg hesitantly asked if it might be for sale. Looking uncomfortable, David said that he was not sure, so he went to find Catalina García to ask her. A few minutes later, Catalina came over and spoke with Greg off to one side. Finally she walked over to the altar and took the piece away to the gallery, where she wrapped it in tissue paper. Greg paid for his new carving. As he was waiting for Catalina to write up the receipt, he casually glanced around the gallery at the carvings that filled the shelves but did not look at any of them closely. Instead he picked up Michael Chibnik's (2003) ethnography about Oaxacan woodcarving production that was on display and casually flipped through it. Greg was very pleased with his purchase. Over lunch he admitted that he was not sure if he had done the right thing by asking to buy something from the family altar but thought that in the end Catalina was happy to sell it. He was excited that it appeared to be an old piece of work, perhaps from the 1980s: "These kinds of things become harder to find as more artisans enter the market and carvings become popular; they just get scooped up."

Unlike the tourists in the first example, for Greg it was not just provenance in an apparently authentic workshop that made the piece desirable. In fact, Greg seemed relatively disinterested in the work that was being produced at the time; he wanted something that was older and unique yet also recognizably a Oaxacan woodcarving. Although Greg could not have known where the woodcarving actually came from, the fact that the artisans themselves had treated it as "genuine" by placing it on their own altar greatly increased its allure, establishing a "genealogical" connection between this carving as an "ancestor" and the Garcías' contemporary pieces. His acknowledgment that it was perhaps impolite to ask to purchase something from the altar shows that his interest was less in the artisans as authors of the carvings and more in the object itself.

The experiences of both the tourists and Greg the collector can also be fruitfully contrasted to those of Rita and Daniel, Mexican American friends of the Garcías who live in Los Angeles, California. Rita and Daniel had met the Garcías about fifteen years earlier when they were selling their work at a craft fair in L.A. and struck up a strong friendship. Rita told me that she cherished her friendship with Miguel and Catalina, because it allowed her to feel a connection to her Mexican roots. Although her family had not been Oaxacan, she felt that her journeys to Oaxaca provided her with the opportunity to reconnect with her heritage. Rita visited twice during my research in San Martín. On the second occasion she decided to purchase a very expensive piece from the Garcías. When she announced that she wanted to buy a piece, Catalina seemed slightly embarrassed. She had intended to give her a smaller carving as a gift, but Rita refused. She explained that she wanted to buy the large piece, as a recognition of Catalina and Miguel's incredible work and skill. She would treasure this piece as the essence of who her friends really are and would always think of them when she saw it in her home. For Rita, the aura of the carvings had very little to do with the generalized cultural content that the tourists value or even the "genealogical" or "authorial" genuineness that collectors seek. The authority of the carving rested on the personal connection between Rita and the Garcías and on Rita's own Mexican heritage. Its desirability was not premised on its production in San Martín or its relationship to other woodcarvings in the genre. Instead, the carving's allure was that it was a very high-quality piece, made in the Garcías home. This is what made it important and desirable for Rita to have in her own home.

Despite these different perspectives, there are continuities between the ways that different viewers come to read the carvings as "genuine." For many tourists, collectors, and other viewers, skill and household production tie the aura of woodcarvings to the lives of their producers, making their purchase in San Martín a more meaningful act than buying similar pieces in Oaxaca City's markets and galleries. The fact that the pieces are carved and painted by hand is extremely important. One American collector with a long history in San Martín told me that she suspected that one of the well-known carvers used power tools in the evenings when no tourists were around. When I asked her why this should matter, if the resulting object was the same, she said that woodcarving in this way was not "true" and "authentic." These carvings "were not the same kinds of things as hand-carved pieces" and in her opinion were worth less money. In other words, producing woodcarvings with power tools reduced the aura of the work, because it lost its authority as handmade art.

These small examples highlight the need for a theory of the artistic encounter that can encapsulate a greater range of experiences than those that agency or authenticity offers. The tourists' encounter with the Garcías' woodcarvings, staged in their workshop and given context by Miguel's demonstration, is surely an example of the "production of authenticity" in the way that is common all over the world. This authenticity is the public side of the artistic encounter, grounded in the discourses that drive tourism and cultural production in Oaxaca. The Garcías have been very successful at positioning their work to fit very neatly within its imaginaries of culture, place, and tradition. However, acknowledging that authenticity is the mode through which these encounters take place does not guarantee their reception as such or that individuals experience Oaxacan woodcarvings only in those terms. The kind of attention that one pays to the art object and its context can greatly influence how such authentic-seeming artworks are read. Greg the collector and Rita the friend are clear examples of the ways that people read works of art from their own perspectives and concerns. The carving that Greg found on the altar became so alluring to him that he even crossed the boundaries of acceptable social behavior in order to purchase it. His own identity as a collector with the knowledge and eye to spot "true" works of art made him value this piece, even though to others it might have been less desirable than the new, more sophisticated work that they could see being made with their own eyes. Rita desired a carving by the Garcías because it seemed to offer a way to reconnect with her Mexican heritage and represented a friendship that she truly valued; its recognition as a culturally authentic good or not was neither significant nor meaningful for her.[6]

What Does Aura Help Us Do?

At the beginning of the chapter I suggested that a central problem for artisans in contemporary Oaxaca is to understand why the work of *some* people appears to be much more desirable than that of others. If purchasing a Oaxacan woodcarving is primarily based on an interest in authenticity—as the local touristic discourses seem to indicate—then *all* woodcarvings made by hand in San Martín Tilcajete should be able to satisfy touristic desires for the "really real." Yet artisans know that certain people in the highly competitive world of Oaxacan folk art and craft have much greater success in capturing the attention of consumers. In order to understand the relationship of aesthetics, value production, and power, the intersubjective allure of artworks that I have so far outlined must be connected to explanations of

value and the competition that occurs within contemporary art worlds. To do this, I draw on Pierre Bourdieu's concept of the cultural field in order to understand how competition among aesthetic producers takes place.

In *The Field of Cultural Production*, Bourdieu (1993) maps out a vision of art that departs both from universalist readings of art and aesthetics and from culturalist approaches that explain art via its meaning and content for the society that produces it. Like earlier art world theories, such as those developed by the philosopher-critic Arthur Danto (1964) and the sociologist Howard Becker (1982), Bourdieu argues that artistic objects are the material results of a collection of actors who make up identifiable communities or networks. However, unlike Becker, who focuses his analysis on the art world as a population linked by networks of direct interaction, Bourdieu addresses his theory to the nature of such relations. He argues that they are not necessarily interactive by introducing his concept of the habitus, as developed in *Outline of a Theory of Practice* (1977). The habitus can be understood as a "feel for the game" that predisposes individuals to act and react to situations in a manner that is neither consciously calculated nor predetermined by social structure. The habitus of a given art-world actor—whether an artist, agent, curator, commissioner, apprentice, or buyer—is always conditioned by his position within the social field at a particular moment.

For Bourdieu, a field is a relational social topography, in which the changing beliefs and actions of actors are continually shifting the nature of that space over time. These changes are regulated by the distribution of what Bourdieu (1986:241) calls a field's "specific capital," that is, the sources of value that render actors more or less powerful or successful within their particular field. Bourdieu (1993:40–41) sees two forms of capital that are particularly relevant in fields of cultural production: symbolic capital (accumulated prestige, knowledge, or honor) and recognition by other actors in the field, which together he glosses as "legitimacy." Each artistic field, however, has its own definitions and rules for this capital; having legitimacy in the world of classical realist painting, for example, does not (necessarily) confer legitimacy in the graphic novel community. While Bourdieu's insights into the relational and subjective-yet-structured nature of artistic fields have been helpful in fleshing out and historicizing the details of how art worlds work, Georgina Born (2010:177) has critiqued his approach for being unable to address "the specificity of the art object." She points out that Bourdieu's approach cannot address the substantive meaning of works of art or why aesthetic formations develop in certain directions over time. The questions that Bourdieu asks relate more to the political strategies of protagonists in competitions for legitimacy, rather than the circulating and chang-

ing ideas about the artworks themselves as they move through time and space (ibid.:178–179).

I agree that Bourdieu's analysis of artistic production is hindered by its inability to account for the intrinsic characteristics of art objects. However, I believe that his insight about the relational nature of artistic fields is useful for connecting the enchanting allure of artworks that I here describe as "aura" to discussions of the production of value and the competition that take place within art worlds. If we reimagine the field itself as an *aesthetic topography*, representing the aesthetic positions of art objects and producers in relation to one another and—critically—in relation to the aesthetic expectations of other actors in the larger art world, we can connect the changing character of aesthetics through time to the variety of ways that value is produced. In such a framework, aura, the alluring and captivating power of desirable or enchanting artworks, is a very large component of their legitimacy. In other words, I am suggesting that the aura itself is a kind of capital in markets for aesthetic commodities and that the desirability of specific works of art drives prices and competition in the market more generally. As I show in the following chapters, some artists in markets for aesthetic products, by virtue of their experiences and exposure to particular kinds of consumers and other cultural authorities, will be more likely to match themselves and their work to the variety of ways that clients are likely to "read" art. Their art will necessarily strike such viewers as more genuine and desirable and therefore also more valuable in both monetary and social terms.

The ways in which aura confers legitimacy and value on an object, and consequently its makers and consumers, are much more complex and subtle than Bourdieu's vision of "specific capital." In the rest of this book, I chart some of the ways that Oaxacan woodcarvings and their auras—their enchantment, legitimacy, and power—articulate with particular formations of aesthetics, ideologies, work, and identity within the economies of culture in Oaxaca mapped out in the introduction. On the one hand, these articulations relate directly to the activities of art production, through the development of aesthetic genres and practices of artistic labor and authorship within workshops. On the other hand, they also articulate with broader existential concerns for artisan communities, such as economic anxiety, community cohesion, and identity. In mapping the ways that aura and aesthetics impinge on these processes in the making of Oaxacan woodcarvings in San Martín Tilcajete, this books brings to light the complex and multiscaled effects of aesthetic production within contemporary forms of capitalism and neoliberal multiculturalism.

Notes

1. See Pinney (2004) for a particularly effective analysis of this type.

2. I cite the lesser-known translation of *The Work of Art in the Age of Mechanical Reproduction* by J. A. Underwood, as this version translates the German word *Echtheit* as "authority," rather than "authenticity" as most other translations to English do. I am using "aura" as an alternative to "authenticity," so it is preferable to retain the distinction made by Underwood's translation.

3. For Peirce, the "index" contrasts with the "symbol," which also refers to the object, but through convention, abstraction, or linguistic code: thus, the word "fire" is symbolic of an actual fire, where smoke is indexical of it (see Hoopes 1991).

4. I have discussed the role that photography by tourists and anthropologists plays in the legitimation of such demonstrations as "cultural facts" elsewhere (Cant 2015b).

5. Although many artisans who produce *fina* and *rústica* carvings make figures of the saints and Jesus, carvings on altars are not as common as one might expect. A manufactured item that has been blessed by a priest or has been brought back from a pilgrimage is more appropriate on an altar than an item that they have made themselves.

6. Interestingly, Rita also made a point of *purchasing* the carving, rather than accepting the gift that Catalina had intended to offer. My intuition is that this was motivated primarily by the desire to own the larger and more finely executed carving but also by recognition that Rita herself is very well-off and wanted to support her friends' business economically as well as emotionally.

Aesthetics of Work in Woodcarving

Craft, skill, and aesthetic decision-making in the creation of Oaxacan wood-carvings are central to artisans' everyday work lives in San Martín Tilcajete. Their days are made up of long intervals sitting at their work benches, quietly engrossed in the details of what they are doing. The arrival of tourists, dealers, and wholesalers is a sporadic feature of their workday or working week, punctuating the relative calm of the workshop with chatter, demonstrations, and negotiations. In order to interrogate how the rhythms of the workshop are central to Tileños' experiences in the world of Oaxacan woodcarving, in this chapter I explore how artisanal modes of work not only are features of an artisan's abilities and expertise but also relate to their own particular "aesthetic of work." The need to consider Tileños' own perceptions of work impressed itself on me as I tried to make sense of the fact that some of my research participants genuinely seemed disinterested in cultivating their skills. While this could simply be explained as a disheartening consequence of woodcarving being their only real economic option in San Martín Tilcajete, it does not explain why other artisans, who find themselves in similar economic conditions, remain interested in developing their skills and "take pride" in their work.

The categories through which Tileños discuss and compare their work with the work of others relate to the overlapping art-world ideologies of talent and authorship, which highly value and prioritize the cultivation of skill (see chapter 3). Without such moralized (and often romantic) perspectives on skill, categories like "talented," "skilled," and "without skill," which are frequently used in this context, would lack the significance and meaning that they carry. At least in cases like San Martín Tilcajete, where most peoples' productive and creative skills are enacted within spaces relatively free from the time and production pressures of the large-scale creative indus-

tries, different categories of skill can be seen to index different aesthetics of work (see Morisawa 2015 and Prentice 2012 for discussions of skill in more formalized regimes).

In studies of labor and workplaces, a consideration of aesthetics has been generally limited to the interactive areas of the service sector, such as the beauty, air travel, and hospitality industries. This research shows how, as part of the "aesthetic economy," the aesthetic work that employees do on both themselves and their clients leads them to embody the product and brand that they are selling (Chugh and Hancock 2009:465; Witz, Warhurst, and Nickson 2003). Oaxacan artisans are also part of the aesthetic economy and indeed may do aesthetic work on themselves, their homes, and their workshops in a bid to sell authenticity and craftwork to their tourist clients (Little 2008; Wood 2008:77–114). However, the aesthetics of work that I wish to discuss here are less explicit than what is described by the aesthetic labor concept. Following Joanna Overing's (1989:159) conceptualization of Amazonian aesthetics as a "sense of community," an aesthetic of work describes a "sense of work": the concrete, affective, and sensory experience of doing one's work and how this experience relates to feelings of satisfaction, dissatisfaction, and desire in relation to the workday (cf. Demian 2000). Note that this is distinct from the satisfaction described by terms such as "material engagement." As I discuss below, artisans' preferred aesthetic of work may require not engaging with their materials or even not producing much work at all. Likewise, an aesthetic of work may incorporate a work ethic, an atmosphere, and a "work culture," but it need not be communal or even consistent through time.

In fact, individuals may desire enormously different "senses of work." In San Martín Tilcajete these differences often relate to different practices of skill. Skillful and unskillful work therefore may be the result not only of individual artisans' capacities but of their desires for different work experiences, different aesthetics of working life. In identifying "skilled practice" as an aesthetic of work, I am drawing attention to the fact that individuals may perceive the sensuous material engagement involved in handwork in a wide variety of ways. For some, the experience of doing skilled work is an immersive, enjoyable practice through which they cultivate their abilities and themselves; for others, the state of concentration or absorption required to do such work is an undesirable way to spend their time. Each perspective signals a different aesthetic of work, a different emotional and affective stance toward the material world and the work process within it. As I show in this chapter, Tileño artisans' aesthetics of work can be understood as their different, sometimes idiosyncratic, perceptions of their open-ended

and ever-changing relationship to the objects that they make. However, as I discuss in the first section, the coexistence of such various aesthetics of work in the same community is underpinned by a larger belief that villagers in San Martín Tilcajete are themselves aesthetic authorities.

Tileños as Aesthetic Authorities

Although the stark beauty of San Martín Tilcajete in the dry season is photographed more often by tourists than by villagers, Tileños also believe that their village is a beautiful place and seem particularly concerned with the ways that things look in their everyday lives. Although it is the work of artisans that draws attention from outsiders, Tileños in general work hard to make things beautiful for themselves. This propensity materializes in both obvious and subtle ways throughout the community. For example, the village has restricted access to water, but the municipality spends large amounts of water, time, and money cultivating the beautiful garden that surrounds a small gazebo in the village's main square. The garden is at the heart of public space in San Martín and is enjoyed by all: families rest in the cool shade on hot afternoons, and teenagers gather to chat, gossip, and flirt in the evenings. Tileño homes, whether their owners are wealthy or not, are always tidy and well organized. Attention is always given to the details of decoration: brightly colored embroidered cushions rest on sofas and beds; pots of flowering plants are tucked into corners of courtyards, adding splashes of color to the dusty trees and vines; and family pictures hang on brightly painted cement walls. Prized objects like ceramic figures of saints, family heirlooms, and fancy tableware are displayed in large, glass-fronted armoires, which are often received as wedding gifts. Most importantly, the family altar, where icons of the Virgin of Guadalupe and the Virgin of Juquila join images of Jesus, Saint Martin, and Saint Jude, are animated by votive candles, incense, and fresh flowers. The aesthetics of altars are central to their efficacy.

Fiestas are particularly important moments when things must *quedar bien* (look good). From intimate family affairs to village-wide celebrations, great attention is paid to arranging flowers, balloons, and hired tables and chairs and especially presenting food. The most common fiesta meal is *mole negro*, a smoky chicken stew flavored with spices and dark chocolate, which is always served with rice and a fresh, bright red radish as a garnish. Families will save for months, sometimes even years, to pay for children's rites of passage. First communions, confirmations, and girls' *quinceañeras* (fifteenth birthday parties) must be celebrated with family, friends, and neigh-

bors and must be embellished with flowers, music, and especially the elaborate gowns that girls and young women don for such important occasions. The Feast of Saint Martin is another fiesta for which young Tileña women spend days preparing. Each year, on November 11, all the young women in the village take part in the *calenda* procession through the streets, carrying elaborate large baskets covered in fresh flowers and marked with images of the saint or other religious symbols (plate 5). Although it is possible to purchase premade baskets in the nearby market town of Ocotlán, most Tileñas prefer to make their own. I was told that this is because Tileños are authorities on how to make things beautiful.

Tileños consider themselves aesthetic authorities as a direct result of the status of San Martín as a community of artisans. They believe that they have special and skilled knowledge about how to produce appealing and meaningful visual displays, even outside of the field of Oaxacan woodcarving. One intriguing example of this is the ongoing renovation of San Martín's seventeenth-century church during my research there. According to research participants, the village had been approached in the late 1990s by the Rodolfo Morales Foundation, a cultural foundation that wanted to renovate and restore the church. After much debate and deliberation in the community assembly, the villagers decided to reject the foundation's offer of assistance and take the renovation project on themselves. While the Morales Foundation turned to nearby Santa Ana Zegache to renovate its church instead, Tileños spent the next ten years fundraising and saving in order to pay for the work that was needed. According to some, this decision had direct repercussions for artisans, because the project could have cemented relations with the foundation. However, they also believed that they would have had to cede aesthetic authority to the foundation with regard to the church if they had accepted its assistance.

In 2008 a crew of eight Tileño builders was working on the church. When I interviewed the leader of the group, he explained that one of the primary concerns of the Morales Foundation had been the restoration of the murals that were flaking away along with the church's degrading plaster walls. He told me that they took this as an indication that these walls needed to be repaired. "Why should we entrust our church to some experts from outside of San Martín? This is a community of artisans—of artists! We have the skills that we need to restore the murals." He went on to explain that an advantage of Tileños being the only ones to work on the project was that the church could be renovated in exactly the way that the congregation wanted. While he was aware that the church of Saint Martin was protected under national patrimony legislation and therefore should have been restored only

under the supervision of the National Institute of Anthropology and History (INAH), he said: "For us, this isn't a seventeenth-century ruin, it is our church, and it is very important to our community. Because we are a community of artisans, we know what looks right and balanced and beautiful, so we don't want any outsiders, not even experts, telling us how to paint our church." While Tileños viewed themselves as aesthetic authorities with the expertise and sensitivity to restore their church, the federal government did not agree; the municipality was eventually fined for the destruction of part of the national heritage.

The aesthetic authority of Tileño artisans spills out of the work of artisanship, drawing other Tileños into self-reflexive practices of aesthetics as well. Tileños in this case expressed a distinct authority vis-à-vis powerful state and cultural interests, which many also deal with in their professional lives as artisans, showing that they are not just passive recipients of aesthetic influences from outside the community but actively engage such influences through their own aesthetic authority in woodcarving and beyond. In the rest of this chapter I explore the ways that the aesthetics of artisanal work unfold in the workshops of San Martín Tilcajete in order to emphasize that an "aesthetic of work" is an entirely different sort of thing than "craftsmanship." By contrasting the practices of those who work with and without skill, I show how the everyday work of Tileño artisans contributes to the production of the art-world principles of talent and authorship that I explore in the next chapter.

Tileño Aesthetics of Artisanal Work

An old cabinetmaker's world view, the way he manages his budget, his time or his body, [and] his use of language and choice of clothing are fully present in his ethic of scrupulous, impeccable craftsmanship and in the aesthetic of work for work's sake which leads him to measure the beauty of his products by the care and patience that have gone into them.
PIERRE BOURDIEU, *DISTINCTION: A SOCIAL CRITIQUE OF THE JUDGEMENT OF TASTE* (1984)

Pierre Bourdieu's description of the relationship between the cabinetmaker's "habitus" and his artisanal skill would not appear out of place if it had been written a hundred years earlier by Arts and Crafts thinkers William Morris and John Ruskin, who sought to convince the public of the ethical value of craft and the decorative arts by arguing that they were a true expression

of "man's happiness in his labor" (Morris 1999 [1884]:31). While we may admire these thinkers for their work toward social justice, we need a broader and more critical view of the relationship between artisans and their work. What of the cabinetmakers who do not live their lives by a principle of work for work's sake yet still make cabinets? Anthropology has become very good at documenting and theorizing the practices and techniques through which people make useful and elegant things, but it still lacks a comprehensive perspective on skill and expertise that can also address makers who evaluate their work by criteria that do not privilege the care and patience that have gone into it.

The basic skills that artisans use to make Oaxacan woodcarvings are effectively the same whether they make *fina*, *rústica*, or *comercial* pieces (see the introduction). Manual skills include woodworking with machetes, knives, chisels, and sandpaper and painting with brushes, sponges, cactus spines, or toothpicks. Visual skills include the ability to produce balanced and well-formed carvings that effectively represent animal or human figures as well as choosing color and pattern combinations for decoration. Knowledge of materials and their relationship to the production process is also important. For example, copal, the wood from which most Oaxacan woodcarvings are made, requires drying and treatment against insects if the figures are not to be damaged in the long term. Artisans also must know what kind of wood to purchase from wood sellers for the type of carvings that they intend to make. The branches of one species of copal, locally called *hembra* (female), tend to be thicker and suppler and thus better for large soft forms, while another that is locally called *macho* (male) is thinner and more brittle and thus preferable for delicate and intricate carving (Chibnik 2003:95).

Within household workshops, the tasks of carving and painting are often divided along lines of gender. Carving is usually done by men and older boys. The few women carvers in San Martín during my research were either unmarried or married to men working in the United States. Although it is sometimes reported in the popular press that women do most of the painting, many of the male carvers that I knew also generally painted their own work. Decisions about who would paint which carving were not made explicitly in smaller workshops but were structured around other considerations such as whether children were home from school and whether people were busy with other activities. Larger workshops with hired employees had a clear and consistent division of labor in most areas of production, particularly between carvers and painters.

Most carvers do not work at tables, which are insufficient against the

force necessary to make the deep cuts with the machete and may also limit arm movements. Instead they use large stumps or pieces of wood as carving blocks, which they place between their legs. A carver's inspiration can come from many sources: an image or story recently encountered, an order placed by a tourist, conversations with other carvers, or, most commonly, previous pieces that the carver has made. For example, Alejandro Pérez, a *comercial* carver, often refers to images from his children's storybooks for animal forms that are not familiar to him. Other artisans use encyclopedias or magazines. For the most part, however, I observed that carvers tend to repeat figures that they are comfortable with, drawing on their aesthetic knowledge about the curves, angles, and balance that work for different shapes (see Chibnik 2003:124–146). Although imagination is central to beginning a piece, carvers immediately incorporate their knowledge of the material and its qualities into their plans: they imagine only pieces that are possible to carve in reality, suggesting that imagination broadens with growing skill.

Every single piece of wood responds to carving differently. Some are even and good for carving, while others are more difficult because the wood is twisted. The wood's constitution is so variable that each piece feels different in the artisan's hands. Lalo explained that for him the experience of carving was about being guided by the tools and materials: "You find the knife moves with the grain of the wood. You don't do it intentionally; it just happens." As Lalo works, the action of his hand with the machete or knife engages with the physicality of the wood. Because the material is variable, every single stroke feels unique and also affects the stroke that directly follows. Thus, the seemingly repetitive action of carving is not a series of discrete cuts made into the wood but a fluid, rhythmic practice through which the carver engages with his tools and materials (cf. Ingold and Hallam 2007:6–7). This rhythmic quality is at the heart of the aesthetic of skilled artisanal work, the characteristic feeling of making something by hand. The sounds of the carvers' machetes fall into harmony as they work together in large workshops like the Garcías'. The experience of the carving can become collective. As Samuel, a worker at the Garcías', said, "You can always tell when your blade is getting dull, because it throws the rhythm off. The others will hear it at the same time as you feel it." It is not surprising, then, that the carvers talk very little during the day and prefer to listen to music with a strong rhythm, which helps to guide their actions. I was told that they used to listen to the *fútbol* (soccer) matches sometimes but would hardly get any work done—it was just too distracting to listen to the game while carving.

Like carvers, painters do not experience working on each piece in the

same way, even though the sanding and preparation of the wood before painting renders the surface of every piece smooth and uniform. The physical properties of the piece—its size, the pose or position of its body and limbs, and even the animal that it represents—all affect the ways that painters go about their work. Rosalinda and Araceli, two experienced painters who work for the Garcías, explained that they prefer to paint large pieces even though they take much more time. This is because they can sit with the piece on their lap to steady it and use the whole length of their arm to make long, sweeping brushstrokes. Small pieces, by contrast, must be held in the hand opposite the paintbrush; many of the women would tuck the figure against their torso or lay their hand on the table in order to stabilize it while they worked. Rosalinda also preferred larger pieces because she felt that she had time to get to know (*conocer*) the character of the piece and the designs that she was painting. She explained that she particularly enjoyed painting finely detailed patterns in rows, because it was a rhythmic activity in which patterns and colors needed to be balanced with one another. She showed me an area that she had just painted, pointing out two different patterns. She described how one pattern emerges if you pay attention to the light and dark tone, but a different pattern emerges if you pay attention to the actual colors. She said that she never really planned which patterns she would use ahead of time. They came to her as she worked.

While many artisans described their methods and experiences of work in similar ways, the results of their efforts were often quite different. People rarely evaluated or spoke critically about the work of one another in everyday conversation. This was in part because most artisans did not have many opportunities to view the work of other producers apart from their good friends and relatives. Workshops were limited and ambiguous spaces: public to tourists, guides, and collectors, but not really welcoming visits by other artisans without reason. Artisans also infrequently discussed the details of their actual work among themselves. Instead they talked about the pragmatic problems of marketing, the politics of Oaxaca's art worlds, or other concerns in the community. Most of the conversations that I was able to have with artisans about the quality and design of the work of others took place in the contexts of markets and craft fairs, where pieces were more readily visible and comparable.

One afternoon in November 2008 I was walking with César Santiago and his wife, Eda, through the large community craft fair that had been assembled around the main square of the village. The fair had been arranged to take advantage of the influx of tourists during the Day of the Dead period, staging a series of cultural performances in the hopes of attracting more at-

tention. As we wandered among the stalls, I frequently stopped to look at the carvings that were displayed. Near the end of one row I found a table of *comercial* pieces painted almost entirely in fluorescent colors. Although they did not glow in the dark, as did Lázaro's figures discussed in chapter 1, they caught my eye because fluorescent paints were not all that common in San Martín. When they did appear, they were usually used only for accenting other colors. The artisan who made them was absent from his stall, and I asked who he was. As was common in San Martín, César answered by telling me where the man lived and which family he belonged to, indicating that he thought he was a distant cousin of his. I commented that the carvings were a little different and asked what César thought of them. He paused speculatively and answered that these colors were not to his taste (*no son de mi gusto*). When I asked if he thought the carvings were not good, Eda interjected: "It's not that they're bad, they're just a different style than he likes to make," tipping her head toward César. "There are tourists who like all sorts of things, so the truth is that there are no objectively bad styles."

It turned out that this was a very common response when I asked people directly about the work of others. Rather than expressing judgments on the relative artistic or artisanal quality of someone's work, they would instead express preferences for particular styles, colors, and forms, often drawing comparisons with their own work as a means of explanation. For example, when I later asked César if he liked the work of Ernesto Pérez, whose work is stylistically quite different from his own, he pointed to a carving and said, "Yes—see, we both like to use combinations of colors that are close to each other, like blue and purple or orange and red. I like this very much." Personal preferences for colors and styles were also used as explanations for purchasing choices among the few artisans who openly resold the work of their neighbors. Catalina García did much of the buying of woodcarvings and other *artesanías* for her family's galleries. She told me that it is sometimes difficult to select among the works of all of her neighbors, "because all of it has value." She explained that she had to make hard decisions based on what she liked and what she thought would combine well stylistically with the Garcías' own work, to provide the customer with "a pleasant and consistent" experience. When she found a piece she wanted to buy, she often used the phrase "this grabs my attention!" (*¡ésto me llama la atención!*)

Artisans frame their evaluations as personal preferences, which suggests that these aesthetic practices are not locally designated standards to which everyone aspires but must be understood as part of the processes through which art objects come into being. Rather than being categories that emerge post hoc as Oaxacan woodcarvings travel along paths of marketing, con-

sumption, collection, and curation, the aesthetic concepts through which producers and viewers understand these carvings in turn work to direct future production, as more objects are produced that match actors' existing understandings. In this way the aesthetic practices of Tileños and others work to condition the forms that Oaxacan woodcarvings will take in the future (cf. Bourdieu 1993:223–237; Fabian 1998:48–51).

As painting styles in Oaxacan woodcarving generally follow convention, individual variation mostly takes place in the forms of the carvings. Rufino Pérez, for example, often carves gazelles, giraffes, and even dogs and cats with long, sweeping legs and necks, a device that he considers integral to his personal style. Although he is known for gazelles, he said that he would not consider it copying if someone else made them as well, unless it was clear that the other carver had tried to do it in exactly the same way. He explained that this was because "it is impossible to keep ideas to yourself; they are constantly floating around, and you don't really know if your ideas came from someone else or not, or if you were both separately inspired by the same idea." He elaborated: "All of us in San Martín have similar lives, similar knowledge [*conocimientos*], so it makes sense that we might have similar ideas." The repetition of particular forms is quite common within and between workshops. As Chibnik (2003:180–182) observes, this has been heavily influenced by popular journalism and collectors' guidebooks, which describe the works of artisans in detail, thus providing an incentive for named artisans to continue to produce work that meets buyers' expectations and an incentive for others to produce forms similar to published photographs in popular media. Repetition in form also is useful, especially for *comercial* producers, when dealing with wholesalers, who often want to buy large numbers of similar pieces to resell. Some artisans also told me that they enjoyed working with the same form over and over again, which allowed them to explore and push the limits of the shapes that they thought were possible.

These practical considerations aside, repetition is also characteristic of tourist art markets in many locations around the world. As Christopher Steiner (1999) has shown, the tendency for repetition is seemingly integral to the functioning of art markets that depend on "authenticity" as their currency. This is also true for the woodcarvings. Buyers' understandings of what woodcarvings should look like are conditioned by their ubiquity— as images in books and online or as actual woodcarvings—in San Martín's workshops, in Oaxaca City, and elsewhere in Mexico. An Austrian tourist who was visiting San Martín without a guide summed it up: "Once you have gone into a few workshops or galleries you get a feel for the woodcarvings, you know what they look like in general. Then you can decide which one

you like best, as you know what they should look like." Artisans, of course, tend to repeat the forms and aesthetics that they believe will easily sell. This repetition of style contributes to a large extent to the reproduction of the larger aesthetic field.

Tileños' aesthetics structure the aesthetic field of the woodcarvings in relational ways: one artisan's style cannot be understood as an isolated characteristic but rather must be positioned in reference to the work of others and the artisan's own earlier work (cf. Sylvanus 2016:77–100). Despite the structuring tendencies of such a market, artisans in San Martín do have the ability to push the boundaries of the aesthetic field. A good example of this is Marina Castillo, a Tileña artisan who used to paint woodcarvings for her brother but now produces papier-mâché figures and sells them in her brother's workshop and at woodcarving fairs in San Martín and Oaxaca. She told me that she began making the papier-mâché because she wanted to pursue her own ideas in a different form. She felt that the malleable and softer medium of papier-mâché suited her personality better than wood. Her figures, depicting women of the different regions of Oaxaca in traditional dress, are distinctive from the woodcarvings, but at the same time they are also *típica*, characteristic of the local culture. Although Marina works in a different medium, the style of her painting on the figures is consistent with the general style of *comercial* Oaxacan woodcarvings, often reproducing floral motifs or incorporating the figures of small birds and insects into her painting (plate 6). Marina has quickly gained recognition for her work; the same year she started working in papier-mâché, she was invited to the large Maestros del Arte fair held annually in Chapala, Jalisco. Although Marina's figures are not examples of Oaxacan woodcarvings, they respond to the same aesthetic expectations as the carvings and perhaps could be understood as a continuation of a Oaxacan woodcarving in a different medium. This process can also be seen in the work of another Tileña artisan, who married the son of one of the well-known Aguilar family, ceramicists in nearby Ocotlán; their figures now frequently include Oaxacan woodcarvings represented in clay (see plate 7).

Although Tileños resolutely avoided negative evaluations of an artisan's style, including the choices of forms and colors, they would occasionally comment on the quality of individual pieces and speak abstractly about standards of quality and artisanship. The elements that were considered indicators of good-quality work were consistent among all of them and were connected to the proper execution of each step of the production process. The selection of a piece of wood is an important decision in the carving process for some carvers, especially those who make larger carvings. *Macho*

wood, for example, dries to be more hard and brittle than *hembra* wood and is thought to be better for carvings with finer details or delicate forms. *Hembra* wood dries to be less brittle; the branches are generally thicker and thus better for large, solid pieces. Carvers who usually made smaller carvings also recognized the differences between the types of wood, but most explained that this affected only the amount of pressure needed on knives and machetes during carving and did not change the final outcome of the piece.

For the artisans who make large *fina* carvings, figures made out of one piece of wood are considered higher-quality work, and carvers often expressed admiration for those who could carve a particularly complex form from a single piece. If a figure broke during carving, it reduced the quality of the piece in their minds, even if the repair work was invisible once painting was complete. In cases where the piece was salvageable, the breakage did not reduce the price of the work, but carvers were nonetheless disappointed in the outcome. In contrast, the cracks that almost inevitably appear naturally as large carvings dry are not considered to affect the quality of the work, because the damage is the result of the wood's nature and not the artisan's craftsmanship.

The drying and treating of wood also affect the quality of the piece in the eyes of artisans. While tourists and wholesalers do not pay much attention to this step, artisans and many collectors consider it central to producing good work. As the wood is very moist or "green" when carved, it must be completely dry before any painting is done. Depending on the size of the piece and the season (rainy or dry), this can take anywhere from a few weeks up to nine months. In most cases, pieces are left in the sun in the center of a courtyard or on shelves in workshop areas. Small pieces occasionally may be put on the household's *comal*, the large, round terra-cotta griddle used for making tortillas. The Garcías have taken this one step further and now use commercial bread ovens to speed up the drying process of larger pieces. The importance of drying relates to the texture of the paint when the piece is finally finished. Oaxacan woodcarvings are almost all finished in acrylic paint, which forms a water-tight seal around the wood when dry. If the wood is not completely dry before it is painted, the paint can bubble and crease as the moisture tries to escape. The artisans and collectors most consistently cited this detail as evidence of poor-quality work.

The quality of paint application is also considered to be highly variable. Smoothness and clarity in applying paint were the most common factors in evaluating the work of other artisans. Clear brush strokes that were not streaky were evidence of a "steady hand," an indication of skill; large areas of color should be evenly painted; and the boundaries between colors

should be sharp, even, and clean. While buying pieces for her shop, Catalina told me that she always checked each piece carefully, even if it was from someone she knew well. "When people are rushed, they don't take as much care with their painting. If the paint has run, or is not smoothly applied, this can ruin a piece. If you look at some of the [*comercial*] pieces, you can see how quickly they were painted, without care."

Working without Skill

One of the first times that I began to think about the possibility of intentionally unskillful work was in the first few weeks of my fieldwork in San Martín, when I was still getting to know the artisans and their families. During my introductions, I had purchased a large number of inexpensive carvings, both as a way to break the ice with artisans and in order to get a sense of the variety of work that was currently being produced in the village. In the evenings, when I returned to the home of the Garcías, I would sometimes show Catalina the carvings that I had bought throughout the day. Once she picked up a small piece made by Blanca Díaz, a *comercial* producer whose workshop was close to the village's main square. Looking at the piece, Catalina pursed her lips and said that she was dismayed that Blanca "works without skill." This was bad, she said, not only for Blanca but for everyone, because it gave San Martín a bad name in the eyes of customers. My initial reaction was that I agreed with Catalina: the small carving of a cat looked rushed—its ears were placed at odd angles on the head and the paint was uneven and dripped in a few places. While I had enjoyed talking with Blanca that afternoon, I decided that perhaps she would not be very helpful for me in understanding artisanship in San Martín. As her workshop was so close to the main square, however, I found myself spending many afternoons sitting at Blanca's workbench. She turned out to be a wonderful research participant: she was warm and funny and loved to spin stories, like many good interlocutors.

Blanca's work practices contrasted greatly with those that I described in the previous section. Most artisans' workshops were quiet, orderly spaces where people concentrated on the tasks at hand. Even the Garcías' large workshop, which at times employed over thirty people, was generally quiet, with small conversations among painters only occasionally erupting into general discussion. Carvers were even more taciturn, as they could not carry on conversations while working, which posed difficulties in conducting research on their experiences of work. In contrast, Blanca's workshop had a small television in the corner. Throughout the day neighbors would pop in

for a chat. Blanca would wander in and out to buy soda, make phone calls, or just stand in the sun. Each morning her husband would give her a box of carvings ready to be painted. She would line up ten to fifteen of approximately the same size on her bench and choose three or four plastic bottles of acrylic paint from the shelf. Using one of these colors, she would paint all of the carvings with a base coat before returning to the beginning of the line to begin the decoration, choosing from the other colors at random as she went along, all the while keeping an eye on the *telenovelas* (soap operas) on the TV.

As I did with other artisans whom I knew well, I would occasionally offer to help Blanca paint carvings as we talked. The third or fourth time I did so, however, she admonished me for being too slow, telling me that I wasted too much time on decorating. "Customers will buy these for fifty pesos, whether you spend five or fifteen minutes on them. . . . It's better to do them quickly and make more of them," she explained. I asked Blanca if it bothered her to make lower-quality pieces. She paused, perhaps a little offended, and told me that of course she sometimes preferred to take her time and work on a large piece but that making quick little pieces did not affect her abilities as an artisan: "I know I can paint well if I want to, but sometimes I have to paint quickly!" While this might sound like a classic explanation of an "economically rational" actor, the truth was that Blanca's workshop was always overflowing with finished pieces. She never seemed under pressure to fulfill the orders that came in from wholesalers. Blanca was not really embarrassed or frustrated by working unskillfully and enjoyed the freedom, flexibility, and pace that being an artisan in San Martín allowed her, especially compared to her previous work in a market stall in Ocotlán, which required her to rise early and work very hard all day. Blanca's work habits do not indicate that she is unskilled—painting with fine brushes and having sufficient knowledge of the Oaxacan woodcarving market to make sellable pieces are skills in themselves. But Blanca chose to complete her work without using time or finesse and did not work to develop her skills further than she had already done. Catalina's comment about Blanca's work underscores this difference: she said that Blanca *trabaja sin habilidad* (works without skill/capacity), rather than *falta la habilidad* (lacks the skills).

Blanca's unskillful work can be compared with the work of Juan, who was also believed to work without skill but in a different way. Juan and Isabel had both been employed in the Garcías' painting workshop for over four years. In this time Isabel had become an excellent painter: she was often asked by the Garcías to paint the largest, most expensive pieces. Younger workers often turned to her for advice. She also had taken on other leadership roles, such as keeping track of the special orders from clients. Juan, in

contrast, had not developed his skills. He preferred to do the preparation work of sanding and gluing. This work was important in the production of the Garcías' very expensive *fina* carvings, but it was not considered skilled in the same way as the work done by the carvers and the painters. Catalina and Miguel often expressed concern and disappointment about Juan's apparent complacency in the workshop, especially because his father happened to be one of the first artisans in San Martín and was considered an expert carver. Two of Juan's father's pieces from the 1980s had pride of place in the Museum of Popular Art (Museo de Arte Popular) in Mexico City, so I was surprised that Juan was content working for the Garcías at all. Carrying on his father's name offered the potential for much greater earnings than wage work at the Garcías, and his father's renown meant that Juan would have less work to do to develop his own name for himself.

One evening when I was visiting his family home, I asked Juan why he preferred preparation work when most of the other painters tried to avoid it. He told me that he just did not like painting that much, did not like how long it took, and did not want the responsibility of deciding how to paint the carvings. His mother, Paula, who was cooking nearby, scoffed, "You see, it's that my son is very lazy. He prefers to do nothing at all!" While Paula characterized her son's working habits as "laziness," his own explanation indicates that he actually prefers the kind of work involved in sanding and preparation to painting. Like Blanca, he desired a working life that did not revolve around the deep engagement with materials and form that highly skilled painting requires. In fact, far from being lazy, Juan was keen to be involved in the more social side of the Garcías' business; his decent level of spoken English allowed him to offer tours of the workshop when Miguel García was unavailable. He enjoyed chatting and interacting with tourists from all over the world and often charmed visitors into ordering carvings that were not yet even finished. One could say that he was working to cultivate his social or entrepreneurial skills in the place of his artisanal skills, but this was generally not recognized by others.

In her study of Muslim artisans in Delhi, Mira Mohsini (2016) interrogates the meaning of the term "artisan" in Western intellectual traditions. She shows how the word conjures, on the one hand, the craftsperson whose control over materials, forms, and production allows for the gratifying cultivation of skill and excellence ("craftsmanship"); and, on the other, the specter of the alienated craftsperson who loses her artisanal "essence" in the process of being estranged from the work and becomes a laborer. She labels these two positions "artisan as symbol of tradition" and "artisan as victim of economic disturbance" (ibid.:246–247). Mohsini shows that these figures do not easily correlate with the ways that Muslim artisans in Delhi experi-

ence and understand artisanship. For them, the line between "artisan" and "laborer" is not a categorical distinction between skills, activities, and identities but rather a lexical marker used to indicate a person's social and economic position at a particular moment and vis-à-vis other people. In fact, her research participants often used the term "artisan" to indicate not control over materials and skill but instead control over other people in the chain of production and marketing (ibid.:250–257).

On a basic level, it might be possible to map the different approaches to work that I observed in San Martín Tilcajete to the two modes of artisanal identity that Mohsini identified in the Western canon. Indeed, Blanca and Juan probably would not have been artisans if other worthwhile options had been available to them (and thus may be "victims" of economic circumstance). However, Mohsini's work points to another possibility. The category "artisan" is not so stable or defined as we tend to think it is, so perhaps it is possible to conceive of artisanship as encompassing a broader range of practices and perspectives, some of which do not value the cultivation of skill and the experience of "material engagement." Both Blanca and Juan prefer different senses of work than those valued by the other artisans whose work is considered highly skilled in painting and carving, but this does not mean that they should not be considered "real" artisans. What is required is a way to distinguish between different modes, forms, and outcomes of artisanal work, what I call different "aesthetics of work."

Both Blanca and Juan prefer different aesthetics or senses of work than those valued by their neighbors whose painting and carving work is considered highly skilled. They desire a sense of work that is more social and interactive than the deep engagement necessary for producing highly skilled work can allow. Their families and neighbors perceive them as working "without skill," which is in one sense correct but in another sense perhaps irrelevant to them as individuals. They do not want to work with skill if this means immersing themselves in an aesthetic of work that clashes with the sense of work that they desire. As such, the recognition of skilled and unskilled work in San Martín can be seen to indicate different individuals' ideas about the nature of desirable work itself. In other contexts, such differences may lead people to choose different career or vocational paths, perhaps eventually finding work that is more appropriate and satisfying to them. However, in San Martín Tilcajete, where choices for work are extremely limited, artisanship and working with skill are the most important style of work that can be achieved and hence are understood generally as superior to other perspectives. In this way Catalina's negative appraisal of Blanca's work and Paula's indictment of Juan's laziness attach categories of skill to emergent moral discourses about work and self-discipline. Those

who work to cultivate their artisanal skills are judged positively, and those who do not are judged negatively. The Garcías pay their employees not only for their time but for the relative skills that they bring to their carving or painting. Although Isabel and Juan started working there at the same time, Isabel's wages are significantly higher than his because her relative skill adds value to the pieces. Her work can be sold for more money than the work of other artisans using the same materials, tools, and time. In contrast, Juan devalues his own labor within this context by refusing to develop his painting skills and is not recognized for the social and marketing skills that he works on instead.

Artisans' actual work practices always take place within the larger ideologies of skill, quality, and production that exist around them. Evaluations of individuals' skills and talent or lack thereof therefore cannot be understood objectively or even independently of one another. They are always made in relation to the perceived work of others within the immediate social world. In San Martín Tilcajete descriptions and evaluations of work produced by Blanca, Juan, Isabel, and everyone else are always made, if obliquely, in reference to the work of other artisans who also make Oaxacan woodcarvings. It does not matter, for example, if more skillful or talented woodcarvers are making devotional carvings in another part of the state. These artisans are not part of the Oaxacan woodcarving aesthetic field, so their skills do not play a role in how people who make Oaxacan woodcarvings are evaluated by themselves and others. However, as all Tileño artisans are part of the same field of practice, other Oaxacan woodcarvers' skills become the de facto standards by which consumers and others evaluate individual work. In other words, Isabel and other skillful artisans can be designated as such only because there are other "unskillful" artisans to compare them against.

The observation that skilled practices are always defined in relation to one another, however, does not wholly explain the reasons why individuals' work varies in practice to such a great extent. In order to understand why some artisans do not strive to cultivate their skills and do not mind if their work is not positively judged in comparison to that of their neighbors, we need to consider what is lost or sacrificed through the cultivation of skill. All skilled practitioners could reflect upon the opportunities for other activities that are lost during the time spent practicing their craft. However, in the case of those whose livelihoods depend on their skills, the question becomes more acute. Differing aesthetics of work account for the difference in the willingness of artisans to cultivate their skills. Some individuals do not want to bend themselves to a style of work that requires concentration, focus, and immersion in their materials and tools, preferring a working life that is flexible, social, and interactive. While this perspective

may seem anathema to those who value a "work for work's sake" ethos, it remains the case that the cultivation of skill is not inherently valuable or desirable to everyone in a saturated craft market with few other opportunities for employment.

This may seem to imply an infusion of Protestant (or at the very least capitalist) notions of the work ethic and morality into Tileños' everyday Catholic perspectives (Navarro and Leatham 2004). However, in San Martín the presence of art-market ideologies that promote particular understandings of authorship and aesthetics of work underpin both the emphasis on the cultivation of artisanal skill by some and its rejection by others. Before Oaxacan woodcarving became an important source of income in the village, success was connected to skills relating to agricultural production, which were fairly evenly distributed among people and had a direct relationship to a family's material well-being. In the art world of Oaxacan woodcarving, the relationship between the exercise of skill and a basic level of success or satisfaction is much more ambiguous. The workings of this market mean that authorship and its related tropes of style and authenticity complicate the matter of skill.

As I explore in the next chapter, for those who manage to cultivate a name for themselves, displaying skillful carving and painting enhances their possibility of success in the future. However, for those like Blanca who do not or cannot develop a name for themselves, cultivating skilled practices may seem a waste of time, as they can earn a basic income by producing many carvings quickly and without much effort. Like Blanca, Juan does not see the point of exerting himself to develop his skills in the Garcías' workshop. Although Isabel earns a higher wage, her skillful work in their workshop does nothing to set her ahead in the Oaxacan woodcarving market or art world; she does not earn recognition, because the authorship of all the carvings she paints is assigned to the Garcías. It is their reputation that is enhanced as she develops her skill (Cant 2016b). Because Oaxacan woodcarvings are cultural commodities and therefore assumed to be made within regimes of culturally shared skills and standards, all Tileño artisans necessarily work within a relational field of skill and talent in which the quality and value of an individual's work is always evaluated vis-à-vis everyone else's work at a given time. Thus, the category of "artisan" in Oaxaca is not only situationally defined by reference to other local trades and larger economic structures, as described by Michael Herzfeld (2004:5), but also situationally defined with regard to its own content. In this way, the concept of an "artisan" in Oaxaca has meaning and allows a diversity of work practices and attitudes to be encompassed in what appears to be a single social and economic perspective.

CHAPTER 3

Authorship and Its Consequences

Through work, people create themselves through their agency and at the same time create others for whom they work, or with whom they share the fruits of their labours.
OLIVIA HARRIS, "WHAT MAKES PEOPLE WORK?" (2007)

In early January, when the cool morning air takes many hours to heat to the highest temperature of the day, Amado finally puts down his blade, steps back from his carving block, and admires his handiwork. Over the last weeks he has transformed a rough-barked copal tree branch into the sleek, proud form of a coyote perched on its haunches. Running his palm over the wood, Amado takes a moment to check the horizontal balance of the piece, making a small adjustment to the curvature of its muzzle before giving it a cursory sanding. The coyote will be properly sanded later by someone else in the workshop. With a black permanent marker, he writes *LIBRE* in capital letters on masking tape on its flank to indicate that it has not been ordered by a client and is free to sell. Placing it on a shelf where it will take many months to dry out, despite Oaxaca's arid climate, Amado immediately turns his attention to a new piece of wood, checking the schedule to see what kind of animal forms have been ordered by clients this month. Two months later, on a late March afternoon, Alice and Mark Wilson are visiting Mexico from the United States. They want to order a woodcarving and are looking through the unpainted figures on the shelves when they find the coyote. They agree that this is just the kind of carving that they would like to have and begin browsing through the sixty or so vinyl photograph albums that document the many different combinations of painted colors and patterns that can be used to produce the distinctive style that has made this workshop famous in the markets for Mexican craft and folk art. Selecting a picture of a mountain lion, they tell Perla, who is taking their order, that they

would like this style of painting but with "earthier colors"; heavier tones of ochre, sage, and rust. Perla notes these directions down in a notebook and records an order number, which she duplicates on the Wilsons' credit card receipt and the flank of the coyote. She explains that they will not receive their carving until the autumn because the wood is still not fully dry. Later that year, in September, as the rainy season draws to a close, Citlali reads over Perla's notes on the color palette requested by the Wilsons. The coyote has recently received a basecoat of light buff-colored paint from one of the women who do piecework sanding and painting for the workshop in their own homes. Over the next few weeks, Citlali uses her creativity and knowledge of color, shape, and form to cover the coyote with the fine geometric painting that has become the workshop's signature style, choosing colors that both complement and contrast with the earthy tones requested by the Wilsons. Three weeks later, just before it is packaged and readied to be shipped to the Wilsons in the United States, Citlali finally applies the workshop's signature to the bottom of the coyote: "Miguel and Catalina García."

Like most of the pieces produced in the Garcías' workshop, in its journey from rough branch to finished work of art the coyote does not pass through the hands of either Miguel or Catalina, the artisans whose names form the signature and the identity—we might even say brand—of the workshop. While Amado, Citlali, and even the Wilsons can be understood as having contributed their skills, talents, and ideas to the coyote as an aesthetic work, we have to look beyond the process of production in order to see why its authorship is assigned to the Garcías.

In *The Craftsman*, Richard Sennett (2008:68–73) claims that one of the ways that art and craft can be sociologically distinguished is by the relative roles that agency and originality are considered to play in their production, citing Benvenuto Cellini's salt cellars as an example of craft-like objects that were ideologically made into works of art. Sennett suggests (2008:69) that this transformation could take place due to the emergence of a new kind of authority founded on the Renaissance ideals of originality and creativity, which imbued art objects with public value because they "exposed and expressed the inner character of [their] maker," a belief that continues to inform popular commonsense understandings of art production today (cf. Errington 1998:140–141; Soussloff 1997:19, 34). In contrast, the public value of craft objects has come to be based on the idea of socially or communally produced productive skills and abilities, often thought to reflect localized, place-based traditions or cultural identities rather than being the result of the internal creative processes of individuals (Hickey 1997:91–93; Metcalf 1997:70–71).

Thus, one of the ways that craft has been historically distinguished from

art is through definitions of authorship. Oaxacan woodcarvings are not clearly either "art" or "craft," however, so the consequences of authorship do not necessarily correspond to those normally associated with personal or cultural forms of ownership. In this chapter I examine how the Oaxacan woodcarving art world's expectations of authorship impact both the nature of competition and the relations of employment among artisans in San Martín Tilcajete. While authorship is often imagined to be the recognition of a direct connection between a maker and the text, music, or object that he produces, I argue instead that this bond must be actively cultivated. I suggest that authorship can come into being only through the recognition of an attachment between object and author *and* processes of detachment that obscure the connections between a work of art and those people whose work is crucial for its existence but who nonetheless are unrecognized as authors. When seen in this way, it is clear that authorship is an inherently political process that has social consequences well beyond the immediate relations of makers, objects, and buyers (Coombe 1998; Myers 2002:39–43, 323–332, 2005). The most significant consequences of this in San Martín Tilcajete have been the ways that authorship has reconfigured relations of kinship and neighbors into relations of employment and competition.

The objective attribution of pure creative genius to artists has of course been challenged by art historians, sociologists, and anthropologists. While Western artists have been constructed as individualized originators of aesthetic forms, in reality they produce artworks within communities of knowledge where ideas, symbols, and aesthetics constantly circulate (Becker 1982; Bourdieu 1993; Soussloff 1997). At the same time, outside of Western art contexts, different cultural perceptions of authorship (or similar formations) often proceed in ways that do not match Western understandings but can be linked to ideas of authorship in support of cultural or legal claims to authorial rights (Coombe 1998). However, this ambiguity has made authorship a difficult concept for anthropologists to come to grips with. Applying Annette Weiner's (1992) "inalienable possessions" concept to art, James Leach (2003) and Fred Myers (2001) have argued that certain artistic objects cannot be wholly separated from their producers, as they retain an essence of their maker long after they have been sold or exchanged (Geismar 2001:32–37). Following their lead, I start from the position that authorship can be understood as the perceived inalienable attachment between an object and its maker, which persists despite its being sold or given away.

As a concept, "attachment" has a large theoretical place within anthropological studies of craft. It emerged as theorists sought to denaturalize craft-making, which was hitherto presented as the straightforward execu-

tion of successive steps within a coherent and unchanging production process (Venkatesan 2010:168; Wood 2008:142). Instead, new theories of crafting have been developed through two interrelated streams of research that focus on practice. The first explores the embodiment of manual skills and techniques necessary for production through learning and apprenticeship (e.g., Marchand 2010; O'Connor 2005; Portisch 2009). The second, based firmly in phenomenological anthropology, focuses on the material practices of craftspeople and seeks to parse affect from the observable steps of production in order to grasp what is happening in terms of experience, perception, emotions, and the senses (e.g., Gowlland 2016; Ingold 2001; Keller 2001).

A key theme that has developed in this practice-oriented research is "direct perceptual engagement" or "engaged material consciousness," through which an attachment between maker and object develops (Ingold 2000:22; Sennett 2008:119–146; cf. Ingold 2001). This idea suggests that what distinguishes the special kind of embodied knowledge of artisanal and creative production from other kinds of material knowledge is the dynamic way in which the artisan feels connected to the objects and tools as she works. This connection is understood to be created through the enactment of complex systems of tacit knowledge that have been incorporated into the body through practice and repetition. Artisans frequently report that it feels as if the materials themselves have an independent agency (Ingold 2001:21–25; O'Connor 2005). While the complex interactions between artisans and their tools and materials have been helpfully brought into view through this focus, Thomas Yarrow and Siân Jones (2014) suggest that the overemphasis on engagement per se has had a tendency to perpetuate popular notions of craftwork as an antidote to the alienation that is supposed to inhere in modernity and capitalist modes of production. When framed in this way, an ideological continuity appears between the basic premises of "material engagement" and the mythology of craftwork, most importantly that crafts are produced through unalienated labor.

The implicit link between craftsmanship and unalienated labor can be seen as a result of the incorporation of Marxist principles into the very definitions of "craft" as it was articulated in the late nineteenth and early twentieth centuries by proponents of the Arts and Crafts movement, such as William Morris and John Ruskin (Greenhalgh 1997:32–36; Mascia-Lees 2016).[1] The Arts and Crafts thinkers assumed that craftspeople avoided the alienation characterized by industrial work by controlling the work process themselves and by their apparent heightened sensuous experience of the process, materials, and forms of their work. This belief still subtly influences craft studies today. Terms like "material engagement" and even "craftsman-

ship" are often implicitly taken to be the antitheses of alienation from the act of production (e.g., Sennett 2008). While this may be the case for some artisans some of the time, as Yarrow and Jones (2014) observe, this emphasis on the "redemptive possibilities" of craft may distract from other processes that are also involved in artisanal work. Based on their research with stone masons at Glasgow Cathedral, they instead suggest that artisanal practice is made up of jointly emerging conditions of both engagement and detachment, where detachment is understood not in opposition to engagement but rather as a *different kind* of material perception within the overall production process. Yarrow and Jones (2014:270–271) report, for example, that stone masons intentionally detach themselves from the specific stones that they have carved in order to subsume their own work into the greater, unified identity of the cathedral as a whole.

While Yarrow and Jones direct their analysis toward the practical and experiential processes involved in the work of Glasgow's stonemasons, I argue that their interpretation of detachment can fruitfully be extended beyond material production in order to consider the processes by which the authorship of artisanal objects is constructed. By extending the opposition of attachment/detachment in this way, light can be shed not only on the inalienable bond perceived between the woodcarvings and their recognized authors but also on the deeply alienable relations between woodcarvings and other artisans who are intimately involved in their production. By charting the processes by which inalienability and alienability are produced in a given context, the nature of authorship and its social and political implications can be more fully appreciated. In the next section I discuss the importance of authorship in the competitive field of Oaxacan woodcarving before addressing how processes of attachment and detachment unfold in the woodcarving workshops of San Martín.

Having a Name and a Style in San Martín Tilcajete

One hot summer afternoon a group of tourists from the United States arrived at the Garcías' workshop with their tour guide in order to see a demonstration of the intricate carving and painting techniques that have made the carvings famous. Throughout the demonstration, Miguel introduced by name many of the artisans who work in his workshop, carving, painting, and sanding the soft copal wood into their fine finished forms. After the demonstration was over, I spoke at length with some of the women in the group, while the others perused the small gallery. As we stood under the shady aw-

ning in the courtyard, one of the women mentioned that she had appreci- ated visiting the Garcías' workshop because, as she put it, she was "more in- terested in ethnic art than crafts." When I asked what was it about their work that made it art, she replied that it showed "real creativity and passion" and that "there was something unique in each piece [and] . . . you could see how Miguel and Catalina put themselves into the work."

A few weeks later a different group of American tourists visited the Gar- cías' workshop. As Miguel's explanation of the painting finished, and the group moved toward the carving area, I noticed that one young woman had hung back and was looking closely at the piece that Citlali, a painter in her early twenties, was just finishing. Although the woman seemed interested in the piece, she asked Citlali in Spanish how long she had worked there. Citlali looked up, smiling, and answered, "Two years." Dropping her voice, the woman then asked, "And do you ever get to sign your own work, or is it always signed by the *jefes* [bosses]?" Citlali's smile flickered for a moment, then she answered, "We are all people of this workshop, and this is the name of the workshop, so that is our signature."

While we may speculate on the dispositions or motivations of these two women whose interpretations of the Garcías' workshop were in such disagreement, it was my own reactions to these events that allowed me to glimpse the central problem that they posed. From my "in the field" per- spective I had been surprised that the first woman was able to feel that Miguel and Catalina had "put themselves into the work" when she had just met a number of the Garcías' employees who spend their days painting and carving in their workshop. At the same time, I was also surprised that the second woman did not understand that the signature applied to the bot- tom of the Garcías' carvings represented something more than just the la- bor that Citlali put into the piece: it stood in for the creative work of the Garcías themselves, which was expressed through the workshop's general style. These observations did not seem inherently contradictory from a per- spective situated within San Martín Tilcajete, pointing to the ways that the art world ideology of authorship has obscured complex social processes that have significant consequences for Tileños and other ethnic art producers like them.

Authorship is a central feature of the woodcarvings' desirability for many customers. Some view the carvings as material representations of an essentialized Mexican or Zapotec culture, while others consider them the works of individual artists. Most artisans in San Martín Tilcajete must con- tinually navigate between these two perspectives in the course of their work. While each interprets the meaning of authorship in very different ways,

both imagine that the legitimacy of a piece of work is connected to the legitimacy of the person who made it. Incorrect authorship threatens the legitimacy—and desirability—of the work of art. This was rather forcefully demonstrated to me one day as I was helping an artisan paint her carvings during the busy lead-up to Christmas. When a collector discovered with shock that I, a Canadian *güera*, was painting carvings, she loudly insisted in front of other customers that she not be sold any pieces that I had painted.[2] Although perhaps extreme, her reaction demonstrates both the perceived inalienability of authorship and that in this context only certain kinds of authors are appropriate. My work threatened to create an attachment between the carving and myself rather than a "true" Oaxacan artisan, which undermined the carving's status as an authentic cultural object. As my fair hair and white skin made clear that I was not an autochthonous author, my involvement in the woodcarvings' production appeared to damage their connection to Oaxaca and hence their authenticity itself (cf. Terrio 1999:128–129; Wood 2008:105–114). While autochthony appears to be a prerequisite for the production of authentic woodcarvings, however, artisans know that not all Tileños can make equally desirable or valuable work. Although everyone in San Martín Tilcajete should, in theory, be able to produce equally authentic pieces, their highly variable successes raise concerns about what tourists and collectors are *really* looking for, a question that crystallizes into conflicts about competition and the copying of styles among artisans (Cant 2015a; see chapter 6). These debates are conditioned by the local view of authorship, which is constituted through the idioms of *nombres* (names) and *estilos* (styles).

In the art world of Oaxacan woodcarving, which includes state actors, wholesalers, collectors, and journalists, a specific understanding of authorship is promoted. It is first articulated through the concept of names. *A tener su nombre* (to have a name for oneself, to be renowned) is an important factor for success; buyers often seek out already-known artisans whose work has been documented in collectors' guides, magazines, and books. Artisans require certifications from state-run organizations and competitions in order to secure invitations and visas to show their work outside of Oaxaca. The power of *nombres* must not be underestimated: as in other art markets, many collectors are especially concerned to have pieces by already-established artisans, while their unknown neighbors may not even warrant a visit. In February 2009 I traveled to a craft show in Tucson, Arizona, with Miguel García and two other artisans from San Martín. The show opened at ten o'clock on a Friday morning. At ten minutes to ten I was very surprised to see a large queue of desperate-looking people, mostly in their sixties and

seventies, waiting outside the glass doors. As soon as the doors opened, these collectors rushed to Miguel's stall. Within twenty minutes they had bought more than ten of his most expensive pieces. While the aesthetics and quality of the Garcías' work are of course also important to their desirability, it was their *nombre* that generated the excitement at the show. When I spoke with a woman who had acquired one of Miguel's pieces, she said that she felt relieved that she had managed to purchase one before they were all sold. Her own collection of "Indian art" had felt incomplete ever since her sister had bought a piece from him last year. While the connection between value and renown might be apparent from the collectors' point of view, the ability to develop a *nombre* is not a clear process for artisans and often appears to be out of their own control. Because of this uncertainty, the details of particular styles, and who had the right to use them, were frequently a source of discussion and concern among Tileños.

Given the plasticity of wood and the wide variety of ways in which carvings potentially can be painted, the consistency in the types of carvings that are produced in San Martín is surprisingly strong. The pieces made there almost always conform to the general aesthetic characteristics established in the early decades of Oaxacan woodcarving: they represent animals or traditional Mexican folk characters and are painted in the bold, bright hues that are common in other Mexican art and craftwork. While this consistency is maintained to no small degree by the expectations of consumers, guides, and state actors, individual artisans are also understood to have personal styles in which they execute their work. These distinctions are explained through the local idiom of *estilo* (style): while an artisan's works should be consistent with the overall genre of Oaxacan woodcarvings, they ideally also carry something distinguishable from the work of others.

In her wonderful study of West African printed "wax cloth" textiles, Nina Sylvanus (2016:77–100) charts the ways that the Nana Benz, powerful women fabric merchants from Togo, are able to consolidate their individual authority by reworking the aesthetics of their fabrics into recognizable "brands" with names. By consolidating the fairly open aesthetics of wax cloth printing into a limited set of colors, forms, and patterns, Nana Benz women are better able to control to whom such styles belong. Likewise, although they are never explicitly articulated as such, *estilos* are locally understood as the property of named individuals rather than being traits of carvings alone. It is *estilo* that allows the authorship of some carvings to be instantly recognizable to artisans as well as to collectors.[3] However, as with *nombres*, not all artisans manage to develop a recognizable *estilo*. Those who have done so are understood to have achieved some level of success that ac-

cords them respect and may guarantee them financial security. Although artisans, as well as the popular and academic literatures about Oaxacan woodcarvings, discursively frame *estilos* as belonging to named individuals, I suggest that styles actually attach to workshops as spatio-social entities that themselves are owned. In most cases, those who work in the same workshop produce the same style of carving and painting.

There are, of course, a few exceptions to this rule. One artisan in his late fifties and his adult son work side by side in their household compound, where both live with their wives and children.[4] Their work is quite distinct, and the son sells his work under his own name. However, a significant number of pieces in San Martín are at least partially made by people who are *not* considered the authors of the carvings they produce. Pieces by Tomás Castillo, for example, which are sold in his workshop in San Martín, in galleries, and online, are not made only by him. Although Tomás has developed his own carving style and carves the pieces himself, his wife, Lupe, has a hand in their production. She paints almost all of the pieces that her husband carves. She has worked to develop her own painting style, which has become characteristic of their collective work. Yet the pieces are always signed "Tomás Castillo" and are considered to be quite collectible. Tomás has made his name over the years and is also the son of one of the original carvers in San Martín. In cases where workshops carry the name of the family (e.g., "workshop of the Salazar Pérez family"), the surname used is always that of the adult man, not his wife or children who also participate in production (Cant 2018).[5]

The division of tasks within production processes serves to reinforce the disconnection of women and children from authorial links to their work. Carving and painting are frequently undertaken by different members of the workshop. Carving is generally done only by men and older boys, and all capable members of the household will do painting work. In almost all of these cases, however, the figures carry the signature of the man who was the head of the household. In only one case was authorship accorded to a woman painter and not to her brothers, who carved. Although *estilo* is most visibly recognizable in the painting, authorship attaches in most cases to the carver. The elevation of creation over decoration is therefore a significant factor within these processes. This is underscored by the fact that artisans often call their products *tallados de madera* (woodcarvings) or *figuras* (figures), emphasizing the sculptural aspect of the objects rather than their colors and surface designs. This division is reinforced through some artisans' discourses that describe women and children's work as "helping" rather than being work in its own right. Thus, the notion that unique styles

of carvings are the creations of adult male woodcarvers works to detach authorship from the women and children who contribute to their production.

The register of *estilo* works even more dramatically to condition the processes of attachment and detachment in large workshops like the one owned by the Garcías. As the piece formed by a carver is completed, he relinquishes aesthetic control to the painter, who then takes it forward. I asked carvers in both of the larger workshops in San Martín if they ever made suggestions about the way a piece should be painted, but none of them said that they did. Most said that they rarely thought about colors or surface designs: after the carving left their hands, it became someone else's piece to work. While this does not constitute a complete detachment from the object, as carvers continue to acknowledge and point out which carvings they have made, they no longer consider them objects with which they can materially engage. This suggests to me that the inalienable connection that Annette Weiner (1992) and others have observed between people and objects may be one of degrees: different *kinds* of alienability and inalienability may coexist, depending on the nature of the relations that are involved within production and circulation.

The ability to work on a piece or have decision-making power about its form or color, however, does not necessarily translate to a full recognition of authorship. As illustrated by the conversation between Citlali and the tourist cited above, although up to four different individuals might work on a single piece in the Garcías' workshop, the signature is always "Miguel and Catalina García."[6] In fact, Miguel and Catalina themselves frequently do not work at all on the pieces that bear their names. These interconnected processes of detachment and attachment are conceptually reinforced through the idiom of *estilo*, which is produced and reproduced—but not necessarily recognized—at the level of the workshop. Although many talented artisans work for them, Miguel and Catalina are considered the true authors of the woodcarvings because they are regarded as the authors and owners of the *estilo* in which the carvings are made.

Their style of carving was initially developed by Miguel over a period of approximately three years in the early 2000s as he and Catalina worked to develop their *nombre*. Today Miguel very rarely carves pieces himself, yet the creative work of authorship is still considered to have been done by him, even when employees produce specific forms that he has never made. Similarly, Catalina is the person who is understood to have developed the painting repertoire of the workshop, including their unique color combinations and their specific patterns and designs. Through their forms and decoration, the Garcías' carvings are easily distinguished from the work of their

neighbors. It is not just the products of the workshop that are seen as specifically belonging to Miguel and Catalina, however, but the style itself. David, one of the painters, also helps his own parents paint their carvings in the evenings after he has finished work. He explained to me that he would never paint his father's carvings in the style that he worked in at Miguel and Catalina's, even though they sell for higher prices. He said that this would not be fair: it would be like stealing. I never saw pieces at his parents' workshop that were at all similar to Catalina's painting style. David did admit that ideas sometimes come to him during his workday that are probably influenced by the Garcías' *estilo*, but that was as far as he should go.

While the nature of authorship in Miguel and Catalina's workshop is such that the pieces always remain firmly attached to the Garcías themselves, the detachment of woodcarvings from the employed artisans who make them is not always complete. Jaime, who is the son of another well-known artisan and has worked for Miguel and Catalina for over three years, is considered one of the most talented painters in their workshop. While the pieces he paints in general match Catalina's stylistic repertoire, he often incorporates flourishes that are recognized by everyone—including the Garcías—as distinctly Jaime's. For example, he will often insert a space between the usual geometric designs in which he might paint a scene, such as women making tortillas or ancient Mexicans building pyramids. At other times, he produces new iconography within Catalina's standard geometric patterns and plays with differences in scale or color to produce distinctive pieces.

Because of the uniqueness of Jaime's painting, which is paired with very high technical execution, his pieces not only earn more money for Miguel and Catalina but also have won Jaime a great deal of respect throughout San Martín. Two of his own pieces (carved and painted at home in the evening) were featured in a special exhibition in the Museo Estatal de Arte Popular de Oaxaca (State Museum of Popular Art of Oaxaca), and many of the other artisans in San Martín recognize that Jaime is one of the most talented painters in the community. Although he is able to exercise some aesthetic agency and maintain some authorial attachment to the pieces he produces at Miguel and Catalina's, members of Jaime's family were concerned that his *estilo* was being appropriated into the general style of the Garcías' workshop. They thought that he would be better off working on his own to develop his *nombre*. For his part, Jaime explained to me that he preferred working at Miguel and Catalina's because he had enough freedom there to try out new painting techniques and ideas, while at the same time earning a steady income of cash—something very desirable to a young man planning on marrying in the next few years. He also said that it was more fun work-

ing in the large workshop with others his own age than at home with his small family.

Although Jaime managed to retain some kind of attachment to the work he produces at Miguel and Catalina's, this is in many ways the exception that proves the rule. Of the twenty-five or so painters who work for the Garcías, only Jaime's work is thought to be somehow exceptional within the general repertoire. Furthermore, this limited authorship, while acknowledged among San Martín's artisans themselves, is not publicized to the tourists and collectors who purchase Jaime's work at Miguel and Catalina's—they are never told which painter or carver has produced the pieces that they purchase. Although the Garcías encourage some of their more talented employees to begin to build *nombres* for themselves, this work is not to be done during work hours. Pieces actually produced in the Garcías' workshop must remain firmly attached to them, and it is expected that pieces produced by employees outside of work will be stylistically distinct from the Garcías' *estilo*. Thus, the processes of attachment and detachment that allow the inalienable connection of authorship to emerge are closely linked with power and authority. To recognize an author is a political act, one that in San Martín Tilcajete has particular kinds of social consequences because of the kind of place that it is. In the next section I explore the social consequences of authorship by highlighting how employment in the Garcías' workshop suffuses work relations of employment with intimate relations of kin and compadrazgo.

Intimacy and the Consequences of Authorship

One afternoon in San Martín I met with Víctor Cabrera, a trained computer technician who worked at a motorcycle dealership on the outskirts of Oaxaca City. Although not an artisan himself, in his spare time Victor often helped the municipal artisan association with event planning. I wanted to discuss the group's relationship with the various government departments that they depended upon. However, Victor wanted to tell me about his son, whose recent withdrawal from his high school course was causing arguments at home. He explained in his typically dramatic manner that his son "was stuck between a sword, a wall, and Catalina [García]." He might finish his education, which seemed to offer very little opportunity in Oaxaca's stagnant climate; follow his friends to the United States to work *sin papeles* (undocumented); or work in one of the few large woodcarving workshops in the village. Given the physical and financial risks involved in crossing the

US border to work without a visa, I was surprised to discover that this option could be preferable to employment in a workshop at home, especially since the Garcías were members of Victor's extended family. As our conversation developed, I realized that for Victor employment by a relative carried the potential for coercion. As he put it, "Once you are in, you cannot get out."

Most small family workshops in San Martín cannot be easily separated from the households in which they are located. Profits and expenses from carving and other small businesses are directly integrated into the household economy, and many of the artisans I worked with found it difficult to separate their workshop's finances from those of their family. As sons approach adulthood, some may work to establish themselves as recognized artisans in their own right, although many continue to produce their work in their parents' homes, even if they no longer live there. After marriage, daughters may continue painting, especially if their husbands or in-laws are also artisans. Other members of the extended family, especially nieces, nephews, and godchildren, may be included in family workshops on an informal basis and are usually paid at piece rates or daily rates. Since they began making carvings in the 1990s, the Garcías have expanded their workshop from this basic arrangement into the more complex venture it is today. As their business expanded, Miguel and Catalina initially hired close family members before exploiting more distant links of kinship. In addition to sentiments of affection and belonging, in rural Oaxaca relations of kin are ideally grounded in performances of cooperation and mutual aid, which in turn generate *respeto* (respect), an important feature that governs social interactions on a daily basis (Cohen 1999; Hunt 1971; Stephen 2005:265–267). The Garcías were obligated in no small way to allow close family members into their business as they became more successful. As their workshop grew and more distant relatives came to work for them, these relations of respect and obligation expanded to their workers' parents, grandparents, and siblings. Because of this, the Garcías slowly became important local patrons, giving them an air of authority in the community in addition to their importance in the woodcarvings' art market. Most of the Garcías' employees are young people, between fifteen and twenty-five, and the workshop also became a space for courtship. As romantic relationships between workers developed into marriages, the connections of kinship within the workshop intensified. This further fortified the relations of obligation and respect between these workers and the Garcías, as these young couples depended on them entirely for their livelihoods.

The familial relations that were nurtured by employment in the work-

shop were overlain by yet another form of kinship that carries more formal-
ized obligations than those with relatives or in-laws: compadrazgo (ritual
co-parenthood). As elsewhere in Latin America, in San Martín compa-
drazgo is an extremely potent social relationship that demands reciprocal
respect and support between a child's parents and his godparents, who be-
come compadres (co-parents) with one another. The importance of respect
between compadres is underscored linguistically. Close friends or relatives
may speak in Spanish to one another using the familiar *tu* but must shift to
the formal *usted* once they become compadres. Compadrazgo is very so-
cially complex in rural Mexico. In addition to the celebration of the Catholic
sacraments, including confirmation and marriage, it can also be established
at secular events, such as the purchase of school supplies or clothing. Al-
though the relationship established at the baptism of a child is paramount,
"lesser compadres" also expect mutual cooperation (Cohen 1999:93–102; see
also Nutini 1984; Stephen 2005:265–267). As compadrazgo establishes an ex-
pectation of respect and assistance, it can serve to create or reinforce bonds
between unequal parties. For obvious reasons, wealthy or powerful fami-
lies are generally considered desirable compadres. The Garcías have become
compadres with many of their employees and have also reciprocated by ask-
ing close employee-relatives to become the godparents of their own two
children.

San Martín is a small community of only about 1,800 people, so the mul-
tiple layers of kinship and compadrazgo that have developed in the Garcías'
workshop recast the hierarchal relations normally found between employ-
ers and employees as intimate relationships that exist within a larger and
particularly dense network of social relations (cf. Yanagisako 2002, 2018).
Miguel and Catalina may be the employers of Amado, Perla, and Citlali, but
they are also very likely to be their cousins, their parents' or grandparents'
compadres, or potentially their own compadres or in-laws in the future.
This means that good relations with the Garcías are important not just for
their work but also for themselves and their families in other arenas of so-
cial life in San Martín. A breakdown of employment relations would not just
mean being fired; it could also strain relations between many families in the
community, all of whom live and work in very close proximity to one an-
other. This is what Victor means when he says, "Once you are in, you cannot
get out": to remove oneself from employment could undermine the fabric
of kinship and compadrazgo that bind Tileños tightly to one another. This
intertwining of work and social relationships underpins the hierarchical re-
lations of the workshop. Most employees do not view this situation nega-
tively, however, but see it as the natural progression of already-existing inti-

mate relationships of themselves, their families, and the Garcías, who have assisted and engaged with one another in accordance with the expectations of local social norms.

The Garcías' workers, neighbors, and clients also view their authority within the workshop as naturally deriving from their authorship of the house *estilo*. Correspondingly, clients are never told which painter or carver has made the work that they purchased. The artisans who work for the Garcías are thus made into employees, as they cannot build a career upon their own work. They are never recognized as the authors of the carvings that they make, so they do not develop a name for themselves or recognition within the Oaxacan art world and market. They would find it very difficult—at least in the short term—if they left the workshop to make carvings on their own. Compounding this situation, when workers do contribute their intellectual and creative capacities to the carvings they make, their innovations are subsumed into the general style of the Garcías' workshop. They are never fully free to abandon the Garcías' house style altogether. Working as an employee in San Martín's workshops thus differs greatly from the traditional European craft guild structures of apprenticeship, in which trainees work under the watchful eye of the master until such time as they are deemed qualified enough to practice the craft under their own names. Unlike San Martín, hierarchy in such traditional guilds is by definition temporary—once the apprentices earn their title as journeymen, they are free, even obliged, to use all of their skills and knowledge to make their own names for themselves (Carrier 1992:545–546; cf. Herzfeld 2004:14–27). In Oaxaca the political consequences of the art-world ideology of authorship intermingle with the affective relationships of kin and compadrazgo to produce and maintain hierarchical relations between authors and workers, who are in reality not apprentices. The durability of these relations is reinforced by the employment of relatives, compadres, or godchildren, who are believed to be less likely than non-kin to break the norms of the woodcarvings' art world, which insist that only the recognized author of a style has the right to benefit from its production. They would not only risk losing very secure employment in precarious economic conditions but also risk creating social frictions that would have consequences for all other aspects of their lives.

In addition to producing workers as an emergent category of persons, this intermingling of kinship and authorship has important consequences for the way performing such labor is experienced in San Martín Tilcajete. Kinship and compadrazgo carry heavy social obligations that require kin and compadres to support one another through money, goods, and work. While usually reserved for expensive fiesta and sacramental life-cycle events, such

obligations may be called upon at any time, creating a general condition of interdependence at any given moment. In other such socially dense contexts, wage labor may be viewed as a technology through which people attempt to curtail expectations of entitlement between kin, as the exchange of money for services may sever future claims upon the social relations created by laboring together (Martin 2018). For Oaxacan artisans, however, wage labor itself is sustained by actors' complex relations of kinship, as they are deliberately built on a form of respect that is considered substantially stronger than simple relations of employment. Relations of *respeto* between employers and workers are crucial within the Oaxacan woodcarving economy of recognition, as workshop owners like Miguel and Catalina must be able to have confidence that their employees are not going to steal their styles and undermine their own authorship and name. Without this assurance, making woodcarvings would become nearly impossible, as they would be unwilling to allow their workers to learn how to produce their particular styles of carving and painting. As it is, the Garcías take what seems the reasonable risk of teaching the workers their detailed and highly valuable aesthetic, expanding the workshop's output. At the same time, this relation of respect means that the Garcías are generally keen to develop the workers' own skills and to delegate basic aesthetic decision-making to them. So long as the authorship remains firmly attached to the Garcías' name, carvers and painters who achieve a certain level of skill are generally encouraged to experiment with forms and colors that complement the Garcías' general style. Hence employees are not under pressure to "steal skills" from their employers as workers may be in other cases (Herzfeld 2004:113–138).

The tension, of course, is that this seemingly balanced system of kinship and respect underwriting relations of waged employment within workshops is simultaneously undermined by the economy of recognition that has contributed to producing it in the first place. In a difficult economic situation where one of the few ways to get ahead is to establish a name for oneself in Oaxacan woodcarving, the pressure to leave employment to begin developing one's own name may be too great in the longer term. Indeed, in the nine years since my fieldwork began, a number of Tileños have begun producing carvings that approximate, with more or less success, the distinctive style of the Garcías' work. The availability of these "imitations" in the market, originally made by a few individuals who were not especially close to the Garcías, seems to have rendered aspects of their style up for grabs for use in the repertoire of Oaxacan woodcarving more generally. Pieces from the original woodcarving community of San Antonio Arrazola that are clearly inspired by the Garcías' style can now be found (cf. Schneider 2006 on appropriation

as artistic practice). A few particularly skilled employees of the Garcías have now decided to strike out on their own in order to establish themselves as artisans in their own right. As these individuals cultivated their skills and developed their own aesthetic sensibilities while working in the Garcías' house style, it is not surprising that their independent work would be influenced by their previous work. Some of these former employees have managed to maintain friendly relations with Miguel and Catalina, while others have not. In any case, the ideology of authorship and the competitive economy of recognition have now profoundly transformed the experience of social intimacy in San Martín Tilcajete.

Notes

1. For Karl Marx, artisans represented unalienated labor par excellence, especially in contrast to the exploitative experiences of factory workers that he observed. He argued that their alienation was evident not only in their estrangement from the products of their labor but also in the act of production itself, which he described as "self-estrangement [through the worker's experience of] his own activity as an alien activity not belonging to him" (Marx 1970 [1844]):111; see also 1976 [1867]:460).

2. Güera: a light or white-skinned woman; a term often used for white North Americans, but also for light-skinned Mexicans.

3. In contrast, when artisans refer to shared patterns and techniques, they often use the term *manera* (manner) (e.g., "these carvings are made in the traditional *manera*").

4. Both have school-aged children, as the father remarried after the death of the son's mother.

5. Naming practices in San Martín follow the typical Mexican form where children take their *apellido paterno* (father's first surname) followed by their *apellido materno* (mother's first surname) to form their own doubled surnames. Because of this, children's surnames are not identical to those of their fathers. Thus, even in the "family mode," workshops' names continue to reflect the adult man's identity.

6. Although Catalina's first name is included in their signature, García is Miguel's paternal surname. In her nonwork life, Catalina never uses the surname García.

Artesanías into Ethnic Art

Late in the summer of 2009 representatives from FONART began a two-week project in San Martín Tilcajete called Manitas Mágicas (Little Magic Hands). Manitas Mágicas is a series of short films and radio reports about the children of artisans in different communities around Mexico, produced as part of FONART's general objective to coordinate and promote craft production across the country.[1] Like the many tourists and collectors who make the short journey to San Martín from Oaxaca City, the project coordinators wanted to document how Oaxacan woodcarvings are made in Tileños' quaint, picturesque workshops. After an initial consideration of the village's concrete-covered square as the setting, the filmmakers decided that the Garcías' large, sunny, and aesthetically pleasing workshop was a better filming location. While this initially appeared to have been a technical decision based on considerations of lighting, it soon became clear that FONART's choice to film in the Garcías' workshop was directly influenced by the matters of aesthetics, authorship, and the alluring power of artworks that have been discussed in the previous chapters. Despite the FONART representatives' clear understanding that Oaxacan woodcarvings are a relatively recent invention not directly tied to traditional or indigenous cultural practices, the film that they produced links the animal forms of contemporary Oaxacan woodcarving to pre-Hispanic Mesoamerican culture: "Long ago the Zapotecs had a calendar made up of animals. And the later generations continued the tradition, carving fantastic animals for each of their children. . . . The tradition continues because we still work in the same techniques as our ancestors."

The community of San Martín Tilcajete holds communal titles to its land. The village's municipal authority is governed through the state-sanctioned collective governance arrangements of *usos y costumbres*, which

work through the enduring cargo system, in which adult males accrue authority and power within the civil hierarchy through service to the community. As such, the decision to represent San Martín through a private workshop seemed generally at odds with other state governance initiatives in Oaxaca, which often—discursively at least—emphasize the value of communal customs in rural and indigenous regions. When FONART began filming at the Garcías' workshop, however, their neighbors were not surprised. Miguel and Catalina's growing fame frequently attracts high-profile visitors from Mexico, the United States, and as far away as Europe and Japan. Even during the low tourism season between the end of Holy Week and the beginning of the summer holidays, when organized tours and independent travelers are rare sights in San Martín, the Garcías continue to welcome visitors many times a week. As I discussed in the introduction, their enviable success posed a puzzle to me as an anthropologist and to their neighbors: how are they able to be so much more successful than their competitors when their work is made from the same materials, produced in effectively the same manner, and located in the same village as other artisans?

The appearance of the FONART film crew in the Garcías' workshop is of course not incidental to the question: many anthropologists have addressed the central role that state agencies like FONART play in fomenting interest in particular types of cultural production. Focusing on tourism, development, and nation-building activities, they have highlighted both the knowledge-producing discourses associated with states' promotion of "culture" and how local people appropriate, rework, and redeploy these imaginaries for their own projects and goals (Brown 1999; Meisch 1995; Stephen 2005:152–199). However, as these analyses usually focus on the entanglements of states, producers, and markets, competition between producers is often undertheorized and is taken as a straightforward consequence of participation in capitalism. While the character of competition within such cultural markets has been profitably linked to the rise of entrepreneurial subjectivities (Comaroff and Comaroff 2009; DeHart 2010), less attention has been paid to the way economies of culture themselves are fashioned through the specific work practices of the individuals involved.

In his research with highland Ecuadorian artisans, Rudi Colloredo-Mansfeld (2002, 2011) shows how discourses of competition work to naturalize local inequalities and heighten real discrepancies in material well-being, while also consolidating cultural identities and commitment to community. As he says, poignantly, "the essential cultural work of competition is not to sweep away the inefficient, but rather to reconcile the painful inequalities emergent within communities with their professed shared val-

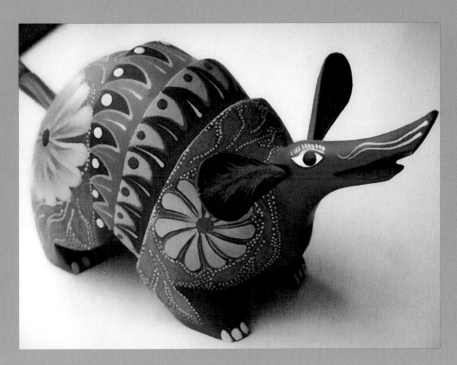

PLATE 1. A typical *comercial* woodcarving

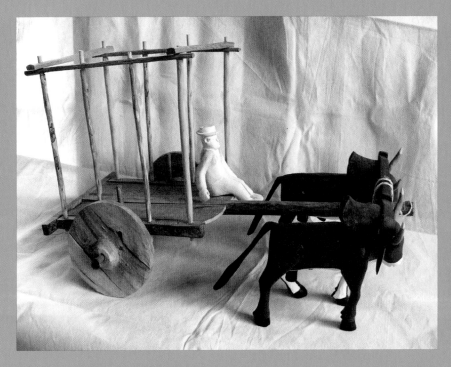

PLATE 2. A *rústica* carving with unpainted figure

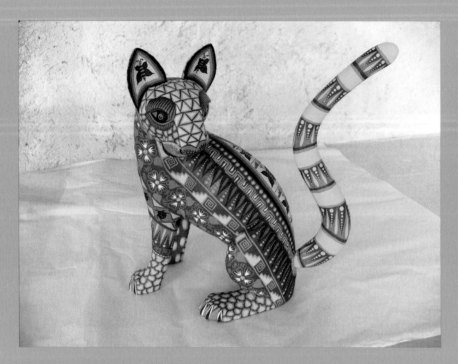

PLATE 3. A high-quality or *fina* woodcarving

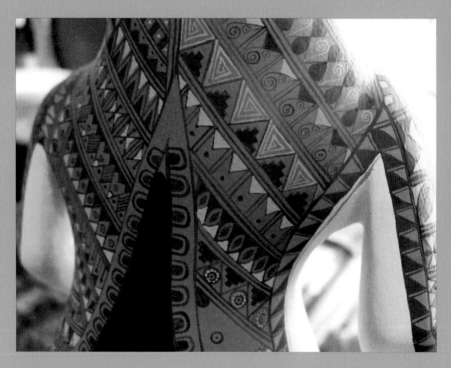

PLATE 4. Detail of a woodcarving in progress from the Garcías' workshop

PLATE 5. Young woman making a basket for a *calenda* procession

PLATE 6. Papier-mâché figures by Marina Castillo

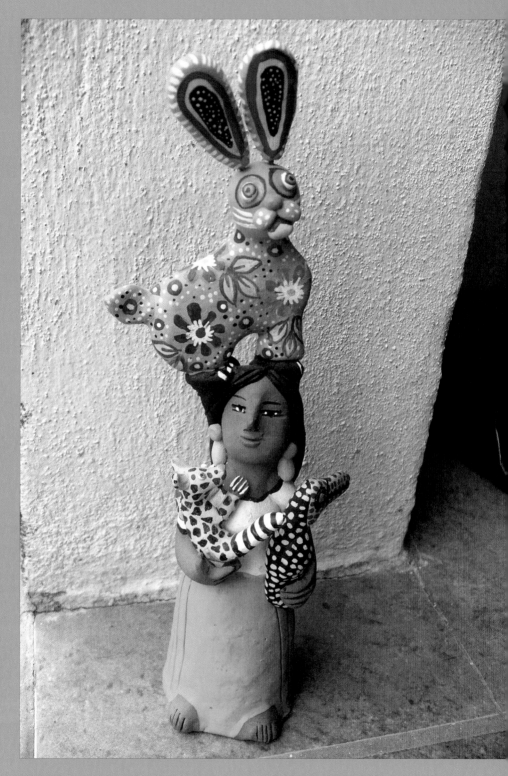

PLATE 7. Oaxacan woodcarvings represented in clay figures by the Aguilar family

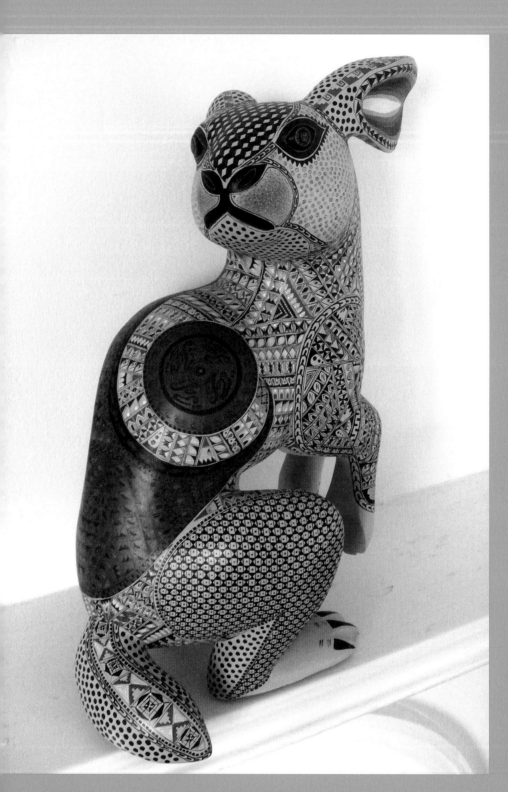

PLATE 8. A woodcarving by the Garcías in the "indigenous art" aesthetic

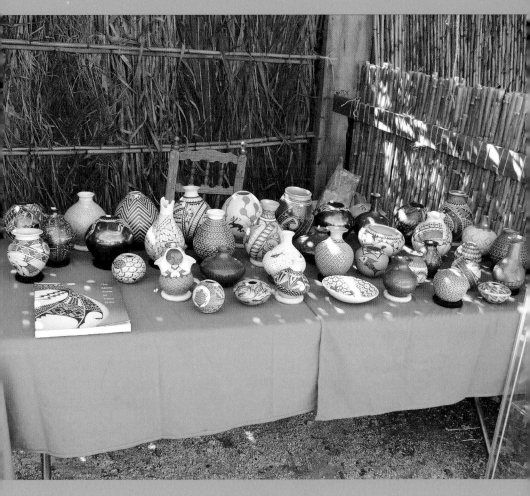

PLATE 9. Pottery from Mata Ortiz, Chihuahua

PLATE 10. A Mickey Mouse woodcarving by Miguel García, made in the 1990s

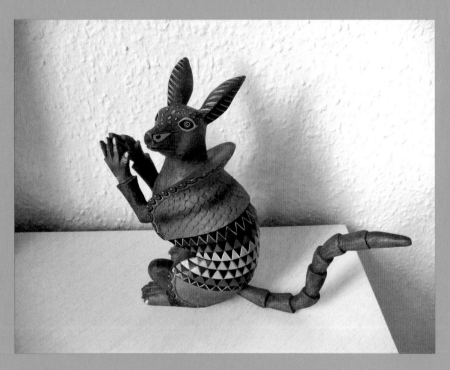

PLATE 11. An InSpiriter resin copy of an armadillo Oaxacan woodcarving

ues" (2002:114). In the previous chapter I showed how familial relations of kinship and compadrazgo underpin relations of employment and competition among family and neighbors in San Martín Tilcajete. This arrangement works both to produce new forms of labor and to reconcile the reality of increasing inequality in the town with Tileños' own avowed commitments to cooperation and communalism. This is certainly not unique to San Martín within Oaxaca: anthropologists working on textile production in the communities of Teotitlán and Santa Ana del Valle have long acknowledged how cooperation, competition, and exploitation can often go hand in hand (Cohen 1999:76–90; Stephen 2005:204–230; Wood 2008:146–151).

However, the observation that capitalist competition underpins intimate relations of dependency and vice versa does not tell us much about the nature of that competition itself: apart from the development of their "names" or fame, how *do* artisans compete with one another in a field that is very saturated with work that appeals to buyers? My research in San Martín suggests that we should not rely on conventional approaches to competition, which are generally based on market models that emphasize economic capital, information, and innovation as the keys to success. Instead, we must pay attention to how competition is often predicated more on "expressiveness, communication, and creative responsiveness" than on purely economic factors, as Colloredo-Mansfeld (2002:114) observed in Ecuador. As the concept of "culture" depends on the existence of an identifiable community as its source or place of existence, competition within economies of culture is better understood as a dynamic and ongoing relationship between intimate actors, who interact within contexts colored by social, familial, and cultural dynamics in addition to economic relations.

In order to understand the nature of competition within economies of culture, we cannot simply view the skills and knowledge of cultural producers as "assets" that individuals can invest more or less shrewdly. Rather, we must account for how producers' work practices, skills, and relationships actively constitute the conceptual and economic terrains on which competition takes place (cf. Mohsini 2016). As I argued in chapter 1, the social dynamics of competition among actors in art worlds can be usefully conceptualized using Bourdieu's model of cultural fields (1993). He emphasizes the way that particular fields are constituted by the ideas, beliefs, and actions of the individuals who participate in them. As each art world runs upon the subjective ideologies and affective practices of people in its given community, value and competition in art worlds are, therefore, also subjectively and affectively formed.

But value and competition in such fields are also manifold and composite

in their nature. On the one hand, they are characterized by the emic standards of their community (generating what Bourdieu calls "specific capital": see chapter 1). On the other, they are impacted by distinct but related fields of cultural production that have their own expectations and understandings of value. For example, the graphic novel genre can be usefully understood as a distinct field of cultural production, with its own norms of authorship, style, and so forth. But it does not exist in isolation: it is highly influenced by the related genres of commercial and "alternative" comic books; superhero television and film; and subgenres of these, such as British horror comics or Japanese manga. Furthermore—and especially in cases of art worlds that map onto economies of culture—value and competition are profoundly influenced by their connections to economic markets in which real political power and monetary value indicate and underpin success. Bourdieu (1993:38–52, 264–265) describes these processes as the competing "principles of hierarchization." The autonomy principle emphasizes those practices of the field that draw value from its emic activities and norms, and the heteronomy principle connects value to regimes beyond their own specific activities, especially those connected to economic and political success. Together, these principles describe the hierarchical relationships of power and prestige of members of particular art worlds.

In this chapter I show how the Garcías' success is due to their ability to position themselves at an important intersection of two neighboring fields of cultural production—Mexican *artesanías* and North American indigenous art. This positioning takes place through the aesthetics of their work. The *cultural* component of value in economies of culture means that it is not only the relationships between artistic and economic actors that are relevant here: the symbolic, material, and aesthetic aspects of the artworks themselves are also at the heart of these matters. The creative expressiveness of artisans' competitive practices identified by Colloredo-Mansfeld (2002:114) is profoundly influenced by the specific aesthetics of the economies of culture in which their work circulates. I therefore build upon research on the ways that identity and performance in craft markets mediate relations between producers and consumers (e.g., Little 2004; Stephen 2005; Terrio 1999) by focusing on the material and aesthetic qualities of Oaxacan woodcarvings and their role in economic competition and success.

The Garcías use consumers' aesthetic expectations of *artesanías and* indigenous art, and the multiple ways in which allure may be "read," in order to position themselves at the most productive intersection of the three economies of culture that are currently at work in Oaxaca. In chapter 1 I discussed the ways in which makers' and viewers' engagements with *particu-*

lar pieces work to constitute their auratic allure. In this chapter I illustrate how artisans' larger aesthetic practices, and the genre of Oaxacan wood-carving itself, are molded by and in turn shape the markets in which carvings circulate. These two processes cannot be conceptually separated from one another: analyses of cultural markets must take into account the inter-relationships of the aesthetic, sociocultural, and economic processes that characterize their forms. The Garcías' success is not based simply on a ca-pacity for "ethnic entrepreneurship" (Comaroff and Comaroff 2009; DeHart 2010) but also depends on their ability to generate and mobilize aesthetics in a way that positions their work as both authoritative and more valuable within the Oaxacan woodcarving market.

By exploring how the Garcías began to include the aesthetic markers of "indigenous art" into what had been understood solely as *artesanías*, I show how they transformed the entire genre of Oaxacan woodcarving. It was this shift in the aesthetic field that established the Garcías as artistic and cul-tural authorities in San Martín Tilcajete, making them not only more vis-ible within the art world of Oaxacan woodcarving but also more imme-diately successful and powerful than their neighbors. Colloredo-Mansfeld (2002:123) observes that in Ecuador "competition is acceptable so long as it occurs amongst artists and not business people," but it is the artistic aspect of competition that generates value for the Garcías' woodcarvings, making them competitors par excellence and causing frustration for some of their neighbors. As I explore in the final two chapters of the book, it is also this aesthetic aspect of competition in the woodcarving market that has led to meaningful changes in some local articulations of identity, ownership, and property.

Making *Artesanías* in the Oaxacan Woodcarving Art World

Miguel and Catalina García are considered to be very successful artisans by guides, gallery owners, and state officials in Oaxaca's tourism and craft in-dustries. Although tourism has experienced difficulties in recent years due to the general economic downturn and frequent media reports on Oaxaca's political disruptions and Mexico's ongoing issues with drug violence, the Garcías continue to flourish and always have a number of pieces on back-order that have been commissioned by private clients, museums, and galler-ies. Compared to others in the village, the Garcías enjoy a striking level of success. While many of the artisans whose workshops line the main street into the village generally receive between 15 and 200 pesos for their carv-

ings (USD 1.13 and 15), the Garcías often sell theirs for 1,000 pesos (USD 75), and their larger, more expensive work now easily fetches over 10,000 per piece (USD 750). Their friends in the tourism and craft industries explain their success as the result of high-quality work, an "entrepreneurial business ethic," and Miguel's good salesmanship. While these explanations are in many senses accurate, they downplay the extent to which the Garcías' success is also greatly dependent on their ability to stake out a new aesthetic territory within the existing genre of Oaxacan woodcarving.

For individual artisans in San Martín Tilcajete, the carving and painting of Oaxacan woodcarvings involves a great variety of aesthetic decisions influenced by both culturally informed and idiosyncratic ideas about what woodcarvings should look like. Chibnik (2006:501–505) reports, for example, that one artisan connects her painting style to her previous work as an embroiderer, while other carvers consider themselves "true artists" who are motivated by creative experimentation rather than market demands. Indeed, assertions of individuality are central to artisans' development of legitimacy within the Oaxacan woodcarving art world. As I discussed in chapter 3, having a *nombre* (name for oneself) greatly influences artisans' success: buyers are more likely to seek out work by known carvers. Artisans must build up histories of documented evidence of their work in competitions and publications in order to secure invitations from galleries and visas to show their work in the United States. Despite certain claims to individuality, the indisputable aesthetic consistency among the woodcarvings cannot be accounted for by individuals' explanations of personal styles and decision-making. This consistency can be understood by considering the expectations of other actors within the art world of Oaxacan woodcarving.

The small villages that dot Oaxaca's Central Valleys region have proven particularly fertile for anthropologists researching the production and marketing of craftwork. Studies of textiles, ceramics, woodcarvings, and replica artifacts have investigated issues of political economy and the politics of culture and provided important insights into the organization of workshops and markets and the roles of the state, wholesalers, and consumers within these structures (e.g., Brulotte 2012; Cohen 1999; Stephen 2005). In conducting this work, researchers have also effectively mapped the contours of the art worlds that are relevant to Oaxacan woodcarving and other local handicrafts. William Wood's research into the art world that surrounds the production of Zapotec textiles in Teotitlán del Valle is particularly useful in this regard. Drawing on the "community of practice" concept developed by Jean Lave and Etienne Wenger, Wood (2008:15) argues that production must be understood within the "social, cultural and spatial geography [that emerges]

as a product of the lives and practices engaged in the making of Zapotec textiles." He identifies and explains how different kinds of people actively participate in producing Zapotec textiles, both as objects and as a genre of craftwork. The main actors that Wood identifies as constituting this community of practice are tourists, guides, collectors, wholesalers and gallery owners, state representatives, anthropologists, and artisans themselves, located both in Oaxaca and in the southwestern United States (ibid.:117–161). These same groups (and in some cases the same individuals) are also constitutive of the aesthetics of Oaxacan woodcarvings.

At first glance, tourists might appear to be the most obvious actors within the art world that influence Oaxacan artisanal aesthetics, as they interact directly with artisans, often in their workshops (cf. Hernández Díaz and Zafra 2005:16). However, while tourist arts can be understood as the co-productions of tourists and art makers (Bruner 1996:159), I suggest that tourists themselves do not often directly contribute to the development of the artistic styles of tourist and ethnic arts. Rather, tourists learn about local aesthetics through their experiences in tourism sites like museums and gift shops and from tour guides and travel literature. In fact, I never observed tourists in San Martín making suggestions about how artisans should carve or paint woodcarvings. When tourists placed an order for a specific piece, they expected that it would be produced in the workshop's own style. In a few instances tourists did give input on the color palettes or the specific form of the carvings that they ordered. These options were constrained by the existent aesthetics of the woodcarvings, however; no one requested pieces that could not have been recognized as generally consistent with the genre.

Tourists therefore cannot be taken for granted as the central force in the development of woodcarving aesthetics, as they are usually more passive recipients of these processes. In many ways they contribute to the aesthetic *consistency* of the Oaxacan woodcarving genre through their forms of consumption. Their expectations are based on those aesthetic conventions that are all around them, in the discourses and actions of other kinds of actors (cf. Steiner 1999). Such other actors—including other kinds of consumers—are indeed central to the aesthetic character of Oaxacan woodcarvings, although they do not influence their aesthetics in necessarily straightforward or predictable ways.

Rufino Pérez is a woodcarver in his early fifties who has also been involved in a variety of community-based artisans' organizations over the years. This work has frequently brought him into contact with ARIPO, the Oaxacan Craft Institute, whose intended purpose is to extend support to Oaxacan artisans through fairs and competitions, low-interest loans, and

small business training and support. Originally established as a private organization for the promotion of Oaxacan craftwork, it was absorbed into the state bureaucracy in the 1980s and until recently has been overshadowed financially and organizationally by FONART (Holo 2004:179–180). Most artisans have ambivalent feelings about dealing with ARIPO: while good relations with staff members may significantly advance individuals' careers or aid the success of an event, ARIPO is also known to be a highly political and opaque organization. In addition to rumors of corruption and nepotism, artisans may experience patronizing attitudes and the pressures of personal obligations with some ARIPO staff. Nevertheless, those artisans who seek to elevate the exposure of their work usually find dealing with ARIPO unavoidable.

One afternoon while Rufino waited for an appointment at ARIPO's headquarters in Oaxaca City, we browsed through the woodcarving display in the gallery attached to the offices. After pointing out some carvings by his brother, he drew me over to a short pedestal standing next to the door. Pointing at the index card accompanying the piece, he proudly told me that he had won a competition a few years earlier. When I asked him why he thought this piece had won, he pointed out the quality of the carving, citing the delicate forms and also the theme of the piece: a large nativity scene, painted in bright colors. It was clear that Rufino had spent a lot of time on the piece, and I mentioned that his hard work and skill had obviously impressed the ARIPO judges. He agreed, saying that he had spent longer on this piece than any other he had made, but suggested that this was not why he had won. Rufino explained that all of the artisans who entered the competition were capable of making equally detailed or finely carved work. He thought he had won because his piece was *muy típica* (very typical or representative). Indeed, I had never seen Rufino sell anything quite like the nativity in his workshop. His pieces were generally small to medium-sized animals painted in bold, geometric patterns in a wide variety of colors. The nativity emphasized floral motifs executed in a more restricted palette of silver, bright pink, blue, and saffron yellow on backgrounds of black and deep purple. When I asked about the difference in styles, he said that in this case he had adjusted his approach because he knew that the judges in government competitions love things that look "really Mexican, really traditional."

Although American collectors have a stronger presence in the academic and popular literature about craftwork, Mexican individuals and institutions form a large market for Oaxacan woodcarvings. Most artisans in San Martín regularly sell to and take orders from Mexican collectors and wholesalers, who prefer aesthetic forms that they describe as "typical" and

"quaint," words that connect the carvings to the popular Mexican genre of *artesanías* (craftwork). As I discussed in the introduction, in Mexico the term *artesanía* carries both positive and negative connotations of culturally inflected, folkloric or traditional material culture of the indigenous and subaltern classes (Bakewell 1995; López 2010). These connotations directly inform the aesthetic genre of Oaxacan woodcarving.

In her detailed study of West African printed "wax cloth" textiles, Nina Sylvanus charts how the Nana Benz, powerful women fabric merchants from Togo, are drawn into Togolese nationalism. They are representatives of the ultimate combination of feminine heritage and tradition on the one hand and entrepreneurialism and capitalist cunning on the other. Sylvanus (2016:77–100) emphasizes that the brightly printed textiles are not just *symbols* of the nation but the *medium* through which the nation comes into being: the "dense materiality" of cloth is able to evoke sentiments and move national imaginaries because it offers a grounding in which the ephemeral notion of the nation can exist.

Likewise, Mexican *artesanías* have become a medium through which the nation can be realized and consumed. They are highly desirable to large parts of the woodcarvings' art world, especially those who are formally or informally linked to Oaxacan and federal state institutions and museums. During the intense ideological promotion of *indigenismo* in the postrevolutionary moment of the mid-twentieth century, indigenous cultural traditions were offered up as a source for an aesthetic of national belonging. Through these processes, the handicrafts of indigenous campesinos (peasants) became highly desirable. The intellectual elite collected and displayed them as cultural curios or *objets d'art* that abstractly and aesthetically connected them to the people that they saw as "their" indigenous compatriots (López 2010; Shlossberg 2015). This impulse was particularly strong among artists associated with Mexican muralism. The story of the Mexican nation grounded in the glorious indigenous past was literally painted onto the capital city through the works of muralists like Diego Rivera and David Siqueiros. Artists like Rivera and Frida Kahlo famously became avid collectors of *artesanías* (Coffey 2012:127–167; Novelo 1993:228–229).

Oaxacan *artesanías* in particular have come to represent the state's cultural diversity and distinctive status as an important source of indigenous authenticity within the nation. They are overrepresented in the collections of national institutions such as FONART and the Museo de Arte Popular in Mexico City. Mexican collectors who place orders for Oaxacan woodcarvings frequently request straightforwardly national symbols, such as the Virgin of Guadalupe, Juan Diego (the Indian peasant who witnessed the Vir-

gin's miracle), and the iconic eagle and snake of the Mexican flag. For their part, many artisans told me that they are more interested in carving other locally important saints or the Oaxacan Virgin of Juquila, but these figures are less popular with customers from Mexico City and elsewhere in the country.

ARIPO directly promotes the *artesanía* aesthetic in Oaxaca through its competitions and programs, as illustrated by the case of Rufino discussed above. All of San Martín's artisans directly or indirectly depend on ARIPO for access to markets, for sponsorship opportunities, and to develop their names. Throughout my research, I often met ARIPO officials at fiestas for birthdays, baptisms, and weddings, indicating the importance of personal connections with these officials for the artisans. Because of this, officials' views about what *artesanías* should look like carry significant weight in terms of defining the visual aesthetics of Oaxacan woodcarving. During an interview, for example, an ARIPO employee made it clear that he felt the organization's role was not only to support Oaxaca's artisans financially but also to "develop an appreciation among [them] for quality and beauty and especially for what is authentic and traditional in Oaxaca." Otherwise, he worried, "Oaxaca may become just like any other resort in Mexico, some kind of Disneyland. If artisans do not preserve our true traditions, who will?"

Artisans whose aesthetics fit well within the expectations of these institutions are more likely not only to make their names through sponsorship and invitations to events but also to match touristic expectations of Mexican craftwork. These institutions frequently set aesthetic standards through their publications, promotional materials, and exporting programs. As such, it is very risky for artisans not to fall within ARIPO and FONART's institutional aesthetic expectations, which might render them less likely to receive support and recognition.

While the interests and discourses that aesthetically frame Oaxacan woodcarvings as *artesanías* have been successful in establishing a genre that recognizably authenticates them for tourists and collectors, they also have the effect of constraining the aesthetics of woodcarving. As Johannes Fabian (1998:48–51) has observed in his study of Zairian popular painting, certain influential actors within local art worlds wield subtle forms of power in addition to those more evident forms associated with wealth and prestige. He focuses in particular on elites' abilities to classify objects as one kind or another, arguing that these classifications are materially significant because they direct the ways that cultural production can develop in the future. As a particular category of art becomes a concept through which pro-

ducers and consumers name and understand artworks, objects increasingly begin to conform to the category. Thus, existing genres of art always organize aesthetic difference in a way that is both productive and conservative.

Oaxacan woodcarving has developed through processes similar to those identified in Zaire by Fabian. The aesthetic constraints placed on Tileño artistic production by the *artesanía* category has meant that the vast majority of carvings in San Martín appear to be "more or less the same" to outsiders, as I was told by more than one visitor. This situation is exacerbated as more artisans enter the *comercial* end of the market each year. While making woodcarvings that fall safely within the genre of *artesanías* might guarantee a basic return on one's work, the Garcías have attained their success by situating their work outside of the established genre, creating value through the production of aesthetic difference. *Artesanías* and the *folclórico* aesthetic are defined in Oaxaca and Mexico more generally in negative relation to the *bellas artes* (fine arts). However, this distinction is only partially congruent with the way art and craft are usually defined in other Euro-American contexts. The two are intricately connected through the aesthetic and social networks that developed out of the postrevolutionary nationalist period (Bakewell 1995:22–23). The aesthetic line between art and *artesanías* is rather indistinct in Oaxaca, as local fine artists often draw heavily on indigenous, peasant, or folkloric imagery in their work. Contemporary galleries in Oaxaca carry works by local artists, such as Fernando Olivera and Nicéforo Urbieta, whose colors and forms echo earlier work by Oaxaca's most famous painters, such as *Dualidad* (Duality; 1964) by Rufino Tamayo and *Conejo con cucharones* (Rabbits with Ladles; 1983) by Francisco Toledo. At the same time, these categories remain materially, spatially, and economically separate, privileging fine arts like painting and printmaking over those normally understood as "craftwork" (see Holo 2004).

As I discuss in the next section, the Garcías have productively positioned themselves at the blurry intersection of these categories by producing objects that can be understood through the general aesthetics of *artesanías* while drawing explicit connections to "ethnic art," whose emergence in Oaxaca is inflected by American and Canadian understandings.[2] In so doing they have also shifted the aesthetic field of the Oaxacan woodcarvings, generating new expectations for consumers and state officials alike, who now read their work as indications of authenticity and artistic authority. Ironically, this aesthetic authority translates into their relative economic success because it satisfies the desires of ethnic art consumers for locally grounded indigenous culture by utilizing aesthetics of indigeneity that are *not* locally produced. The Garcías have learned how to signal indigenous ethnicity in

ways that are not easily replicated by other artisans in San Martín, making their work appear to be *most* authentic and culturally valuable, although it diverges significantly from the established genre of Oaxacan woodcarving.

Transforming *Artesanías* into Ethnic Art

During my fieldwork, I spent many afternoons in Miguel and Catalina García's workshop to learn about their techniques and rhythms of work. In the late mornings groups of tourists from Oaxaca City would often arrive for demonstrations.

As I discussed in chapter 1, Miguel's demonstrations directly linked the carvings to Oaxaca's pre-Hispanic heritage, often eliding their relatively recent origin in Arrazola. He connected both the materials and forms of the carvings to this deep past. He told the tourists how the copal wood used to make the carvings had also been used for thousands of years as incense in rituals and ceremonies and that the original forms of the Oaxacan woodcarvings came from the ancient Mesoamerican calendar. The days of that calendar were named for different animals native to Mexico, known as *tonas* (animal spirits) in Zapotec. Linking the styles and materials of his work to the ancient Oaxacans whose ruins form key sites within the local tourism geography, Miguel would say: "If you visit the state museum [Museo de las Culturas de Oaxaca (Museum of the Cultures of Oaxaca)] in Oaxaca City, you will see that the ancient Zapotecs always wrote their codices in three colors: black, yellow, and red. We can still make these colors today, using natural plants and minerals." He then demonstrated this, producing striking colored pigments in his palms.

These references to Zapotecness and indigeneity not only are found in Miguel's performances for tourists but also are apparent in the carvings themselves (plate 8). Unlike the bright hues associated with *artesanías*, their work generally utilizes the "natural" color palettes of browns, greens, reds, yellows, and turquoise that many American and Canadian consumers identify with indigenous art. While other artisans in San Martín carve saints and skeletons or exaggerated or anthropomorphic animals like lions, giraffes, and dragons, the Garcías' repertoire generally consists of naturalistic representations of animals of the Americas, such as coyotes, bears, and jaguars. They decorate these forms with finely detailed painting that includes overt symbols of indigenous culture, such as feathers, masks, and the cardinal points, which Miguel and Catalina have elaborated into an explicit system in which each form is said to carry meaning: frogs mean "water"; triangles mean "mountains."

The Garcías' ability to reference indigenous identity in their demonstrations and their art indeed indicates a capacity for "ethnic entrepreneurship." While the direct connections that they make between the carvings and indigenous or Zapotec culture are not consistent with the history of Oaxacan woodcarving, they do draw on real expectations that San Martín Tilcajete can be understood as a Zapotec place. While the Zapotec language is no longer spoken in the village, residents know that their grandparents spoke it and that their ancestors lived in the ruins on the hillside in pre-Hispanic times. Many of the social and religious practices found in San Martín today are also common in nearby Zapotec-speaking communities (see chapter 5). By connecting their aesthetics of indigeneity to these local indications of Zapotecness, the Garcías are able to satisfy the desires of consumers of ethnic art for objects that are locally produced by authentic indigenous people. However, the *content* of their indigenous aesthetics is not in fact local. While their woodcarvings appear to be authentic representations of local Zapotec culture, they are in reality more aesthetically aligned with indigenous art sold in the United States than with items sold in Oaxaca.

In the last ten years the Garcías have purposefully cultivated friendships with key American wholesalers and collectors who function as gatekeepers to the tourist and ethnic art markets in the United States. These gatekeepers have aided the Garcías through the obvious routes of providing publicity and introductions to other actors in their networks but also work in subtler ways by facilitating opportunities to show the Garcías' work at a wide variety of museums and upmarket galleries in the United States. During these journeys, the Garcías have become familiar with experts' discourses on skill and quality, giving them the language and the means through which to match their work to the expectations of wealthier American consumers and to see how comparable art objects look and are marketed in other locales. In particular, their many trips to the Southwest over the years have influenced the aesthetic nature of their work, which they now explicitly describe as "ethnic art."

In February 2009 I was invited to join Miguel and two other artisans on a sales trip to Tucson, Arizona, where they had been invited to sell their work at a gallery show. I spoke to a number of collectors as they jostled anxiously around Miguel's table at the show. A number of them had waited since the previous year's sale when Miguel had sold all of his pieces within the first hour. As one customer put it, she needed a piece for her collection because "Miguel and Catalina make true ethnic art." Like the American wholesalers who sell Zapotec textiles in the United States, the Garcías have recognized that Mexican indigenous identities can be easily subsumed into the aesthetics of ethnic difference that characterize the American Southwest: design

characteristics such as color-blocking, figurative patterning, and the use of "earthy" or "desert" palettes, like umber, vermilion, turquoise, and jade are easily translated into Mexican aesthetic categories. The desert landscapes of both Oaxaca and the Southwest have been claimed to influence regional aesthetics (cf. Wood 2008:77–114).

The American Southwest is also a particularly appropriate place for Oaxacan craftwork to be sold because it is often associated with indigeneity and Mexicanness in the national imaginary, much like Oaxaca within Mexico (Maruyama, Yen, and Stronza 2008; Rodríguez 1997). The Southwest also happens to be the location of a particularly robust art market focused on ethnic art, selling work by individuals from many different Native American communities, including pottery, baskets, and kachina "dolls" by Hopi and A:shiwi (Zuni) artists and woven wool blankets and silver jewelry by Diné (Navajo) artists. Santa Fe, New Mexico, is considered to be the third-largest art market in the United States and is focused on the annual "Indian Market," urban galleries in the Plaza District, and the surrounding Pueblo Indian communities (Maruyama, Yen, and Stronza 2008:457).

While many of San Martín's artisans have shown their work in the United States, Miguel and Catalina have had significantly more sustained and intensive interactions with a variety of American ethnic art "experts": collectors, wholesalers, gallery owners, and even museum curators and art instructors at universities. Over time, they have been able to incorporate the subtle and often diffuse expectations of these actors into a coherent aesthetic strategy that is not obvious to artisans who sell their work in American craft fairs perhaps only once every few years.

While many collectors who purchase the Garcías' work uncritically accept the link between an indigenous identity and their carvings, other members of their art world recognize the more active role that they have played in cultivating this aesthetic connection. While Miguel was describing the imagery on his carvings in elegant English to the collectors at the Tucson show, his friend and colleague Tommy Bolan told me quietly that "Miguel learned to sell like that in the US." Tommy is an American dealer who travels to Mexico many times per year. As time has gone by, he has found it convenient to work quite closely with Miguel. Rather than spending many days hunting around the woodcarving villages for stock, he generally now buys most of his supply through the Garcías, much to the disappointment of other artisans with whom he had previously worked.

Along with woodcarvings and Oaxacan textiles, Tommy also specializes in delicate, expensive pottery from the mestizo community of Mata Ortiz, in the northern Mexican state of Chihuahua. This pottery is known

for its fine etching and detailed geometric patterns created in glazes before firing. Like Oaxacan woodcarvings, Mata Ortiz pottery was "invented" in the twentieth century and draws on both Mesoamerican and North American Indian aesthetic conventions (Parks 1997). In two different interviews Tommy pointed out that the Mata Ortiz pottery had a direct aesthetic influence on Miguel and Catalina's style of painting and that Miguel would never have seen it if it had not been for their friendship. Indeed, the similarities between the pottery and the Garcías' work are striking (see plates 4 and 9). Miguel and Catalina themselves do not deny this connection but say that they have incorporated the "feeling" (*el sentimiento*) of Mata Ortiz work, rather than directly copying its style. This example illustrates the extent to which the aesthetics of indigeneity in Mexico not only emerge "organically" from the lived experiences of indigenous peoples but also are self-consciously elaborated and circulated through the different art markets in which Mexican artisans work.

The Garcías' process of incorporation and elaboration of indigenous aesthetics—what Arnd Schneider (2006) theorizes as a "practice of appropriation"—has taken place over a number of years. After the Tucson show was over, Erin Kers, an American who knew the Garcías through her previous work at a world art gallery in California, invited us to her home for dinner. As they reminisced about the past, Erin mentioned that she had carvings by Miguel in "his old style." When I asked what that meant, she pointed to some pieces that were displayed in her living room, indicating a large one on the left (plate 10). Laughing, Miguel said, "Yes, my work has really changed since then." He later explained to me that when he first started carving he did not know what kinds of things he should make, but he learned from looking at the work of other artisans. He explained that he made this Mickey Mouse carving because he thought that people would want figures of popular characters, adding that he began to develop his own style during his early sales trips. He was able to see what kind of objects sold well and talk to collectors and wholesalers, from whom he learned more about the history of ethnic art and *artesanías*. "Once I started going to the States, my work changed very rapidly. I had so many inspirations from all different kinds of work, and I could talk to those expert collectors who really knew about our kind of art."

By linking Oaxacan woodcarvings to an ethnic art aesthetic of indigeneity, the Garcías assert that Oaxacan artisans' genealogical connection to their Zapotec ancestors is a significant part of their artistic production today. This not only renders their work "authentic" within the North American context of ethnic art collection but also satisfies contemporary Mexican national understandings that have historically valued "safe" indigenous

cultural production as a keystone of the nation's distinctiveness (García Canclini 1993b). While Miguel's earlier Mickey Mouse carving would have struggled to sustain this level of aesthetic authority, the Garcías' current work seamlessly attaches itself to the commonsense understandings of indigenous art that circulate within both of these art worlds that link objects to culture, history, and identity (cf. Townsend-Gault 2001:240–243).

The Garcías have therefore been able to position themselves, both aesthetically and commercially, at the intersection between two different economies of culture, or fields of cultural production in Bourdieu's terms. As Bourdieu (1993) described, actors in different fields attach value and meaning to different concepts, which then work as kinds of capital or currencies among their members (see chapter 1). In the economies of culture of the American Southwest and Mexico, "authenticity" is a powerful currency for art producers. Indigeneity is intimately tied to authenticity in the Southwest, both in terms of the person of the artist and as the basis for the allure of the artwork itself. Both artist *and* object need to be sufficiently indigenous in order to enjoy the currency of authenticity. As Wood (2008:88–103) has shown, any uncertainty about an artist's or artwork's authentic indigeneity in the American Southwest can cause their legitimacy to be questioned and undermined.

In the art world of Mexican *artesanías*, authenticity is less strongly linked to indigenous ethnic identity than to its mode and place of production in the "humble" rural workshops of Mexican artisans. As I described in the introduction, the allure of *artesanías* lies in their status as the legitimate cultural products of the rural peasantry. As such, they are a source of a vital national identity for Mexico. Fortunately for the Garcías, the strong aesthetic and ideological connections that they have forged to particular American southwestern notions of indigeneity and Zapotecness do not undermine their claims to authenticity in the art world of Mexican *artesanías*. Likewise, authenticity in the American Southwest and the field of Mexican *artesanías* further buttresses the Garcías' allure for tourists who desire Oaxacan woodcarvings as souvenirs, as their fame and aesthetic abilities create a sense of cohesion and genuineness. They are able to straddle the border of these cultural and artistic regimes, producing value for their work and themselves as they move back and forth between the American Southwest and Oaxaca. This is possible precisely because the three economies of culture at play in Oaxaca place value on similar kinds of objects and experiences that assume long-standing cultural connections between people and the objects that they make.

What has made this positioning by the Garcías so effective in terms of

their economic success is that these fields of cultural production are also in hierarchical relations with one another (and with the larger fields of "folk art" or "material culture," of which they are a part). As American collectors of ethnic art are more likely to spend greater amounts of money on a single piece by a well-known indigenous artist, the value of "Zapotec style" work signed by the Garcías in the Oaxacan woodcarving market in general goes up. This "hierarchization," as Bourdieu (1993:37–45) calls it, means that authority and value from the ethnic art world of the American Southwest spills across the border, increasing the value and aesthetic authority of the Garcías' carvings at home.

This not only affects their success but also has implications for their neighbors in San Martín Tilcajete, whose work is now cast in a different light because it may appear *less* authentic to some viewers precisely because it does not overtly reference indigeneity (in Bourdieu's terms, this is an example of a principle of "heteronomy" overriding a principle of "autonomy").[3] In the final section of the chapter I look at the political implications of the Garcías' success before moving on to the broader effects of the indigenization of Oaxacan woodcarvings in terms of local identity and cultural property in the last two chapters of the book.

The Politics of Aesthetic Competition

Because of their popularity in the United States, and the prices that their carvings command, Miguel and Catalina have increasingly become authority figures within the art world of Oaxacan art and *artesanías*. They are frequently invited to attend openings and events in Oaxaca City, which is the center of its own important fine art market (Holo 2004:59–101), and have cultivated relationships with high-level government officials and members of Oaxaca's press and tourism industry. As many of these people have not traditionally been within the woodcarvings' art world, the Garcías' indigenized Oaxacan woodcarvings now circulate in ways that the products of other artisans cannot do. The frequent recurrence of the Garcías' ethnicized explanations within these popular and wide networks of actors means that "their version" of woodcarving aesthetics has gained authority and legitimacy. It has not only consolidated their success in Oaxaca but also affected the authority and aesthetic legitimacy of other Tileños who continue to work in the more traditional markets for *artesanías*. Their indigenized aesthetics are now often promoted in Spanish and English advertisements and articles throughout Mexico and North America. Many of these feature

interviews with Miguel or Catalina and often include their explanation that the woodcarvings are the product of their indigenous or Zapotec culture, a trope that is now often picked up by tour guides and gallery owners from Oaxaca City.

In the spring of 2009 I spent much of my time working with Rufino Pérez and Artesanos del Pueblo, a community artisans' organization of which he was the president. I wanted to work with Rufino and the other artisans in his group precisely because they were not involved with the Garcías through their galleries or events. I wanted to know to what extent other artisans were interested in, or aware of, the aesthetics of ethnic art that the Garcías were working so hard to construct. At this point I knew that relations between Rufino's group and the Garcías were strained. Tensions had flared the previous autumn as the two groups held simultaneous woodcarving fairs in San Martín (see below). As the members of Artesanos del Pueblo knew that I had spent a lot of time working with Miguel and Catalina, I decided to help them organize their Semana Santa (Holy Week) fair in order to gain their trust and to learn more about how the group worked.

After a morning meeting of Artesanos del Pueblo's executive committee had finished, the men of the committee lingered in Rufino's patio area. The conversation turned to the autumn fair and the altercations that had taken place with Miguel and Catalina. As the four men pulled up chairs and invited me to sit, Rufino's wife, Rosa, brought us cold Corona beers, the unofficial and ubiquitous drink of San Martín Tilcajete. Once we sat down, Andrés asked me if I knew the story of the small track that led out of the village toward the neighboring town of Santa Ana Zegache. When I said that I did not, Andrés began, adopting a storyteller's intonation. When he was a boy, his grandmother always told him to be careful when walking near the track, because that is where El Catrín had been known to wander after dark. In Mexican folk mythology, El Catrín is an elegant and wealthy gentleman who should not be trusted, because he is often the devil in disguise (Beezley 2008:46). Andrés said that he had run into El Catrín just once when he was coming home from the fields after dark. El Catrín stopped Andrés for a chat: "He was very nice, always always smiling. And do you know what his name was?" he asked me. "No," I replied. "Miguel," he said with a wink, as the other three men laughed aloud.

This story, although obviously told as a joke, emphasized the nature of the tensions between the Garcías and many of their neighbors. The problem was not that the Garcías were economically successful. Many migrants to the United States had achieved a fair amount of security over the years, often investing in large, and frequently unfinished, homes in San Martín in

the hope that they would one day retire there. It was also not that the Garcías had achieved notoriety per se. Other well-known artisans, like Isidoro Cruz, who had brought the woodcarving craft to San Martín, had also received great recognition in Oaxaca and abroad without falling into disfavor with their neighbors. In fact, everyone considered Isidoro, affectionately known as "Beto," to be friendly and a good neighbor.[4] By naming Miguel "El Catrín," Andrés was making clear that his success was somehow dangerous to other Tileños, causing his neighbors discomfort and suggesting that his conduct was somehow amoral. This implied social critique of Miguel and Catalina's activities was palpable among many Tileños. Gossip circulated that Miguel might be transporting drugs across the US-Mexican border hidden inside the carvings, a speculation that no one took very seriously but that they nonetheless enjoyed repeating.[5] People also expressed concern that the Garcías were taking advantage of me by "making" me work in their workshop. I denied this, explaining that I had asked them to teach me how to paint the woodcarvings and that I was keeping my carvings for myself.

Although these tensions do not causally relate to economic achievement or notoriety, they are clearly connected with issues of competition in San Martín. Migrants are not subjected to the same criticisms for their successes, which suggests that economic prosperity generated within the village is somehow more difficult to accept than prosperity generated far away. This observation evokes the image of "limited good," the suggestion made by George Foster (1965) that the Mexican peasant worldview considers the amount of "good" (luck, money, success, etc.) in the social world to be restricted, so that one person's achievement is another's loss. While the limited good theory seems to resonate in some ways with Tileños' discourses about competition, it does not explain why only Miguel and Catalina were subjected to the strong moral critique of their neighbors. Other artisans also enjoy success—admittedly not to the same degree—but without any of the same difficulties. Historically, most villagers sustained themselves through agricultural production on collective land and migrant remittances, so Tileños had more or less equal access to the means by which they could earn a living (Pérez Vargas 1993:29–31). In recent years, however, this basic level of household equality has changed: some families are now very well off in ways that are obvious to others. The source of this uneven prosperity is most visibly located in success in woodcarving production and sales, so competition between neighbors is experienced acutely. This intense competition is not new: the journalist Shepard Barbash (1993:27) described San Martín's competition as a "curio arms race."

Tileños' worries about competition are not focused only on the very suc-

cessful; concerns are palpable even among friends and artisans who work together in the same organizations. At the Artesanos del Pueblo's Holy Week fair that I helped organize, for example, I was surprised to see that the participating artisans had left large spaces (about twelve feet) between most of the tables that they set up in San Martín's main square. On the first morning I suggested to Rufino that they should consider moving the tables closer together in order to create a more market-like atmosphere, so that it felt busier when customers arrived. Rufino looked skeptical but walked around the group, encouraging them to move the tables further in. He did not have any success in convincing the artisans to move closer together. Later that afternoon I asked Marina why the tables were so far apart. Looking around, she pointed out to me that not everyone had tables widely spaced: the tables of Ernesto and Andrés were right next to one another, as were Blanca's and Vicente's. Marina explained that this was because they were family: Ernesto and Andrés were brothers, so it did not matter if they overheard one another's prices. They knew that they could trust each other not to steal their ideas and styles; Blanca and Vicente were husband and wife.

Marina's explanation surprised me. The twenty-two artisans who were participating in the fair had worked pretty well together planning the event in the preceding months. I had assumed that they got on well enough not to worry about stealing styles, a concern that I had often heard artisans express in interviews about their work. However, it seemed that I had underestimated the power of such worries about competition, even among the participants of the Artesanos del Pueblo group, which was founded to help artisans work together for their collective benefit. Despite this uneasiness about competition, however, members of Artesanos del Pueblo did seem to share a general sense that this kind of competition in itself was a normal, even desirable, state of affairs. Although artisans did not want their neighbors to hear their prices or steal their own styles, Alejandro observed that seeing other artisans' successes right in front of his eyes inspired him to try to make new and unique forms. Apart from the concern about stealing styles, Tileños never described the "normal" acts and conditions of competition in the negative ways that I heard the Garcías' activities discussed.

I first became aware of the tensions between the Garcías and some of the other artisans early into my fieldwork, when I was interviewing Román Castillo, another producer of *fina* work, about his clients and customers. Intending to discuss the effects that the political problems of 2006 had on his business, I started by asking him what he thought the biggest changes in the woodcarving market had been in the last five years. To my surprise, Román launched into a long discussion about Miguel and how he was currently mo-

nopolizing all of the "sources of the market." He explained that Tommy Bolan, the dealer with whom Miguel had developed a very close relationship, used to buy carvings from many different people in San Martín. Now, Román asserted, he just bought directly from Miguel: not only did other carvers lose an important source of their livelihoods, but Miguel himself earned a small profit off each piece that Tommy bought. Román added that it was Miguel who first began the practice of paying tour guides commissions on their sales. Now almost everyone must pay commissions or the guides just take their customers elsewhere. He explained these behaviors were evidence of Miguel's *egoísmo* (selfishness), noting that Miguel and Catalina were not content to be the most successful in the village: they always wanted more. The Garcías actually were not the first artisans to pay commissions to guides and taxi drivers in San Martín. Chibnik (2003:204–205, personal communication 2018) reports that artisans he interviewed as early as the 1990s complained about other carvers paying commissions. However, Román connects all significant structural changes in the local economy to the success of the Garcías, which shows the extent to which they now effectively dominate the economic and social field of Oaxacan woodcarving.

While some artisans expressed feelings similar to Román's, many others did not feel the same way. Although Miguel and Catalina have made the growth of their business the main focus of their activities in recent years, they also collaborate with other artisans in the community. In response to the difficult economic year that artisans experienced in 2006, Catalina established an artisans' organization called Artistas Artesanales, to which she invited those artisans whose works were, in her own words, "of high or collector quality and were unique to that artisan." The organization was conceived to help promote their work as a group throughout Oaxaca and to organize fairs in San Martín. Many of the artisans who are members of Artistas Artesanales have already made names for themselves in Oaxacan woodcarving. Catalina elaborated: "We were also thinking about our clients when we formed the group: people who buy from us are likely to be interested in work by Pedro, Daniela, María. . . . This way, we help them discover new work they might like, and we as a group benefit." Furthermore, many members of Artistas Artesanales have long-standing personal relationships with Miguel and Catalina, through friendship, compadrazgo, or kinship, and a number of their children or godchildren work in the Garcías' workshop (see chapter 3).

In late October 2008 Artistas Artesanales held its second annual fair to take advantage of the high numbers of tourists who travel to Oaxaca for Day of the Dead. Although all fifteen members of the group contributed to the

costs of marketing and decorating the fair space, the Garcías paid a large part of the expenses. All of the organization was done by their office employees. The event was held at their successful restaurant on the highway by San Martín, in order to take advantage of passing traffic to Ocotlán and the coast. The event space was beautifully decorated with traditional decorations like *papel picado* (cut paper bunting) and marigolds (the flowers of the dead), giving the space an overall aesthetic coherence. Traditional *ranchera* music played quietly in the background while carvers gave short demonstrations to visiting tourists. Based on Artistas Artesanales' success the year before, Artesanos del Pueblo also decided to arrange a craft fair in the main square in San Martín. Artesanos del Pueblo is the municipal organization of artisans, so any Tileño is permitted to join and participate in its events, including those who are also members of Artistas Artesanales. However, Catalina asked the members of Artistas Artesanales not to participate in both events. Artesanos del Pueblo organized ten days' worth of cultural events, demonstrations, and a market space to sell carvings, local food, drinks, sweets, and mezcal. Unlike the Artistas Artesanales event, which was organized by Catalina and Miguel's office staff, the community fair was entirely organized by volunteers from the Artesanos del Pueblo executive committee, many of whom had no previous experience planning an event of such a large scale.

The day after the two events began I encountered Rufino and some others from Artesanos del Pueblo at the intersection of the highway and the road that leads into the village, which is immediately across from the Garcías' restaurant. They were playing very loud rowdy *banda* music and had put up a hand-drawn banner. They also had two megaphones and were shouting at the cars passing by, directing them toward their fair and away from the Artistas Artesanales event. When I stopped to chat with them for a moment, Rufino told me that their new approach was working. They had already had more tourist traffic that morning than most of the day before. Across the highway at the Artistas Artesanales event, the atmosphere was decidedly dampened from the day before. The patio of the restaurant, which was normally busy, was practically empty. Although it was a beautiful day, most of the customers were sitting inside. Only a few tourists idly wandered around the parking lot to the side of the restaurant where the Artistas Artesanales stalls had been set up. The *ranchera* music that had been playing for background ambiance had been turned up to an uncomfortable level and was clashing with the music coming from the other side of the highway.

This situation persisted into the late afternoon until the performance of the Danza de la Pluma (Feather Dance; see chapter 5). The Artesanos del

Pueblo executive committee had arranged for San Martín's dance group to perform a shortened version of the dance in the basketball court in the center of their fair and had advertised it widely on their fliers and radio announcements. They believed that it would be a big attraction for tourists, since it would not normally have been performed at this time of year. After the dancers had been performing for about fifteen minutes, Miguel arrived in his pickup truck with an American couple and waved me over. He explained that the man and woman were acquaintances of his from the National Museum of Mexican Art in Chicago, who had come to Oaxaca to make some purchases for the museum's collection. He said that they had been interested in seeing some of the Danza de la Pluma, so they had stopped there to watch it before continuing on to his workshop. After they left, a few members of the Artesanos del Pueblo executive committee began talking off to one side about what had just happened. They somehow already knew that the visitors Miguel had arrived with were from an American museum and were upset that Miguel had used "the community's event" to impress the Americans, thus promoting his own interests. Vicente muttered, "These days, Miguel is more *político* [politician] than artisan."

Frederick Errington (1987:300–301), in a piece centered on public auctions in the small town of Rock Creek, Montana, suggests that the American residents of this town are able to reconcile their apparently opposing beliefs, placing value on individual entrepreneurial and competitive success but at the same time valuing the ideals of community and mutual aid. His informants insisted that competitors can remain friends so long as everyone followed what they considered to be "fair business practice," which often included the tempering of aggressive competition and the exchange of gifts and favors between competitors. Despite this insistence, the economic conditions and nature of competition in Rock Creek meant that some businesses failed. Those failures necessarily entailed some kind of benefit for competitors. Errington suggests that public auctions of repossessed goods and homes are important institutions through which this conflict is (temporarily) resolved, rendering the tension invisible by reconstituting the purchase of the failed competitor's capital as "good neighborly" conduct (ibid.:303).

Unlike the ideals of Errington's American informants, however, Tileño ideals of community do not include individualism or competitive success. They focus on sharing responsibility and costs among households. As such, community institutions and events such as the craft fairs described above reveal rather than disguise the tensions between this ideal and current entrepreneurial practices by Miguel and Catalina. I often heard guides and collectors admiringly remark that Miguel's business acumen was what set him

apart from many other artisans. They attributed his success to the combination of these skills and his workshop's beautiful carvings. While their enthusiasm and respect for Miguel's business approach is resonant with modern capitalist conceptualizations about hard work and success (cf. Lengyel 2002), from the villagers' perspective these practices are directly contradictory to understandings of how people should interact with their neighbors.

The entrepreneurial outlook that has contributed in part to Miguel and Catalina's great success necessarily involves the redefinition of the public/private divide. As entrepreneurialism is focused on (culturally and contextually defined) notions of efficiency and the maximization of profits (Colloredo-Mansfeld 2002:123), it also entails clear definitions of ownership and the foregrounding of "business success and leadership" as an essential measurement of personal value (Hart 2001:96). While Tileño collective ideals do not reject private ownership or individual success, the Garcías' entrepreneurial practices contradict Tileño ideals about what should be made publicly available, redrawing the lines so that their labor, goods, *and* their aesthetics of culture stay within their private realm. The case of the competing craft fairs is evidence of the tensions that surround this process of privatization. Although the Artistas Artesanales event was not just for Miguel and Catalina's benefit, it occurred on private property and was clearly organized and directed through their private interests. Their use of the community as a resource to impress the visiting museum representatives was also read by other Tileños as an attempt to redraw this boundary between the private and public. Miguel's presentation of the Danza de la Pluma as "our tradition," while at the same time not participating in the community-organized event but instead competing with it, was read by the Artesanos del Pueblo group as an act of selfishness at the expense of the community. These processes of privatization are felt strongly within a community where the ideals of communality and mutual benefit are considered ideals and models for good practice (cf. Cohen 1999).

However, the problem of privatization does not fully explain Tileños' discomfort with the Garcías' success. Rudi Colloredo-Mansfeld (2002:113) suggests that competition in contemporary "new" markets is predicated on expressiveness and communication rather than solely on economic factors (cf. Thomas 2009). In the case of the Garcías, these expressive and communicative factors are intimately connected to their aesthetic project of indigenizing the woodcarvings' aesthetics. As discussed above, Miguel and Catalina have benefited greatly from their ability to match the aesthetics and discourses of authenticity to the ethnic art market's expectations. Thus, the tensions between the Garcías and other members of their community are

not incidental to their aesthetic projects but rather are central to the practice of aesthetics in San Martín today. While I agree with Jorge Hernández Díaz and Gloria Zafra (2005:14) that artisans can learn about aesthetics and meaning-making from tourists in the exchanges that take place in Oaxaca, those artisans who have had the opportunity to travel to the United States also have had the advantage of engagement with a greater variety of perspectives and networks. This may include exposure to new aesthetic ideas as well as having a greater understanding of the discourses and ideologies of art that drive the markets in which their products circulate. Knowledge of these processes can be understood as a certain kind of competence or "ability to make one's way into other cultures" (Hannerz 1990:239). In the context of a competitive market for woodcarvings, where the variety of the aesthetic forms is limited and all are at least potentially able to make the same kinds of claims to authenticity, this competence becomes another kind of social capital that allows some artisans to more easily move within these global networks of actors and to match the expectations of their consumers (Notar 2008; cf. Salazar 2010).

For those artisans who have not accessed these same networks, this ability is a subtle and difficult-to-identify quality that appears to be simultaneously a cause and effect of success. This explains in some ways the stories about Miguel and Catalina's involvement in the drug economy and the jokes about El Catrín. Their rapidly increasing wealth seems "unnatural" within the more limited *artesanía* economy in which most artisans participate (cf. Nugent 1996). This intangibility means that it is often unclear to others exactly what Miguel and Catalina know that they do not. Thus, I argue that the situation in San Martín does not fit conventional assumptions about the role that competition plays in engendering innovation. The aesthetic innovation in the products of San Martín's artisans and the ability to sell them for higher prices are not wholly the result of competition within the market. They result from the uneven distribution of opportunities to develop the specific social and cultural skills that allow better access to ethnic art and *artesanía* markets.

Connecting the Garcías' success to their ability to produce a convincing aesthetics of indigeneity therefore not only allows us to understand why they have become more successful than their neighbors in terms of the ethnic art market but also illuminates something important about the nature of competition in cultural markets itself. By viewing the effects of their aesthetics innovations at the level of the entire genre of Oaxacan woodcarving, the relationships between actors in art worlds can be analytically connected to artistic production. If we conceptualize genres as aesthetic fields upon

which artists compete with one another for aesthetic legitimacy, then we can see that the Garcías' successful engagement with indigeneity necessarily constitutes a change in the entire genre of Oaxacan woodcarving and hence also affects the aesthetic authority and legitimacy of other artisans working in the same field. As the authority and value of the Garcías' work expands in Oaxaca, the woodcarvings produced by other artisans in San Martín are also increasingly evaluated by reference to the Garcías' work, which inevitably appears more authentic and true because it has set the new standards itself.

In response, a few artisans in San Martín have attempted to incorporate an aesthetics of indigeneity into their work. Some utilize widely recognized local symbols of Zapotecness, such as the "grecas" pattern from the ruins at Mitla that is also often replicated in textiles or even more straightforward representations of pre-Hispanic cultures, like pyramids and jaguars. However, these carvings are generally still executed within the *artesanías* aesthetic in terms of color, style, and form and do not connect in the same way to the expectations of "ethnic art" now held by certain consumers. Other artisans in San Martín have attempted to develop their work toward this ethnic art aesthetic. Many have access to only a few of the Garcías' pieces that are displayed in local museums as examples of indigenous art, however, so their attempts have (so far) been deemed "mere copies" by consumers and other artisans. As the apparently locally grounded aesthetics of indigeneity utilized by the Garcías are not actually local in inspiration, other artisans with less experience abroad are unable to produce "indigenous art" that appears sufficiently local and authentic. The consequence of these processes for the Oaxacan woodcarving genre is that its aesthetic field and its concomitant relations of power and competition are fundamentally altered as different kinds of references to indigeneity also become unevenly valued and evaluated.

Notes

1. The Manitas Mágicas program is produced and managed on behalf of FONART by Comunicación Comunitaria, a nonprofit organization dedicated to promoting and preserving artistic and artisanal education and rights in Mexico.

2. Street art is another important genre that has emerged relatively recently in Oaxaca and has important political, social, and aesthetic implications for Oaxaca (see Arenas 2011).

3. My thanks to Bill Wood for drawing my attention to this point.

4. Isidoro Cruz passed away in 2015 at the age of eighty-one.

5. I hasten to state that I have never seen any evidence that the Garcías or any other artisans were exporting anything other than craftwork.

CHAPTER 5

The Art of Indigeneity

There is a larger "aesthetics of place" inherent in the term "indigenous."
STEVEN LEUTHOLD, *INDIGENOUS AESTHETICS* (1998)

The sunny, dusty streets of San Martín Tilcajete were typically quiet one afternoon in late August as I returned to the Garcías' workshop from interviewing one of the original first-generation woodcarvers. Usually the village's peaceful atmosphere spilled into the workshop itself, where young women and men work in quiet concentration, painting elaborate designs onto the smooth planes of the figures. As I arrived that afternoon, however, I found that this usual tranquility had been broken: woodcarvings in the process of being painted lay abandoned on worktables as giggling teenagers strained their necks to see Miguel climbing up onto the roof with a *güera* (light-skinned woman). "Enough! Get back to work!" Catalina admonished her young employees as she shooed them back toward the workshop space. Still whispering and giggling, they returned to their worktables.

A moment later the clean scent of copal incense drifted down on the breeze. Intrigued, I asked Catalina what was happening, as I had missed the beginning of the episode that was drawing so much attention. David, Catalina's nephew and a frequent ringleader of mischief in the workshop, grinned widely and said, "Uncle Miguel is practicing his *brujería* [witchcraft]. Didn't you know he was a *curandero* [healer]?" Catalina turned to me and said in a low, halting voice, "Miguel is using incense to help a Dutch woman who has a bad knee. . . . You know how he is." A few minutes later, Miguel and the Dutch woman descended from the rooftop and reunited with her American husband, who was waiting at the front of the house. "How does it feel?" the husband asked his wife. "Much better, I think," she answered. As Miguel smiled openly, Catalina caught my eye and arched her eyebrow before fol-

lowing the couple into the small gallery, where they purchased two expensive carvings that had been made in the Garcías' workshop.

While Miguel's attempt to cure the injured knee through spiritualistic healing practices was in a general way consistent with other aspects of the Zapotec culture that he often explicitly avowed, Catalina's discomfort and David's mirth seemed to cast a shadow of skepticism, if not cynicism, over the event. It was not the first time that I had encountered such dissonance in my research. Over the preceding months I had become increasingly uncertain about what to make of the frequent but often contradictory allusions to indigenous belonging made by different people in San Martín Tilcajete. As in other places around the world where seemingly evident cultural heritage has become central to economic and political activities, concerns about the authenticity of cultural identities have become palpable in relation to Oaxacan artisans in recent years (Brulotte 2012:144–168; Wood 2008:111–114).

Anthropologists have long questioned expectations of cultural authenticity and have interrogated the multitude of ways that it is produced, deployed, and challenged by particular actors. In Latin American research this discussion has particularly emphasized how the logics of authenticity run against the contextual and fluid nature of ethnic belonging throughout the region (de la Cadena and Starn 2007; Little 2004). At the same time, international institutions and activists have insisted that we take self-identification seriously, especially in contexts like Mexico, where indigenous communities have experienced long histories of ethnic violence, discrimination, or acculturation (Canessa 2007). For these reasons, I initially interpreted the erratic expressions of indigeneity that I encountered in San Martín as distinctly tangible, if confusing, features of ethnicity in Oaxaca in the twenty-first century. However, instances like the event described above left me uncertain about the character of this ethnicity. I found it hard to come to terms with the fact that specific expressions of indigeneity by Tileños are sometimes met with doubt both by individuals who may be described as "knowledgeable outsiders" and—significantly—by other Tileños themselves (cf. Brulotte 2012:150–152).

These events in San Martín illustrate a conundrum of such contexts in which economic, political, and social processes render ethnic distinctions both valuable and ambiguous. How can we account for the uncertainties or reticence toward certain claims to cultural belonging but at the same time take our research participants' accounts of their own lives seriously? Kristin Norget (2010:120) has observed that "'indigenous' is one of those terms commonly regarded as coherent and universally intelligible," which in reality references an "opaque dialogue" through which different nuanced percep-

tions interact and conflict. Following her reasoning, I start from the premise that indigeneity may be misread if we consider it only through the idioms of ethnicity and collective belonging. While ethnicity may be productively read as a "loose . . . repertoire of signs" through which relations are forged and shared sentiment is made visible (Comaroff and Comaroff 2009:38; cf. Wade 1997:18), in this chapter I argue that in San Martín Tilcajete expressions of indigeneity are not entirely consistent with the sense of emplaced collectivity generally associated with the ethnic concept, even in its most expansive definition. Instead, I suggest that they are better understood as a social effect of the particular ways that value has come to be produced within the art world of Oaxacan woodcarvings analyzed in the preceding chapters. Rather than reflecting an inherent or invariable identity, the expressions of indigeneity that I discuss here evidence the desire by some Tileños to connect themselves personally to the value, respect, and authority that now gathers around the woodcarvings as valuable commodities in Oaxaca's economies of culture. In other words, I suggest that these claims to indigeneity are one of the ways in which artisans and their families seek to convert the value of their woodcarvings as objects into value, recognition, and esteem for themselves as people. As such, these expressions of indigeneity evidence one way in which art-world ideologies "spill out" into larger social lives.

Like Ronda Brulotte (2012:145), who has investigated how artisans navigate the ambiguous dynamics of ethno-racial classifications in Oaxaca, I am concerned neither with proving or disproving Tileños' indigeneity according to any diagnostic schema nor with evaluating the authenticity of their claims. Instead, I am interested in analyzing the forms that their assertions of indigeneity take from their particular positions within art worlds, which tell us something important about how value transfers from places and objects to people in such social arenas. While authenticity is an important source of value within Oaxaca's economies of culture, Tileños' expressions of indigeneity cannot be taken only as "cultural performance": individuals also earnestly engage with the idea of their own indigeneity for what it might offer to themselves.

In trying to account for these practices within the larger frames of ethnicity and belonging at play in Oaxaca, I have found it useful to think about them as "articulations" rather than full-fledged discourses or identities. Focusing on articulations provides a useful framework to understand how certain characteristics are made explicit and expressible, especially within the diverse political terrains of neoliberal multiculturalism (of which "economies of culture" are a part). Following Stuart Hall's (1986) reading of Anto-

nio Gramsci, the framework attends to both meanings of the word "articulation"—styles and modes of speaking on the one hand and the social and political linkages created by individual practices on the other. The utility of this approach lies in its analytical focus on both *forms* of expressing indigeneity and the *causes and consequences* of these expressions (Clifford 2001; Li 2000; Muehlmann 2009:476–477). As such, this is a particularly useful concept to highlight the connections between such expressions and the forms of value produced within art worlds, as it emphasizes both process and power. Furthermore, I suggest that within contexts like San Martín Tilcajete, where actors are believed by many (including themselves) to be particularly artistic, these articulations will often take aesthetic forms.

Approaching these particular expressions of indigeneity as "aesthetic articulations" helps me to make sense of the cases of those individuals in San Martín who most frequently raised the topic of Tileños' indigeneity during my research: Catalina and Miguel García and Agustín Flores, the son of an established artisan and the de facto leader of the community's traditional dance troupe. It is no accident that the people most interested in indigeneity are also those most effectively tied into Oaxaca's economies of culture: they know firsthand that having "culture" means having value in such places. Thus, it is also no surprise that they express indigeneity through aesthetic practices that are also considered to "contain" culture, such as dance, visual, and material culture. While these aesthetic and material practices explicitly signal "indigenous culture," they often are more about the crafting of a personalized self-identity than about forming a collective or holistic ethnicity for the community or an identity that is compatible with the political assertion of indigenous rights. This, I suggest, is wholly consistent with the logics of the "economies of culture" that I described in the introduction, which position culture as a kind of property that one can have and own (see also chapter 6). I begin by briefly charting the general characteristics of ethnicity and identity in the Oaxacan region before turning to the specific ways that indigeneity is now articulated in San Martín Tilcajete.

Ambiguities of Indigeneity in Oaxaca

Researchers have long been challenged by the complexity of social and ethnic distinctions in Oaxaca. Unlike other southern Mexican states, such as Chiapas and Quintana Roo, where ethnicity was historically a marker of social stratification, clear divisions between indigenous and nonindigenous Oaxacans had already been undermined by the late eighteenth century through

demographic and class changes (Chance 1978). Contemporary Oaxacan identities appear malleable and contextually dependent on other factors, such as community membership, religion, or class, which often emerge as more important focal points for belonging than language use or overt ethnic groupings (Cook and Joo 1995; Dennis 1987:95–109; Schmal 2007; Stephen 1993, 1997). Despite this flexibility, understandings of indigeneity in Oaxaca, as elsewhere, are also mediated by intersecting local and national logics of race, class, ethnicity, and gender and are primarily founded upon certain expectations of autochthony and primordiality (Norget 2010:119). For the dominant mestizo society in Oaxaca, and Mexico more generally, the indigenous category continues to carry a deep history of both positive and negative associations that connote backwardness and ignorance as well as cultural genuineness and authentic connection to the Mexican territory (Poole 2009).

The federal state's emphasis on *mestizaje* throughout the twentieth century has had a lasting impact on how indigeneity is imagined and reproduced today (Alonso 2004; García Canclini 1993b; Knight 1990; López 2010; Mallón 1992:35–38). In particular, postrevolutionary *indigenista* narratives that glorified pre-Hispanic cultures while seeking to assimilate Indians into the modernizing nation continue to influence national policies that paradoxically cast indigenous peoples as both a source of cultural pride and a legal, political, and developmental problem to be solved (de la Peña 2005). Within these genealogical and geographical imaginaries, Oaxaca and the other southern states with large indigenous populations came to represent the "Indian element" that distinguishes Mexico from its historical connections to Europe and cements its modern identity as an authentic mestizo nation (Alonso 2004:467–469). In tension with these national narratives, Oaxacan intellectuals and cultural elites have historically emphasized what they saw as their own state's exceptional ethnic diversity, not as a fount of authenticity for Mexico but rather to "make diversity itself the consensual basis of a unified [and unique] Oaxacan identity" (Poole 2011:188). In so doing, they reframed the distinct cultural content of people from around the state as diverse manifestations of a coherent Oaxacan culture, to which all Oaxacans are understood to be genealogically and emotionally connected (Poole 2009:208–218).[1] In addition to these nationalist and Oaxacanist understandings of ethnic difference, the cultural tourism imaginaries in which Tileño artisans now work are also inflected by the perspectives of middle-class Americans and Canadians. Their perceptions of indigeneity are conditioned by relations with indigenous groups in their own countries, whom they normally encounter only through representations in the media or through visual and material culture (Townsend-Gault 2004). As I described

in chapter 4, North American understandings of indigenous ethnicity have directly contributed to the rise of what Wood (2008:77–114) has termed "the Zapotec industry" in Oaxaca and elsewhere.

Michael Chibnik (2003:242–243) reports that in the 1990s he "never heard artisans in [San Martín Tilcajete] identify themselves as 'Indians' or 'Zapotecs'" and that their own self-portrayals differed greatly from the touristic portrayals that often presented them as such. By the time of my research in 2008 and 2009, certain individuals frequently and insistently described themselves as *personas indígenas* (indigenous people). Some younger people expressed a desire to learn the Zapotec language still spoken in neighboring communities. Many Tileños had an increasing interest in the artifacts that were being excavated by archaeologists at the pre-Hispanic Tilcajete sites, which sit above the village on the hillside.[2] One artisan even claimed that he was more legitimately indigenous than his neighbors, as his surname was Zapotec and not Spanish. However strong these new intermittent assertions, they have not translated into widespread understandings that San Martín Tilcajete is unambiguously an indigenous community.

The village does exhibit many of the characteristics that are often considered indicators of indigeneity in Oaxaca: it is an autonomous municipality governed through *usos y costumbres* and holds collective title to the land on which Tileños continue to cultivate the traditional Mesoamerican crops of beans, maize, and squash.[3] Villagers also participate in enduring social practices of *tequio* (unpaid labor for community projects), compadrazgo (ritual co-parenthood established at various points during the life cycle), and *guelaguetza* (reciprocal gift and service exchange networks), which are common in nearby Zapotec-speaking communities (Cohen 1999; Stephen 2005:230–249, 264–281).[4] However, surveys conducted in the Central Valleys in the 1990s showed that these "nonlanguage forms of ethnocultural expression" could not be readily used to identify distinctions between indigenous and nonindigenous villages, as they were of equal importance in both (Cook and Joo 1995:36–37). At the same time, all Oaxacan craft-producing communities may occasionally be ascribed indigenous identity by government officials, tourism personnel, and local intellectuals. Individuals from these communities may also now explicitly assert "Zapotec" or "native" identities, which contrasts with the more amorphous modes of identification in the region (Brulotte 2012:157–161; Stephen 2005).

In his elegant study of potters in Nicaragua, Les Field (1999:172) likewise shows how artisanship ambiguously links people who make crafts for a living to dominant ideological tropes of indigeneity and national belonging. One of his informants explained to him, "Pottery is being Indian. But pot-

tery is what we do and being Indian is not really our concern." Field goes on to show that for such artisanal communities in Nicaragua the meaningfulness of identity is found in the "continuity and community [of the] practices of daily work and the materials out of which daily life is made" (ibid.).[5] Similarly, in everyday interactions in San Martín I found that most people do not articulate identity claims in any sustained manner; even the demonyms "Tileño" and "Tileña" were used very infrequently. It was much more common to hear phrases like *la gente por aquí* (the people from around here) or simply *nosotros aquí* (we here) rather than collective proper nouns. When interacting with other Oaxacans, they usually used phrases like "from San Martín Tilcajete, near Ocotlán." In fact, Tileños are much more likely simply to describe themselves as Oaxacans—*yo, como un hombre Oaxaqueño* (I, as a Oaxacan man)—than to speak about ethnicity at all. When asked directly whether Tileños are indigenous or Zapotec, my research participants often hesitated or seemed unsure. In most cases, they would eventually respond by explaining about the past, referencing either the Zapotec language that they know their relatives spoke "before the priests banned it" or the pre-Hispanic ruins, which they abstractly acknowledge as the place where their distant ancestors lived. Some Tileños of older generations insisted that they were not really Zapotecs, because they were good Catholics and campesinos, suggesting that the real Zapotecs lived somewhere in the mountains.

Unsurprisingly, those who were most interested in discussing language, culture, and the past were individuals directly involved in the economies of culture in which Oaxacan woodcarvings circulate. The links among cultural production, tourism, and new articulations of indigeneity or autochthony have been observed by anthropologists in many locations around the world. While earlier analyses of this process sought to delineate and define this emerging "touristic ethnicity" (Wood 1998; cf. MacCannell 1984), more recently anthropologists have highlighted how the interactions and relations enabled by tourism lead to complex social identities that may transcend or obfuscate straightforward ethnic characterizations (Brulotte 2012; Feinberg 2003). As Walter Little (2004:11) argues for indigenous Guatemalan craft vendors, "international tourism has contributed a larger palette and more colors from which [they] can construct, maintain, and reflect on their identities as vendors, Mayas, and *indígenas*." Likewise, involvement in the economies of culture in San Martín has provided new conceptual options from which some Tileños actively construct their own characterizations of "being indigenous." Instead of addressing these portrayals only as a form of tourism-catalyzed ethnicity, I argue that they are better understood as specific aesthetic practices through which individuals convert the value

of their art and culture, which they witness through their work as artisans, into value for themselves as people.

James Clifford (2001:472) suggests that articulation theory allows us to circumvent two claims that are often made about contemporary indigenous peoples. On the one hand, that indigeneity is essentially about primordial or long-standing attachment—understandings that elide the pragmatic and disorderly character of everyday life. On the other, that indigeneity is reducible to utilitarian identity politics, appealing to invented traditions within an age of neoliberal multiculturalism. By focusing not on content or authenticity but rather on how indigeneity makes and unmakes connections between different kinds of actors and social forms through time, the articulation approach allows us to account for the disagreements and uncertainties that surround contemporary indigenous experiences (ibid.:478–480). This is helpful for the case of Tileño artisans, because the character of the indigeneity currently being claimed can be understood neither as containing distinctive or long-standing cultural content nor as a foundation for participation in active indigenous politics or even forms of collective belonging and experience.

It is helpful to think about the particular ways that people articulate indigeneity in San Martín by reference to the concept of "indigenous voice," which Anna Tsing (2007:38) uses to describe the language conventions through which indigeneity is verbally communicated by activists, public intellectuals, and community leaders. She argues that the "indigenous voice" genre generates modes of communication that structure not only who can speak for indigenous peoples but also how they speak and what kinds of audiences hear them. She emphasizes that it is not the individual speakers but the genre conventions themselves that carry power within their specific transnational dialogues. Similarly, the aesthetic practices of individuals engaged in asserting indigeneity in San Martín Tilcajete are both enabled and constrained by the ideologies and expectations of the art worlds and economies of culture in which artisans are embedded.

In the next section I show how the aesthetic practices of the Garcías and Agustín Flores articulate (communicate) ideas about indigenous belonging that connect them as people to the positive values that indigeneity carries within the worlds of art and culture in Oaxaca. Because they fit comfortably within these existing regional frames of indigeneity, they also work to articulate (connect) them to certain people and ideologies within these important networks within the economies of culture of tourism, *artesanías*, and ethnic art. I then move on to consider how and why the aestheticized and individualist nature of these practices also produces disagreements be-

tween the Garcías and Agustín Flores about the content of their indigenous expressions.

The Art of Indigeneity in San Martín Tilcajete

As I described in the last chapter, references to Zapotecness and indigeneity have become key stylistic tropes within the Garcías' carving and painting repertoires. In San Martín and beyond, their demonstrations connect Oaxacan woodcarving to the pre-Hispanic past, and the aesthetics of their work exhibit a naturalistic color palette and overt symbols of Native American culture. Because of the Garcías' increasingly important place within Oaxaca's tourism and art worlds, these tropes have also now become incorporated into the way that many consumers and other artisans understand Oaxacan woodcarving aesthetics.

While Miguel García's ability to reference indigeneity in his demonstrations clearly indicates a capacity for "ethnic entrepreneurship" (Comaroff and Comaroff 2009; DeHart 2010), I came to understand that viewing these expressions simply as marketing techniques or performances failed to account for the entirety of the ways in which the Garcías cultivate the idea of their own indigeneity. Both their demonstrations and their interest in indigenous culture developed over the past fifteen years, as they frequently traveled to art and craft fairs throughout the United States and Mexico, dealt with wholesalers and other artisans knowledgeable in the marketing of ethnic art, and were tourists themselves in other cultural tourism destinations. Through these experiences, they not only have come to learn about the aesthetic genres of ethnic art but also have reflected on how such aesthetics might relate to their own identities. As Catalina told me, "Before [we traveled] we didn't know who we were. No, it's more than that, we didn't even *think* about who we were. I want my daughter to know who she is. I want her to be proud that she is *indígena*."

The specific ideas about "respect for indigenous culture" that Catalina and Miguel espouse, which they speak about with frequency, connect to popular Mexican and North American notions of indigeneity more than to the politics and public debates over indigenous rights in Oaxaca itself. In conversations they frequently linked an abstract idea of indigenous culture to a generalized sense of social justice and defense of the environment, a perspective that resonates with the particular aesthetics of indigeneity that they both produce and consume. The private areas of their home are filled with books, *National Geographic* magazines, and videos describing the cul-

tural practices and art of indigenous groups from all over the Americas, and they have also become avid collectors of ethnic art from the United States and Mexico.

The Garcías understand themselves to be part of the transnational community of indigenous people who are represented by these publications and artworks and ultimately see themselves as sharing a fundamental cultural perspective on the world with the larger community of indigenous artists and other cultural producers. Catalina recounted to me the pride that she felt when a Navajo man from the United States visited their workshop in 2007. She explained that it was an amazing opportunity for her family to hear about the "history of indigenous people and about our culture that we all share." While indigeneity in Mexico is often experienced in ambivalent, negative, or exclusionary ways (Brulotte 2012:160, 165–166; de la Peña 2011), the Garcías' close relations with certain American and Mexican consumers who value indigenous aesthetics and culture have allowed them to view indigeneity as a positive project through which they craft their own identities within a larger world populated by individuals who they believe are like themselves. This is not to say that they are unaware of the belittling attitudes and structural burdens that indigenous people (and at times themselves and their neighbors; see below) experience in Oaxaca and elsewhere in Mexico. Rather, they actively focus on how indigeneity can be used for positive and productive goals and to generate feelings of belonging and self-confidence for themselves and their children.

Across town from the Garcías' large workshop, Agustín Flores spends his evenings painting carvings with his sister Alma in his father's small but esteemed workshop. In his early twenties, Agustín is of the first generation of Tileños for whom Oaxacan woodcarving has always been the livelihood of their community. While many plan to become artisans themselves, some others now aspire beyond the most apparent options of woodcarving or undocumented migration to the United States. During my research Agustín was studying for a university degree in languages in Oaxaca City and was the first member of his family to complete high school. While the Garcías situate themselves as Zapotec artisans within a generalized understanding of indigenous culture, Agustín expresses an indigeneity grounded in the particular history of Oaxaca through his participation in San Martín's Danza de la Pluma (Feather Dance). Like other Mexican "conquest dances," the Danza de la Pluma enacts a narrative of the arrival of the Spanish and their battles with the Aztec emperor Moctezuma. It is a physically demanding performance, in which young men wearing heavy traditional costumes and large feathered headdresses leap and pirouette in symmetrical and os-

cillating formations. When the full version is performed in San Martín for saints' feasts and other fiestas, it takes over three hours to complete. Agustín dances the role of Moctezuma, the central protagonist in the narrative, which also positions him as the de facto leader of the troupe. He takes his leadership role very seriously and often spends his free time researching the pre-Hispanic and colonial histories of Oaxaca and the Valles Centrales region at the university library and online. We often discussed what he called "microhistories of Spanish imperialism." Agustín said his interest in history was motivated by the dance itself rather than by any particular aspect of his university studies. While he found it interesting to learn about the indigenous history of San Martín intellectually, he explained that it was useful if only it could be actualized through cultural activity today.

The Danza de la Pluma is a highly visible symbol of indigeneity in Oaxaca. In official state and tourism representations it is understood as *the* traditional dance of the Valley Zapotecs and represents the Central Valleys region in the annual Guelaguetza Festival as well as on postcards, advertisements, fountains, and other public sites throughout the capital city. The official Guelaguetza has its roots in the 1932 celebration of the 400th anniversary of the founding of the city of Oaxaca (see the introduction). Today's celebration takes place for two weeks each July and consists of a number of events, including the annual selection of the *diosa centéotl* (corn goddess)— the young woman who best displays knowledge about her community's culture and traditions. The central attraction is the weekly performance of dances by delegations from communities throughout the state. These performances are attended by the governor, Oaxaca's cultural and political elite, and Mexican and international tourists. Performances must be authorized months in advance by the powerful Committee of Authenticity, which is made up of twelve anthropologists and folklorists who travel throughout the state to hold auditions. Their task is to ensure that "the delegations really present themselves with the authenticity and dignity of their ethnic group" (cited in Poole 2009:215).

One morning in March 2009 the Committee of Authenticity arrived in San Martín for the first time to judge whether the Tileño Danza de la Pluma was sufficiently authentic for the Guelaguetza. Before the performance began, Agustín gave a short presentation about what made San Martín's Danza de la Pluma both authentic and unique. He detailed certain aspects of the choreography that were not performed in other communities and emphasized that their dance was grounded in "real history." He presented the committee with his own Spanish translation of an archaeological report about the Tilcajete pre-Hispanic sites. While other versions of the dance presented

an inverted history that portrayed Moctezuma defeating the Europeans, the performance they were about to see told the true story of the conquest, showing how the Europeans defeated Moctezuma, an event that "created the foundation for contemporary Oaxacan culture." He explained that the battles between the Aztec and the Spanish were especially relevant to the particular history of the Central Valleys. When the Spanish arrived, the region was controlled by the Aztec Empire. According to Agustín, the people of the Central Valleys were uniquely the descendants of both Zapotec and Aztec cultures; this is why some place-names in the region derived from Nahuatl (the Aztec language) while others are Zapotec. After the speech, the dancers began a fifteen-minute arrangement of the key movements of the dance. After some deliberation, the Committee of Authenticity met with the dancers and their relatives to tell them that they had approved the Tileño Danza de la Pluma for the official Guelaguetza that year.

For the young dancers who make up the regional delegations, an invitation to dance at the Guelaguetza is "both an opportunity to pursue careers as cultural performers and a means to establish politically crucial ties to representatives of the Oaxacan state" (Poole 2009: 215). Indeed, since 2009 Agustín has actively become a part of the statewide community of cultural actors that includes Oaxacan government officials, intellectuals, dancers, and other cultural producers. Through his participation in this network, San Martín's dance troupe has been invited to perform at many other public and private cultural events in the capital and other locations in Oaxaca. It is no coincidence that Agustín's emphasis on particular historical pasts and genealogical connection is well received by the Oaxacan intellectual and social elite. His understanding of what constitutes indigeneity is both informed by and supports those perspectives that emphasize Oaxaca's distinct genealogical, aesthetic, and historical identity (Poole 2009: 213).

The Garcías' and Agustín's articulations of indigeneity not only are informed by their interactions with art collectors, tourists, university professors, and government officials but also are active attempts to recast the value of their cultural expressions into a value for themselves as people (cf. Bunten 2008). By cultivating modes of indigeneity that accord with the values at play within these economies of culture, they are able to take on and embody the characteristics that such powerful interlocutors recognize and respect. Their relatively secure economic situations mean that they do not often experience as many of the negative consequences of being an "Indian" in contemporary Oaxaca. Their interactions with consumers and Oaxaca's cultural elite allow them to view indigeneity as a potentially positive aesthetic project through which they can craft specific positions for themselves

within their larger social worlds. It is noteworthy that while Agustín and the Garcías find these expressions of indigeneity valuable and important for themselves, they make no determined attempts to engage other Tileños in their identity-crafting projects. In fact, as I address in the final section, the idiosyncratic nature of these projects also creates frictions between themselves and other actors in their social fields who read indigeneity in different ways.

Dissonances in Indigeneity

Approaching the Garcías' and Agustín's claims to indigeneity through the lens of aesthetic articulations makes it possible not only to analyze the productive forms and consequences of their identity projects but also to examine the differences and disagreements that they engender (Clifford 2001:479). Disagreements between individuals' conceptualizations of indigeneity work both to make and to unmake connections among different actors, networks, and ideologies of culture, as these disagreements can produce active reflections upon identities and the modes through which they are expressed.

In contrast to the more uncertain or even skeptical perspectives on indigeneity that I encountered among other Tileños, it might appear that the Garcías and Agustín were in general agreement about San Martín's indigenous heritage. However, while they concurred in the abstract that San Martín was an indigenous place, they disagreed directly about the content and meaning of this indigeneity. On the evening when Agustín's group auditioned for the Committee of Authenticity, I joined the Garcías for dinner. Miguel told me that Agustín had clearly impressed the judges, but he thought that the emphasis on the Aztec domination of the Zapotecs in sixteenth-century Oaxaca was neither appropriate nor important. "While each culture has its own history, all of us together make the indigenous heritage of Mexico. What is the point of confusing the issue? We should be proud to be a Zapotec community and leave it at that." Later the same week Agustín told me that Miguel had mentioned this concern to his father, but he resisted: "I understand that he wants to be proud of being Zapotec; I am proud too, but many of the things that he says about Zapotec culture can't even be proven!" While he thought that it made some sense to offer tourists simple explanations, there was no point in taking these explanations as truth for themselves. By denying that Tileños also had Aztec and even Spanish ancestors, Miguel was "missing the opportunity to really know himself."

Agustín was not the only one who felt doubtful about the way that the

Garcías drew on a generalized indigeneity in their crafting of identity. Certain knowledgeable outsiders often suggested to me that Miguel's expressions of indigenous belonging were "merely touristic performance." At a craft and ethnic art fair in the United States where Miguel and two other Tileño artisans were showing their work, I met an American woman named Ellen who had spent a number of years traveling to Oaxaca. On this occasion Miguel had worn *traje* and *huaraches*—traditional embroidered cotton clothing and leather sandals associated with indigenous groups in Oaxaca and Mexico more generally. Ellen asked me in a low voice what I thought of Miguel using Huichol traditional dress to sell his products.[6] I replied that I understood it was part of the costume that the young men from San Martín wear for the Danza de la Pluma. She replied that it certainly was not; she knew about the Danza de la Pluma from the time she spent in a weaving community that she described as a "real Zapotec village." When I suggested that perhaps San Martín's costume was different, she paused and said, "Maybe . . . but we both know Miguel doesn't speak Zapotec." Ellen was not the only person I encountered who questioned the authenticity of cultural claims made by artisans. A gallery owner in Oaxaca City told me that I should not believe any Tileños who claim to be indigenous: "They have lost all connection to their past." On another occasion a Oaxaca-based intellectual doubted Tileño artisans' suggestions that Oaxacan woodcarving might be connected to the earlier making of wooden utilitarian objects or toys through the skills involved. While we may want to critique the issues of power and expectations of cultural continuity evidenced by these skeptical observers (Harris 1995), they also underscore that indigeneity is not imagined to be a personal project of self-fashioning but rather an organic and collective expression of culture.

Despite their disagreements, Agustín and Miguel's (and even Ellen's) discordant visions of indigeneity should not be assumed to produce wholly oppositional positions. They are all engaged in identity projects that are generally compatible with touristic, Oaxacanist, and even nationalist understandings of indigeneity. The Garcías not only are important actors within the part of the woodcarvings' art world focused on the United States but also are well connected to powerful individuals and institutions in Oaxaca. Likewise, Agustín's involvement in his father's workshop and performances in Oaxaca City connect him to touristic understandings of indigenous culture.

Their articulations of indigeneity have been crafted through the logics, ideologies, and aesthetics of the state- and elite-sanctioned art world of Oaxacan woodcarving, which explains why they have not been conducive to

producing politicized identities or participation in larger social movements for indigenous rights in the region. In fact, the Garcías, Agustín, and the vast majority of other Tileños are strongly opposed to the frequent protests and blockades by civil society groups in Oaxaca City, including indigenous activists. As such, the aestheticized nature of these articulations in fact may produce "safe" indigenous identities from the perspective of the state and tourism industries. Charles Hale (2004) has described the *indio permitido* (authorized Indian), an apolitical indigenous subject actively produced through governance structures who works to support rather than challenge contemporary neoliberal policies that are generally at odds with indigenous peoples' goals of empowerment or autonomy.

It is also important to emphasize that, while Agustín and the Garcías can actively create their own particular imaginaries of indigeneity, identity can never be entirely removed from the larger social world in which it takes place. Historical and contemporary structures of race and racism in Oaxaca always frame articulations of indigeneity, even when they are made largely through aesthetic or positively valued formations. Ronda Brulotte has described how makers and vendors of replicas of archaeological artifacts in Arrazola, the "birthplace" of Oaxacan woodcarving, play with identity concepts in those ambiguous social spaces that "mark and unmark them as indigenous" (Brulotte 2009:459). By stating *soy nativo de aquí* (I am native here), rather than directly claiming indigenous ethnicity, vendors attempt to manage the expectations of interlocutors from a variety of backgrounds as to what it means to be indigenous. She links this ambiguity to the "tense dynamics of being categorized by others [while] seeking to define themselves within and against indigeneity's dense web of symbols, fantasies, and meanings" (Brulotte 2009:459).

Surprisingly (or perhaps not), two artisans recounted to me a story that was also told to Brulotte by her research participants (ibid.:469). Several years ago some artisans from Oaxaca had been invited to a FONART craft exhibition in Mexico City. Much to their surprise when they arrived at the hotel where their rooms had been booked by the exhibition's organizers, however, they found they had been assigned rooms with no beds. Like Brulotte's informant, my research participants interpreted this situation as a humiliating example of being treated like an *indio*, who always sleeps on *tapetes* (woven mats) on the ground. One Tileño artisan noted that the next day he met some sculptors from the city of Puebla and discovered that they had been given normal hotel rooms with beds. Moments such as these, which artisans recall with such clarity years later, are telling. Although newer dynamics of cultural tourism in Oaxaca have inspired peo-

ple like Miguel and Agustín to use their claims to indigeneity as a grounding for positive identification and self-confidence, these processes come up against very real and often negative interpretations of what it means to be indigenous in contemporary Mexico. Less dramatically, the artisans I worked with often experienced negative interactions in their day-to-day lives with urban Oaxacans who treated rural dwellers poorly (cf. Cook and Joo 1995:36). Catalina García told me that she refused to shop at the fanciest department store in Oaxaca City because, as she put it, "although I can afford to buy their nice things, the staff members take one look at my *morena* [dark] face, and assume that I shouldn't be there."

As I was sitting with Catalina in the Garcías' painting workshop on another occasion, she took a phone call from a client in Mexico City who had commissioned an expensive carving of Juan Diego, the indigenous peasant who witnessed the miracle of the Virgin of Guadalupe. Catalina had emailed the client a photograph of the piece as it was being painted so that she could find out what kind of colors to paint on his sarape (the cloak where the image of the Virgin appeared). After a moment, Catalina held her hand up in the air for silence in the workshop then put the call on speakerphone. The client was explaining that Juan Diego's skin was painted much too dark. She wanted it repainted in a lighter tone before the piece was shipped. After hanging up the phone, Catalina looked very unhappy. "What can I do? This customer has paid a lot of money to commission a piece, and we always try to deliver what the customer wants." Catalina took the piece from the young woman who had been painting it, saying that she would rather finish it herself, so that she could reflect on what the woman had said.

Tileño artisans also encounter difficult moments during the course of their work-related outings in Oaxaca City. When I accompanied artisans to speak to state employees in their offices, I was occasionally surprised by the bureaucrats' insistence on using the familiar *tu* form of speech, when their respective ages and lack of close social or familial ties would normally have occasioned the formal *usted*. I once asked Rufino, with whom his children and neighbors always used *usted*, how he felt about this. He said, "You know, these *licenciados* have so much education, yet they don't have any education at all [*no tienen nada de educación*]."[7] Rufino was playing with the phrase "being educated," as in having gone to school, and the Spanish phrase for "having education": having good manners. He mused that they probably spoke to him that way because he was "just an artisan."

Anthropological research on indigeneity in Mexico and Latin America more generally has approached the topic from a wide variety of angles. Many authors have usefully interrogated the processes through which the

category "indigenous" is produced, ascribed, and enacted through intersecting logics of race, ethnicity, class, and gender, to name a few. While this research has led to important insights about the variability of indigenous experiences today, the expressions of indigeneity that I encountered in my fieldwork did not fit so comfortably within these frames. In particular, the seemingly cultivated and individualized nature of these expressions made it difficult to analyze them in terms of ethnicity. They are not shared by everyone in San Martín or uncontested by other actors in their social worlds. The obvious connection between cultural tourism and new expressions of indigenous identities at times provokes anxieties for locals, tourists, and researchers about their authenticity and durability. These anxieties are not incidental to the question of how economies of culture produce value, as they often appear precisely where monetary value is most overtly attached to a subaltern identity, inverting the usual hierarchies of respect and wealth.

In order to analyze these complex situations as a whole, it is productive to consider in what ways different actors articulate indigeneity and how those articulations map onto the economic and ideological worlds in which people live and work. I have shown that the Garcías' and Agustín Flores's explicit and deliberate articulations of indigeneity produce and reinforce social, economic, and aesthetic connections to important people within the economies of culture in which Oaxacan woodcarvings circulate: North American consumers of ethnic art and Oaxacan political and cultural elites. These connections not only are formed through practices of performance and speech but also are purposefully crafted through the material and aesthetic practices that are involved in woodcarving, dance, and other cultural expressions.

Widening the scope of articulation theory to aesthetic and material practices offers anthropologists an opportunity to address the intricate and multifaceted ways that identities are produced and transformed over time and by different actors within a given context. Paying attention to aesthetic articulations, in addition to verbal articulations, also allows an analytical focus on the multiplicity of things that indigeneity *does* in particular social fields, rather than limiting analysis to interpretations that focus purely on meanings or motives. While aesthetic and material practices are one way that people can purposefully make and remake identities for themselves, they will always be grounded within the larger structures that categorize groups and individuals according to the logics of ethnic and social identities already at play. As such, it is essential that analyses of aesthetic and material articulations are always viewed in relation to the historical, social, and political processes that produce them. Indeed, one of the strengths of ap-

proaching indigeneity through aesthetic and material practices is that it can account for individuals' assertions and disagreements without losing sight of what allowed these engagements in the first place. The disagreements about indigeneity and belonging in San Martín Tilcajete mirror the ambiguity that characterizes many aspects of woodcarving as a practice, vocation, and livelihood, as I have shown in earlier chapters.

Notes

1. This emphasis on diversity has not precluded the development of racial or regional hierarchies (Poole 2009).

2. Since 1993 archaeologists from the University of Michigan have been excavating the "Cerro Tilcajete" sites (see Elson 2007).

3. San Martín Tilcajete is officially classified as a municipality with a "scattered indigenous population" because less than 40 percent of Tileños live in households where a direct relative speaks an indigenous language (CDI 2010).

4. According to research participants, *guelaguetza* is significantly less formal than it was twenty years ago and diverges from the stricter exchange reckoning reported by Cohen (1999).

5. At least in Field's own interpretation: one of the most challenging, but creative, aspects of his text is that it juxtaposes his ideas with those of his partial co-author, the local intellectual Flavio Gamboa.

6. The Huichol or Wixáritari are an indigenous group from west-central Mexico.

7. *Licenciados* are people with undergraduate degrees; used as a term of address, like "Doctor" or "Professor" in English.

CHAPTER 6

The Allure of Art and Intellectual Property

When El Americano arrived in San Martín Tilcajete in the autumn of 2007 with the resin replicas of Oaxacan woodcarvings that he had made, they provoked palpable, almost physical reactions from the Garcías and many of their neighbors (see the introduction).[1] Made in China and trademarked as "InSpiriters," these figures were cast from five original Oaxacan woodcarvings and came nestled in expensive, satin-lined boxes. When I first saw them myself, I felt a mixture of anger and confusion: anger that a person who presumably enjoyed more favorable life chances than most of the artisans I knew would so callously exploit them; confusion about why anyone would want to own these resin casts, which struck me as gaudy and lacked the delicacy and tactility of the originals.

Yet Antonio's question continued to linger: why *did* the resin copies provoke such strong reactions from artisans in San Martín and the other Oaxacan woodcarving villages? As I discuss below, the copies genuinely seemed to pose no economic or cultural threat. Journalists and government officials at the time argued that Oaxacans' creative expressions were being poached and sold en masse, undermining the market for the "real thing" and committing the morally charged offense of cultural appropriation, an accusation central to many disputes involving indigenous and minority groups today (Coleman 2004; Coombe 1998; Geismar 2005; Tan 2013). Indeed, the anxieties that I described in the first few pages of this book were palpable for many months after the copies came to light. Artisans spent a lot of time and energy that might have been used promoting their own work to organize a collective response to the situation.

Some readers will agree with my initial reaction: people whose livelihoods depend on the perception that their works are both authentic and unique naturally would be disquieted by the appearance of industrially pro-

duced figures that mimic their own. In many ways, this interpretation is correct: the desire to protect the styles and designs of Oaxacan woodcarving is a logical position, as artisans themselves have very little control over what happens to the carvings once they leave their workshops. While my research participants were sincerely concerned about the industrial replication of their work, however, Antonio's question forced me to consider what else claims to intellectual property (IP) might be doing in Oaxaca. Rather than relying on generalized economic or culturalist explanations of artisans' appeals for intellectual property protection, in this final chapter I suggest that local appeals to IP must be understood within the broader aesthetic practices and conditions of competition within the Oaxacan woodcarvings' art world that I have described and analyzed throughout this book.

Tileño artisans have become accustomed to working in the registers of different economies of culture. Depending on context and the people with whom they are speaking, individuals may describe their work as examples of "traditional culture" or "individual creativity." While this situation allows artisans to position themselves in creative ways and to take advantage of different opportunities, it also generates conceptual dislocations whereby the recognition of authorship and the rules of the game seem to change without notice and success and failure seem capricious. Miguel and Catalina García most acutely embody this ambivalence, not only because they are the most successful, but also because their work aesthetically deviates from the older, established genre of Oaxacan woodcarving.

As I discussed in chapter 4, the Garcías' success has been largely built upon their ability to position themselves between two different economies of culture that are at play within the art world of Oaxacan woodcarving. Their work now draws on the aesthetic expectations of Americans and Canadians about "indigenous art," using colors, styles, and forms that signal indigeneity to those consumers. At the same time, they symbolically connect their work and themselves to a reified, even romantic, notion of "Zapotec culture" (cf. Wood 2008:105–114). This has allowed them simultaneously to tap into the aesthetic imaginaries that adhere to nationally held notions of *artesanías* by Mexican audiences and Canadian and American expectations of indigenous art.

In connecting the ethnicized aesthetics of indigenous art to the field of Oaxacan woodcarvings as *artesanías*, the Garcías have not only produced economic value for their own work. They have also opened up the field of Oaxacan woodcarving to an entirely new art world, with its own norms, expectations, and "currencies." This shift now affects *all* Oaxacan woodcarvers, as artisans themselves do not have the ability to choose when and how

consumers encounter and interpret their work. As I discussed in chapter 1, viewers' own expectations and intentions dramatically affect the ways in which they understand works of art. This is particularly so in cases where the balance of financial and cultural capital places consumers in a position of power vis-à-vis artisans. However, viewers are also not autonomous in their interpretations. The allure of ethnic art is grounded precisely in the idea that it is the product of a distinct group of people with their own culture and that this culture has *distinctive content* (Comaroff and Comaroff 2009:8–21; Errington 1998:118–155; Townsend-Gault 2004). For the increasing number of consumers who engage with the woodcarvings as ethnic art, what the woodcarvings mean, their desirability, and their allure are no longer wholly about their beauty, their Mexicanness, or the individual artists who make them. Rather, they are contingent upon the fact that woodcarvings can be seen as true representations and distillations of Zapotec culture into an expressive and meaningful object.

This newer perspective that sees Oaxacan woodcarving as a genre of ethnic art also therefore imports particular understandings of legitimate authorship. Where the aesthetics of Mexican *artesanías* are generally open to use by anyone—or at least anyone with a connection to Mexico (Bakewell 1995)—ethnic art is understood to be legitimately produced *only* by members of the ethnic group (Coleman 2004; Myers 2005). This not only creates the potential for boundary-making between authorized and illicit cultural producers but also reframes particular stylistic and aesthetic forms as "cultural properties" that are collectively held by members of the ethnic group (Coombe 1998:208–247). While this may be relatively unproblematic in situations where people use cultural objects collectively (for example, for religious purposes), it becomes distinctly fraught with difficulty where shared culture is the basis for individual economic activities.

This tension between perceived collective culture and a desire for individual gains is a common feature of "cultural assets": commodities like Oaxacan woodcarvings that are simultaneously claimed to be marketable yet have special cultural value for communities of producers and the nation-states that promote and seek to protect them. Crucially, for something to become a cultural asset, it not only must be embedded in local expressions of tradition or culture but also must be to some degree "enclosable": it must be possible to limit production or trade only to recognized "insiders" (Colloredo-Mansfeld 2011:54–58).

When the Union of Woodcarver-Producers of Alebrijes and Animal Spirit Carvings of Oaxaca was established in April 2008, enclosure was the ultimate goal. However, the use of IP frameworks to respond to the indus-

trial replicas in this case proved to be problematic. Artisans hold very different expectations about the rights of authors than those enshrined in IP principles and legislation. I argue that the artisans' hopes for the collective trademark actually indicate that they were primarily anxious about relations among local producers themselves, rather than being seriously concerned about the resin copies. These anxieties were caused by artisans' uneven abilities to master the emergence of the complex and often contradictory relationships among the established logics of the tourism and *artesanías* economies of culture and the aesthetic expectations and new forms of meaning and value projected onto their work by the world of ethnic art.

The local, national, and international economies of culture at play in Oaxaca therefore place Oaxacan woodcarvings in a field of contrasting interpretations of what they are and mean. From the perspective of the consumer and, indeed, the art object itself, this is generally not an issue: this instability is an inherent characteristic of works of art, which always shift their meanings and roles depending on context and mode of "encounter" (see chapter 1). For the producers who depend on them for their livelihoods, however, this seeming restlessness can be frustrating and understandably causes concern. A single carving can simultaneously be viewed as an individual work of art, an indigenous artifact, and a piece of traditional Mexican craftwork, which contributes to the complex formations of value that surround these objects. The shift toward viewing Oaxacan woodcarvings as ethnic art connects the monetary value of the carvings to the cultural authenticity of the maker. But artisans are also encouraged by these same processes to adopt the outlook of the cultural entrepreneur who uses culture as a resource to compete for individual rights of authorship and personalized success with neighbors (Comaroff and Comaroff 2009; DeHart 2010).

What Does Intellectual Property Do?

The blending of these two ideologies of "extraordinary authentic culture" and "commonsense entrepreneurship" underwrites contemporary forms of neoliberal multiculturalism that characterize current relations of states, citizens, and markets around the world (Gershon 2011; Hale 2005). Neoliberal multiculturalism profoundly transforms the relationship between people and their cultural identities by recasting groups and individuals as the *owners* of culture and thus annexes liberal concepts of property and rights into lived cultural practices, all the while producing economic value at the boundaries of cultural difference (Comaroff and Comaroff 2009; Coombe

1998; Gershon 2011:539–543; Myers 2001). This cultural propertization has taken place in tandem with the extension of intellectual property (IP) law both industrially and geographically. It has become a powerful tool that states and international institutions promote to regulate the increasingly lucrative immaterial aspects of capitalist production. Through IP, the intellectual or creative elements of products are legally separated from their material forms, creating new possibilities for ownership and the production of value (May 2010:49–58).

This separation has been analytically productive for anthropologists. Haidy Geismar (2013), James Leach (2008), and Marilyn Strathern (1999, 2001), among others, have used IP to interrogate how different understandings of property mediate the social and material relations that surround them. Conversely, others have focused on how technologies of mass reproduction and distribution have led to a proliferation of replica consumer goods that push both IP and local engagement with "originals" and "fakes" in novel directions (Newell 2013; Sylvanus 2016; Taylor 1999; Thomas 2013). In Latin America in particular, scholars have explored the intimate relations between "piracy" and the production of illegality, interrogating how IP reconfigures citizenship, subjectivities, and morality under the unstable conditions of the region's neoliberalizing states (Dent 2012). IP often becomes a tool through which heavy-handed states use neoliberalist frameworks to assert further control, whether in the context of "wars on piracy" or the formalization of hitherto informal but lucrative economic relations (Aguiar 2013; Bowen and Gaytán 2012; Thomas 2013).

IP's advancement has also challenged anthropologists who work with artists and craftspeople, as it actively produces regimes of authorship that may or may not accord with local understandings or practices (Aragon 2011, 2014; Brown 2003; Geismar 2005). As I discuss below, the authorship concept as enshrined in IP presumes a clear relationship between a recognizable author and the products that he creates, which forms the foundation of the author's rights in those products. This presumption engages core debates within the anthropology of art, in particular the recognition and production of authenticity, which is itself a discourse about legitimate versus illegitimate production. As authenticity and its related forms of value are increasingly marked by legal recognitions of IP, it now has real consequences for *all* artistic producers, including those who do not directly engage with it (Myers 2005).

Anthropologists can thus be said to approach IP as an analytical "place of condensation," a term used by Jesús Martín-Barbero (2000:28) to visualize culture industries as complex spaces where legal, technological, mer-

cantile, and political processes are tightly entwined, "condensing" their individual features into a consequential aggregate and making visible their collective synergies. Likewise, within anthropology, IP has become a conceptual space in which the collusive logics of property, nationalism, capitalism, and neoliberalism more generally are analytically connected and can be rendered visible (cf. Hirsch 2010). The expansion of IP thus offers anthropologists a useful lens through which the subtleties of artistic economic life can be refracted and teased apart, while at the same time casting light on the new puzzles and predicaments that arise within cultural economies.

Indeed, one key element for understanding Tileños' strong reactions to the discovery of the industrial replicas is common to all economies of culture: the intense competition in Oaxaca has created new and marked hierarchies among producers of ostensibly traditional material culture. As I addressed in chapter 4, in San Martín Tilcajete these hierarchies are largely due to unequal access to knowledge about what different kinds of consumers think Oaxacan woodcarvings *should* look like. Miguel and Catalina García have deliberately cultivated their work to appeal to these perspectives, while other artisans are unable to make the same aesthetic moves. I suggest that the appearance of the industrial replicas threatened an already unstable matrix of cultural expression, by hinting that foreigners may be able to replicate the appeal of successful Oaxacan artisans' work.

From this point of departure, the central argument of this chapter—and indeed my answer to Antonio—proceeds along two interconnecting paths. First, drawing on theoretical perspectives elaborated by Walter Benjamin and Mario Biagioli, I argue that the resin replicas provoked anxieties for artisans not because their rights were violated per se but because they called into question the anticipated relationship between authorship and the desirability of works of art (see chapter 1). In an unpredictable economy in which aesthetic authority seems unevenly distributed among local producers, the collective trademark's allusion to shared identity and authorship chiefly references anxieties *within* the community about the desirability of Oaxacan woodcarvings.

As we have seen, the ways in which Oaxacan artisans position their work in order to enhance its appeal are complex and diverse. Rather than concentrating on how these practices relate to touristic configurations of authenticity, I argue that desirability must be understood in relation to the authority of the woodcarvings *as art objects*, which can be theorized via Benjamin's concept of the "aura" of works of art (see chapter 1). Benjamin's aura is a useful device here because it points both to the enigmatic allure of artworks and to the way this allure is intimately connected to the viewer's own under-

standing of the art object. This is particularly useful in San Martín Tilcajete, because consumers of Oaxacan woodcarvings are by no means a homogeneous group. While some see the carvings as characteristic of Mexican popular culture, others read them as Native American art, while still others are more interested in how the carvings may represent their own personal experiences or attributes.

Second, I argue that anxieties about industrial replicas reflect and heighten ambivalent positions within globalized art worlds and that the artisans turned to intellectual property in order to clarify the artistic and economic processes that they work within when making and marketing Oaxacan woodcarvings. I suggest that artisans, like anthropologists, view IP as a "place of condensation" that may help to illuminate uncertain relations and possibly offer solutions to larger issues than the specific case at hand. In answering Antonio's question "why do they care?" this book provides an illuminating explanation of how hierarchies and uncertainties are formed and negotiated in response to particular art-world configurations. In connecting these processes to aesthetic practices and the enduring allure of art, my analysis also suggests that the agentive qualities of art and craft objects themselves offer ways of conceptualizing popular engagements with discourses of intellectual property.

Desiring Intellectual Property in Mexico

Concerns about copying are now a pervasive theme in the global economy, where the branding or identity of products can be of greater value than the actual commodity itself (Foster 2007). In response, intellectual property has also become a concern for actors and analysts concerned with the economic, social, and legal consequences of globalization and neoliberal transformation in recent decades. The laws and language of intellectual and cultural property are globally extended through international bodies such as the World Trade Organization (WTO) and the United Nations (UN), which use carrot-and-stick approaches like the Agreement on Trade-Related Aspects of Intellectual Property Rights (TRIPS) to encourage national governments to enact strong IP legislation (Bowen 2010; Matthews 2002; May and Sell 2006:176–194).

National governments have responded to this pressure by passing stricter IP laws and encouraging individuals and companies to register their work through patents and trademarks. With encouragement from the UN's World Intellectual Property Organization (WIPO), many nations have also sought

to extend protection to artistic, expressive, and cultural activities, which have become enshrined in international parlance as "traditional knowledge" and "traditional cultural expressions" (Aragon 2014; May and Sell 2006:194–198; cf. WIPO 2004:1–3). Not coincidentally, these attempts have come at a moment when both development and business circles are placing a new emphasis on the "knowledge economy" and the "information society," key concepts promoted by international development institutions (Chan 2011:91).

Mexico has wholeheartedly embarked on the process of consolidating IP laws, at the same time as it has shifted toward neoliberalism. Despite apparent political differences, successive Mexican governments have increasingly consolidated IP in the context of larger political and economic change. In 1991 President Carlos Salinas de Gortari signed the Law of Industrial Property, aligning Mexico with the requirements of the North American Free Trade Agreement and the WTO's current General Agreement on Tariffs and Trade (GATT). This formalization of IP in Mexican law accompanied many other neoliberal reforms, including fundamental changes in land distribution programs and the privatization of many public industries (Hayden 2003:87–90). In 1997 President Ernesto Zedillo augmented the Law of Industrial Property by criminalizing certain copyright violations and by establishing two federal agencies responsible for enforcement and regulation: Instituto Nacional del Derecho de Autor (INDAUTOR, the National Copyright Institute) and Instituto Mexicano de la Propriedad Industrial (IMPI, the Mexican Institute for Industrial Property) (Smith 1998).

Since 2000 the governments of both Vicente Fox and Felipe Calderón have further strengthened IP enforcement, partially by positioning it as a weapon against organized crime. Pressure from the United States has led to more concerns over the production of goods in Mexico that do not respect the IP rights of multinational and American corporations, such as the distribution of pirated DVDs. Empirical research indicates that production and marketing of these counterfeit media products are primarily run through loose family networks unrelated to the cartels or gangs (Aguiar 2010, 2013; Cross 2011:306). However, politicians and the popular media continue to link pirated DVDs to the activities of the major crime organizations.

Through such political processes, IP has also become entwined with the long-standing and pervasive ideologies of Mexican national patrimony. Public and media articulations of heritage in Mexico are now frequently expressed in the idiom of IP, often resulting in the relocation of formerly public spaces and objects to the sphere of commercialization (Breglia 2006:31–35; Colloredo-Mansfeld 2011; Hayden 2003:87–90; Scher 2010). During my fieldwork, stories in the media about issues such as the confiscation of handmade piñatas by American border agents because they represented char-

acters held under copyright by Disney and other American firms led some Tileño artisans to distrust intellectual property regimes that they felt were changing the rules of artisanal production to the benefit of foreigners (see Nájar 2010).

At the same time, the Oaxacan state has become increasingly concerned with foreign goods that are passed off as locally made. The most common "trespassers" are textiles made in Guatemala. Because of the high-profile stories of intellectual property working against Mexicans, it also seems to offer the possibility of protecting Oaxacan culture. The federal state also currently directs a tremendous amount of resources toward putting IP into practice and often works with the WIPO to educate cultural producers about the benefits of registering their work. Artisans in San Martín Tilcajete are encouraged in government-sponsored training sessions to register their individual workshops as private companies with formally established trademarks. Although only a few artisans have taken the steps to do so, the language of intellectual property is now commonplace among producers. One artisan often told me that he was very happy since registering his company, because he believed it will allow him to pass on his styles and rights to his children. He also saw his personal registered trademark as a tool through which he could discourage his neighbors from copying his styles. This point was emphasized by the government instructor, although he offered no practical advice on how to do it.

By the time El Americano's InSpiriter replicas were discovered in Oaxaca, FONART and the Secretariat of Economy had signed an agreement on active registration of collective trademarks for *artesanías* (FONART 2012). Twenty-four different collective trademark programs have been established for Mexican artisanal products since 2004, like guitars and embroidered textiles from Guerrero and Puebla's Talavera pottery (FONART 2012, 2016). The FONART and ARIPO representatives that the artisans originally approached for support assured them that it would be easy to replicate these experiences and that it was a worthwhile project to pursue.

For the officials who work in ARIPO, the discovery of the InSpiriters was yet another example of Oaxacan culture being appropriated by foreigners. As discussed in chapter 4, ARIPO representatives view the woodcarvings as authentic and desirable expressions of Oaxacan culture. The genuineness of woodcarvings is amplified for the bureaucrats through their central role in the ongoing production of the Mexican nation through their work in the cultural institutions of the state. The discourses that positioned *artesanías* at the heart of Mexican nationalism in the twentieth century continue to inform government practices and ideologies today. In an interview with a senior official at ARIPO, I was told that any affront to the craftwork of Oaxaca

was simultaneously an offense to the Mexican nation. He explained that "the designs and symbols of the Oaxacan woodcarvings are the patrimony of authentic Oaxaca" and that "the state is obliged to fight to legally protect them from [pirating]."

Despite ARIPO's assertions of appropriation, the state's reaction to the discovery of the InSpiriter replicas is more complicated than the "cultural appropriation" reading suggests. In the summer of 2009 newspaper stands in Oaxaca were selling plastic toys for children called "*Alebrijes*: Impossible Animals," produced by Televisa, Mexico's largest media corporation. Santo Domingo Animation also produced a children's animated film in 2010 called *Brijes 3D* in which children discover their animal spirits while reading a pre-Hispanic codex in a museum (as I discuss in the conclusion, the 2017 film *Coco* by Disney-Pixar is another recent iteration of the commercialized representation of *alebrijes*).

Although the executive committee of the Union of Woodcarver-Producers of Alebrijes and Animal Spirit Carvings of Oaxaca presented ARIPO with examples of the Televisa *alebrije* toys, the state representatives were seemingly unconcerned about these products and remained focused on the InSpiriters. Over time, it became clear to me that the state's strong reactions were directed more toward foreigners replicating *Mexican* cultural forms than toward protecting established cultural producers' rights to their own work. The fact that the InSpiriters were made in China was particularly outrageous from ARIPO's point of view: although an American businessman profited from the production of the resin figures, being made in China was often highlighted as the most important point of the case in government statements to the media.

Mexico's economic relationship with Chinese industrial development is of great concern for the state. China overtook Mexico as the leading source of imports into the United States in 2003, while it exports approximately 33 billion USD worth of goods to Mexico annually (Godoy 2010). This loss of primacy in exports to the United States is often attributed in the popular press to unfair labor practices in China ("México, inconforme por restricción de China a exportaciones" 2009; cf. Gallagher and Porzecanski 2010; Sylvanus 2016:109–140). From the perspective of the state, the factory copies simultaneously represent a cultural affront to the uniqueness of Mexican *artesanías*, a key ingredient of Mexican national belonging, and also touch a nerve about Mexico's position vis-à-vis China in the current global economy.

The concern with China was made particularly apparent at a conference in Oaxaca City in 2009, where artisans from all of Oaxaca's craft-producing villages could attend talks by experts in intellectual property and marketing from IMPI and the WIPO. The two-day event was held in Oaxaca

City's Camino Real hotel, which occupies the former convent of Santa Catalina, which was built in 1576 and remains a central landmark in the city's UNESCO-protected historical center. During the closing remarks given by an IMPI director, he accidentally knocked one of the InSpiriter figures against the wall of the historic building. In a voice of feigned concern, he explained, "Oh! I don't want to *enchinar* this sacred place." The audience erupted in laughter. The official was playing on the similarity between *enchinar*, which in this context could mean "to make Chinese," and *enchingar* (to fuck up), a joke that my artisan friends gleefully repeated many times that afternoon.[2]

The contrast between the state's palpable concerns about the InSpiriters and indifference to the children's toys and the animated film, which both also used the name and aesthetics of Oaxacan woodcarving without any recognition or restitution to Oaxacan artisans, makes it clear that the concerns of these state employees mainly stemmed from the use of cultural patrimony by non-Mexicans as opposed to its potentially unfair use within Mexico's borders. As the woodcarvings have now been incorporated into the national imaginary as *artesanías*, they embody the value and uniqueness of Mexico as a nation for the state representatives, whose jobs it is to promote them as such.

The carvings themselves draw on many recognizable symbols and motifs that have circulated for generations in popular art from all over Mexico, which makes them even more apt as symbols of Mexico, invoking the nation as a unified cultural space. Copies made outside of the country therefore posed a great threat to the aura of the woodcarvings as authentic products of the Mexican nation. It raised the possibility that these symbols, and perhaps other national symbols as well, could be made to signify something other than Mexican authenticity and belonging, revealing once again that the aura of the woodcarvings might not be as stable as their audiences would like them to be. This instability could generate anxieties about the value of the work that the officials do in their daily lives and quite obviously combined in a meaningful way with the already existing tensions in regard to China evident in the media. When the artisans approached ARIPO for help, it is not surprising that the government took on the task wholeheartedly and with much fanfare.

InSpiriters and the Collective Trademark Union

When the possibility of a collective trademark for Oaxacan woodcarvings was initially proposed, artisans received much support and encouragement

from ARIPO and the federal agencies discussed above. In the course of three meetings in 2008 and 2009, the union's executive committee, made up of representatives from all three main Oaxacan woodcarving villages, negotiated the terms by which individuals could join the union and use the collective trademark. In the collective trademark's rules of use, which were distributed to artisans who attended union meetings, the stated objective was "to develop and register a collective trademark, denomination of origin, or any other national or international judicial form of commercial or intellectual protection, that has the objective of the protection, preservation, development, and promotion of the techniques of [Oaxacan] woodcarvings."

While many indigenous and minority groups may turn to IP in attempts to prevent the use of their culture by outsiders, it is worth noting here that the underlying reasoning of IP law stands in direct contradiction to the mobilization of rights in this way. IP was not developed to prevent the reproduction and circulation of images or ideas but to guarantee that authors receive fair compensation for their use (Brown 2003:59–61; Coombe 1998:77–78, 86, 169; Merlan 2005). While the logics of IP do not readily provide the protection that indigenous and minority groups seek, as Rosemary Coombe (1998:174–207; cf. Noble 2007) wryly observes, property-oriented claims are often more persuasive to the public and judiciaries than assertions of cultural or emotional injury, which often makes IP seem the more pragmatic choice.

Notwithstanding the conceptual complications involved in trying to trademark culture, the InSpiriter industrial replicas are troublesome even if one takes a favorable perspective on the possibilities of IP protection. It is worth noting the legal and practical difficulties that the collective trademark faced when responding to the InSpiriter replicas.[3] Collective trademarks are not intended to protect the content of works. Instead, they are arranged in order to identify products as the work of a member of a particular organization, which ostensibly guarantees certain levels of quality, geographical provenance, or other characteristics determined by the organization itself. What is protected is the use of the trademark's sign, name, or logo, *not the intellectual or aesthetic content of the objects to which it pertains.* Thus, the value of a trademark is its power to "persuade consumers to consume a particular iteration of something that might be more generally available" (Leach 2008:337; cf. Brown 2003:55–59, 74–76; Coombe 1998:169–170). Even if the Oaxacan woodcarvings were protected under more robust IP frameworks such as copyright, however, it is doubtful that the InSpiriters would be considered a legal violation, because it is unlikely that consumers could confuse them with Oaxacan woodcarvings. While the resin figures are visually similar to the woodcarvings that served as their prototypes, the

significant material and marketing differences between the resin figures and the carvings underscore Antonio's bewilderment about the artisans' reaction and render the collective trademark relatively impotent.[4]

Oaxacan woodcarvings are produced from copal, a softwood common to the arid regions of southern Mexico. Although it is moist and pliable when freshly cut, copal is brittle and extremely lightweight when dry, giving the woodcarvings a distinctively delicate, hollow-like quality. Once dry, the wood can be sanded to a very smooth finish that provides an ideal surface for the delicate application of paint. Smoothness in carving and painting are valued as indicators of quality by both artisans and buyers alike (see chapter 2). In contrast, the InSpiriters are made from an industrial polyresin compound that can be cast into molds, which in this case were produced from the original woodcarvings that El Americano purchased in 2006. The figures are surprisingly heavy and have a waxy, synthetic texture to them. Because their design details are cast during the pouring of the resin, the decorative patterns feel raised on the surface, giving texture to each piece (plate 11).

In addition to these material variances, there are significant differences in how and to whom the objects are marketed. Nowhere on the InSpiriters' website or accompanying leaflet is any claim to be Oaxacan, Zapotec, or even Mexican. They also do not explicitly make claims to "indigeneity." They are not produced by members of a recognized American Indian tribe, so under the US Indian Arts and Crafts Act (DOI 1990) they legally cannot claim or suggest that they are made by Native Americans (Wood 2001b, 2008:96). Instead, they rely on a generalized Native American aesthetic, using what Michael Brown (2003:89; cf. Tiffany 2006:139) refers to as the "look and feel of indigenous cultural products." InSpiriters are marketed to two distinct but overlapping groups of consumers: North American New Age spiritualists and purchasers of what may be called "giftware," industrially produced objects sold in gift and greeting card shops. Drawing on New Age interpretations of Native American spirituality, the InSpiriters' website indicated that each animal form carries special attributes that can be matched to the customer's personality and spiritual needs (the armadillo was said to help with setting personal boundaries; the ram represented determination).[5]

Like the aesthetics of ethnic art to which Miguel and Catalina and increasingly other Tileños appeal, these objects draw on the discursive and aesthetic markers of North America's "circulating aboriginality," through which repetitive images of the peoples and cultures of the Pacific Northwest, the Great Plains, and the American Southwest come not only to symbolize Native American peoples but also to metonymically represent North

American landscapes and nations in general (Graburn 2004:144). At the same time, this circulation of aboriginality makes the symbols of Native Americanness inconspicuous by subtly infusing the everyday material lives of both indigenous and nonindigenous national subjects with indigenous-like aesthetic forms (Townsend-Gault 2004:187–188). As a result, even the aesthetic products of specific Native American cultures come to be "scaled up" to a level so generalized they are read only as "difference," in the same way that "ethnic art" commodities and markets materialize all forms of difference as representations of the "exotic" (Errington 1998:98).

In view of this, the consumers of the woodcarvings are distinctly different from those who purchase the InSpiriter factory figures, making it very unlikely that the resin copies are actually competing economically with the Oaxacan woodcarvings at all. Although media and everyday explanations of the replicas argued that they threatened Oaxacan livelihoods and culture, these material and marketing differences between the InSpiriters and Oaxacan woodcarvings show that the copies posed no immediate threat to the cultural or economic well-being of Oaxacan artisans and were not legally censurable from the perspective of IP law. In the final section of the chapter I return to my earlier suggestion that the InSpiriters provoked a reaction from the artisans not because of the direct threat they posed but because they exposed particular local ambiguities about authorship and the desirability of Oaxacan woodcarvings.

Aura: The Allure of Art and Intellectual Property

Although the collective trademark mobilized discourses of IP as a way to address the InSpiriters, in fact this case offers a good example of what Mario Biagioli (2014:66) has identified as a frequent problem in commonsense understandings of intellectual property: *plagiarism* is often confused with copyright violation (cf. Litman 1991).[6] Biagioli argues that such cases provoke strong emotional reactions because plagiarism involves not only the unauthorized copying of a work ("piracy") but also the displacement or denial of authorship. In examining the intimate conceptual connections between Western ideologies of authorship and parenthood, he argues:

> Copyright's notion of copy and plagiarism's notion of appropriation are significantly different, and not only because the former concerns objects while the latter focuses on relations. The difference may in fact be traceable to the specific location where the plagiarist inserts himself in the chain of autho-

rial agency. Piracy operates downstream, affecting the production, circulation and sale of some copies of the work. Instead, because the author is construed as the origin of the work, the name swap performed by the plagiarist has the effect of appropriating the whole work . . . it is the scale of the appropriation resulting from the name swap that makes plagiarism feel "personal": not so much the symbolic affront of seeing your name erased and substituted with that of somebody else, but the fact that, through that simple elision, you have indeed lost your whole work. (2014:69–70)

Biagioli focuses on the author's affective experience of erasure and how acts of plagiarism fundamentally call into question the expected relationship between the author and work over time; where IP concerns itself with ownership, plagiarism addresses authorship. However, as "cultural objects," Oaxacan woodcarvings are not necessarily linked by straightforward connections of single-author to single-work. I suggest that the real danger that the InSpiriters posed was not erasure so much as threatening to reveal the inconsistent and unstable nature of the relationship between authorship and how woodcarvings are rendered authoritative in the first place. This alarmed the woodcarvings' makers and caused them to seek clarification via the already-institutionalized rules apparently offered by IP.

In fact, apart from the previously quoted general statement, the collective trademark's rules of use and other guidelines had nothing to say about intellectual property at all. Although the collective trademark presents artisans as if they are a single group with similar interests and goals, its details instead reveal a desire to create a uniformity of practice among artisans. The rules of the collective trademark serve as a way to define not only who should produce Oaxacan woodcarvings but also how they should be produced. Instead of addressing the threat of replicas, the artisans who organized the collective trademark were more concerned with woodcarving production in Oaxaca.

The collective trademark's regulations begin by delimiting which Oaxacans have the right to produce carvings, stating that only artisans of the legal age of majority from eleven designated communities are eligible to join the union. The list includes communities that are not particularly known for woodcarving production where families have occasionally made woodcarvings for sale. As Julia Flores, San Martín's executive committee representative, explained to me, this clause was included because they did not want to exclude anyone who had already begun to make carvings but also did not want "any old Oaxacan to claim rights to our livelihoods." Further, the regulations describe in detail acceptable materials, tools, and processes

of production for making Oaxacan woodcarvings. There was also debate about whether all artisans from designated communities should be allowed to join the union. It is well known that some, especially those in the lower end of the market, purchase unpainted carvings to finish and sell as their own. Some believed that the collective trademark should protect only "true" artisans who produced the carvings entirely themselves.[7]

These delineations of how and by whom authorized woodcarvings should be made are attempts at "enclosure" through what Lorraine Aragon (2011:71–73) calls "sequestering strategies," referring to the combination of secrecy and legal tools used by minority groups to protect themselves from outsiders who do not share their culture. In this case, however, the sequestering strategies are instead focused on preventing *other Oaxacans* from making Oaxacan woodcarvings, rather than taking steps to halt illegitimate versions made by foreigners, as the state representatives wanted to do. Instead of preventing cultural appropriation by outsiders, the collective trademark actually creates boundaries between otherwise similar people by distinguishing "true artisans" from other Oaxacans, demarcating who can legitimately produce woodcarvings and who cannot.

This boundary-setting is particularly important in fields like Oaxacan woodcarving. As Bourdieu (1993:37–56) has argued, artistic fields are subsumed within their larger categories of culture (*artesanías*, ethnic arts, and so forth) and larger fields of economic and political power (the economic and social relations in which artisans work in Oaxaca, Mexico, and the United States, for example). The distribution of aesthetic and symbolic capital within these "encompassing" spheres always affect how power, prestige, and legitimacy develop within a given field. Furthermore, Oaxacan woodcarving is what Bourdieu would call a relatively "unautonomous" space within the larger field of cultural production. As I have shown, Tileño artisans' gains and losses in terms of prestige, legitimacy, and sheer economic well-being are always affected by the economic and political conditions of tourism, the markets for *artesanías* and ethnic arts in Oaxaca and Mexico more broadly, and the practices of bureaucrats, tour guides, art collectors, and even other Oaxacan artisans. Therefore, in order to understand why these practices of boundary-making are important, we must consider uncertainties about the connections of authorship, authority, and desirability in the markets in which artisans work.

As described throughout this book, Oaxacan woodcarvings are produced within a complex and potent network of different art worlds that view them as ethnic art, Mexican *artesanías*, and souvenirs. Yet some viewers and consumers of Oaxacan woodcarvings are often not as concerned with learn-

ing about the cultural intentions of artisans as they are with *their own experiences* of how the carvings embody certain feelings or perceptions. Recall the examples from chapter 1: a Mexican American visitor saw the purchase of an expensive carving as the reestablishment of a physical connection to her Mexican roots, which she felt she had lost, while an Anglo-American collector saw his "discovery" of an older piece in San Martín as evidence of his own identity as an ethnic art connoisseur and a cosmopolitan and well-traveled person (cf. Steiner 1995). In order to understand the authority and desirability of art objects, we must account for their intersubjective nature, which I have suggested can be theorized by using Benjamin's concept of the "aura" of works of art. In fact, Benjamin's concept of the aura is useful for thinking through the peculiar allure of *both* art objects and intellectual property, because it captures the affective and ideological dimensions of both.

As I argued in chapter 1, the aura can be usefully redeployed for the anthropological study of art. It allows us simultaneously to pay attention to the creation of artistic authority, art's affective allure, and the contexts in which art is encountered (Cant 2016a; cf. Pinney 2002, 2004:189–191; Steiner 1999). Benjamin describes the aura as the affective embodiment of an artwork's "genuineness" and inexplicable allure or desirability, what Alfred Gell (1998:68–83) calls "enchantment," which prevents the viewer from completely comprehending and therefore resolving the object. The authority or desirability of an artwork is a manifestation of the encounter of artist, object, and viewer and therefore is also unstable and relational in character and contingent on "acts of reading and interpretation," characteristics all insinuated by Benjamin's aura (Hansen 2008:359). Multiple factors can influence a reading at any given moment. They are necessarily conditioned by the contexts in which art is encountered; by the cultural, institutional, or semantic frames in which it is presented; and by the motivating desires behind the attention given to the object by the viewer (cf. Errington 1998; Price 1989).

One consequence of these acts of reading is that differences among viewer-consumers are more meaningful than they might at first appear. Although San Martín's artisans seem to be competing within the same field, not everyone has equal access to knowledge about different kinds of consumers. For example, the Garcías have benefited from their long-standing friendships with particular dealers, collectors, and officials, who facilitate travel throughout Mexico and the United States. These journeys have allowed them insight into the aesthetic expectations of consumers of indigenous art, which they have actively incorporated into their own work. As

they showed their work at increasingly important museums and upmarket galleries, they also interacted with different kinds of artists and experts, exposing them to specialist discourses on skill, quality, aesthetics, and history and thereby providing the language and the means through which to calibrate their work to the desires of wealthier consumers. In this way, the Garcías have enhanced the auratic authority and allure of their own work. Their pieces appear *more* genuine and desirable than those of their competitors precisely because they fulfill connoisseurs' existing expectations of what ethnic art should be.

While this situation is clearly beneficial to the Garcías, their success has generated a large amount of suspicion and anxiety in San Martín. It is widely known that their work commands much higher prices than others can attain, and their success was somewhat bewildering to some of their neighbors. Other artisans were aware of their relationships with gatekeepers but were uncertain about what benefits they provided. They had only vague ideas about how the Garcías' work and presentation diverged from their own. One artisan admitted that he went to the Museo Estatal de Arte Popular de Oaxaca to look in more detail at pieces by successful families in order to "steal their inspirations," as he put it. He began producing what were essentially copies of the Garcías' work. He justified this by claiming that they were selfishly using "everyone's culture of woodcarving" for their own benefit, a sentiment expressed by other artisans in similar situations. Thus, even before the appearance of the InSpiriter figures, the linkages of culture, authorship, and desirability in the Oaxacan woodcarving market were already ambiguous. For the majority of the Garcías' neighbors, the truth about the power of their woodcarvings was uncertain. This provides part of the answer to Antonio's question: these artisans are concerned about the production of industrial copies because they cannot be sure about what is actually driving consumers' desires for their work and therefore also cannot be sure that the resin copies might not be able to meet these desires as well.

Given this, we might expect that successful artisans like the Garcías would be less concerned about the factory copies, because they seem to have learned the secret of their own work's desirability. Yet the Garcías were in fact a major force in the initial formation of the collective trademark union. Their enthusiasm for the program becomes intelligible when considered in terms of the energy and time that they have invested in constructing the fragile aura and aesthetics of ethnic art around their woodcarvings. They are under no illusions that the "ethnic art" discourses within which they situate their work might be right—that the aura of their work derives natu-

rally from authentic indigenous identities in the Mexican countryside. Instead, they know that they have cultivated this aura through hard work and knowledge gleaned from other people and contexts far removed from San Martín and that there is nothing stopping others from constructing auras around similar objects in the same way. Miguel admitted to me in conversation that he was worried because, as he put it, "the InSpiriters have even stolen my selling style; this American has learned my moves." The Garcías also know that the ethnic and tourist art markets, despite their apparent desires for authenticity, are highly susceptible to market pressures like labor costs. For example, they know Zapotec weavers who have produced Navajo blanket designs at a fraction of the cost to sell in the United States (see Stephen 2005:189–194; Wood 2008:88–95). Thus, the resin factory copies raise the specter that their own designs, which are not unique within the context of Mexican popular art, could move out of San Martín to another sufficiently authentic location.

Artisans' appeal to IP for their designs, then, is an attempt to protect the designs from use by other people, specifically from people who may also learn how to construct auratic power in the Mexican context and could make products equally desirable to the same consumers who currently purchase Oaxacan woodcarvings from San Martín. This anxiety helps to explain the artisans' significant attention to the formalization of rules surrounding production processes and which Oaxacans have the right to produce woodcarvings. Given that the carvings were invented by a single person who was not related to anyone from San Martín Tilcajete, it is clear to Tileños that the ability to produce both the carvings and the auras that surround them could easily be adopted by anyone living in the state of Oaxaca. The aesthetics and the genre are most durably connected to the region and not to any specific community, culture, or family.

It is not immediately clear how the InSpiriters threaten the security of Oaxacan artisans in the *artesanía* and ethnic art markets in which they work. For the tourists and collectors who are their primary consumers, the desirability of woodcarvings seems secure by their emplacement in what appear to be authentic household workshops, located in small rural communities like San Martín Tilcajete. The InSpiriter figures, in contrast, are not produced under these conditions, nor do they claim to be. Instead, they are directed toward an entirely different market in which they are desired for their reference to a generalized Native American spirituality. Despite this, the factory copies generated a large amount of anxiety among the artisans who produce the carvings. I have shown that this anxiety arose because the InSpiriters seemed to reveal the inconsistent and unstable nature of the aes-

thetic processes that take place in the production and marketing of Oaxacan woodcarvings. For many, the appearance of the InSpiriters touched a nerve: although consumers appear to believe that their work's appeal is due to its authentic production in San Martín, not everyone seems capable of producing equally desirable and authoritative carvings.

As such, the case of the InSpiriter factory copies and the artisans' response to them can tell us something important about the ways that value is (or is not) produced within art worlds. Bourdieu's model of art worlds as relational fields of cultural production is helpful for imagining such social spaces where actors use particular concepts and standards as symbolic capital in their competitions with one another for recognition and legitimacy. This model does seem to describe, on a basic level, the competitive position-takings (to use Bourdieu's phrasing) of Oaxacan artisans: the Garcías have taken a particularly lucrative position that has allowed them simultaneously to engage the aesthetic expectations and regimes of value that are at play in multiple fields (*artesanías* and ethnic art). This has also allowed them to generate economic wealth from their new symbolic capital. As Bourdieu might have predicted, this, in turn, has changed the nature of the art world of Oaxacan woodcarving more generally. As the Garcías' ethnicized explanations of their work gain traction, the work of other artisans comes to be judged by the terms of the ethnic art field.

However, as Georgina Born (2010:178–180) has argued, Bourdieu's formulation has insufficient space for the art object in and of itself. She emphasizes that his attention to aesthetics is marginal to his understanding of artistic life and that his model is unable to account for historical transformations of art worlds. I extend Born's critique to Bourdieu's connection between symbolic capital and economic value. As the InSpiriter case shows us, it is not only the legitimacy or aesthetic content of artworks that is central to their value but their auratic nature itself. At heart, the value of works of art is contingent upon what I have described as their allure, the mercurial experience of encountering artworks, which is affected by viewers' own readings as well as the contexts in which they are encountered. Objects that do not have this kind of allure are not works of art (see chapter 1).

Bourdieu's "field" approach alone cannot help to explain why the artisans were so concerned about the InSpiriter copies, because allure is not sufficiently objective or stable to work as "capital" in his sense. Allure cannot be witnessed or assessed in the same way as other sources of value, such as "authenticity," for example. Although not synonymous with beauty, it is to a certain extent in the eye of the beholder. This means that the value of works of art is in reality much less certain than it might appear in the gal-

lery, auction, or workshop. It is precisely this uncertainty that was put under the spotlight by the appearance of the InSpiriter resin replicas.

While the view from outside of San Martín Tilcajete may see the wood-carvings as more or less homogeneous cultural artifacts, woodcarvings are heterogeneous aesthetic projects whose successes vary greatly from the artisans' own perspective. This generates concerns about how Oaxacan wood-carvings should be legitimately produced. These anxieties are addressed through the idiom of intellectual property because it appears to work as a "place of condensation" (Martín-Barbero 2000:28) where rules and boundaries can be set and the logics of markets can be clarified. Artisans' claims to IP were much more about Oaxacan production than about the actions of foreign replica-makers. The development of the collective trademark seemed to offer a chance both to make sense of and to stabilize the economic and social processes in which they work and seemed to generate an aura of possibility and hope for the future.

Notes

1. I never met El Americano myself, and attempts to contact him in 2009 and 2010 were unsuccessful. Catalina García explained to me that he had brought the replicas to San Martín because he wanted to produce a new series of the resin figures and thought that he could entice some carvers to join his business venture.

2. *Enchinar* generally means to curl or perm one's hair; *china* is the adjective both for "Chinese" and for "curly."

3. The collective trademark also faced practical problems in its execution. Gallery owners in Oaxaca City were either unaware of the union or misinformed about its function, and it was not effectively linked with actors in the tourism and museum industries.

4. Hypothetically, any legal challenge would have to be made on behalf of the individuals whose carvings were used as prototypes (and would therefore not extend to Oaxacan woodcarvings in general) or would have to establish that Oaxacan woodcarvings are a protectable Traditional Cultural Expression, a category limited to a particular people or territory (May and Sell 2006:194–198). Given the relatively short history of Oaxacan woodcarving and the fact that it is not limited to a definable people or territory, it would struggle to fit WIPO definitions.

5. At the time of writing, the website no longer exists. It appears that the company has gone out of business. The InSpiriter figures are still available to purchase through third-party sellers.

6. Biagioli (2014:79) points out that authorship must still be recognized even when IP expires and content moves into the public domain.

7. This issue is reflected in the name of the union: the founders felt compelled to indicate that union membership was for "woodcarver-producers," rather than all artisans.

Conclusion: At the End of the Aura

As I was preparing to leave Oaxaca and return to London in September 2009, a package was delivered to the Garcías' home. Inside was a large carving of a fox, intricately painted in cream and charcoal black with accents in deep red and orange. Its body was turned so that the fox was looking over its shoulder, and the carving was so good that it seemed to be peering at us as it sat upon the kitchen table. Although the paint work that cloaked the fox's form was bright, clear, and fine across its back, the paint on its haunches and chest was flaking away in large patches, leaving the pale wood exposed. All across the piece, the smooth surface of the wood was gouged by small channels, each ending at a dark, perfectly round hole that bored straight into the heart of the wood.

Catalina sat at the table, considering the fox. It had been a special order from an American couple who gave it to their niece as a wedding gift. Less than a year later the evidence of an insect manifestation had appeared, and the customers were very upset. Their niece had sent the fox back to them, and they were uncertain whether they should have the piece replaced or give her something else. Catalina was upset too: she could not believe that one of her pieces had been destroyed in this way. In part she was embarrassed that the appearance of the insects undermined her status as a producer of fine, high-quality work. But she was also upset that the piece itself had been destroyed, that something that was made in her workshop was no longer a beautiful piece of art but now a piece of rubbish, neither useful nor beautiful. The aura had been broken.

I asked Catalina what she planned to do with the piece, as it was clear that it could not be salvaged or repaired. "I will put it in my living room, upstairs," she said after a moment. "As a reminder that our pieces are real, they are part of us, and that we must always take care with what we make with

our own hands." So perhaps the aura of the artwork persists, even once the object itself is destroyed.

Scholars of material culture have for some time asserted that physical objects are not passive features around which humans enact their social lives. Instead, they have shown in a multitude of contexts that "there can be no fundamental separation between humanity and materiality," insisting that we take objects seriously as social participants in human lives and worlds (Miller 2005:8). Taking objects seriously requires analytical strategies that can account for materiality, the human worlds in which objects find themselves, and the fact that different kinds of objects act within the social world in very different ways. Some objects demand more of our attention than others, and art objects are particularly demanding. As Alfred Gell (1998:23) suggests, it is their power to "fascinate, compel, and entrap" viewers that makes them so effective as social devices.

One of my principal aims for this book was to develop a way of thinking about art that could account for its particularly assertive nature. It is not enough to speak *just* of the "agency" of artworks when many other material features of the world impress themselves on human societies in agentive ways. We need to pursue what it is that makes art *art*. One special quality of art is that it is able to accommodate a multiplicity of perspectives, what I have called "readings," by makers and viewers and yet still remain inherently connected to the context in which it is made, found, or purchased. This apparent flexibility and inalienability in meaning and association are the essence of the allure of works of art: people want to view, own, collect, and duplicate artworks precisely because they can reflect something of themselves and the world at the same time. It is my contention that aesthetics are a fundamental mechanism through which this allure takes effect and enacts social change.

Form, color, pattern, rhythm, composition, and atmosphere are modes of communication and action that go beyond traditional anthropological concerns with the meaning and symbolism of a culture's art. While I am not proposing a return to the "ethnoaesthetic" customs of cataloguing and collecting, I am certain that we should pay more attention to how these features of artistic objects, practices, and beliefs affect the ways that people see and make the world. By viewing aesthetics as a form of embodied knowing through which people engage in metaphoric reflection in response to their experiences (Mascia-Lees 2011:6), we can better see the workings of the relationships between people and art. This "metaphoric reflection" takes us beyond a concern about (personal, local, or universal) definitions of beauty,

by moving beyond the expectation that aesthetic experience necessarily involves pleasure. Aesthetics are intimately connected to their allure, but this does not mean that the source of their attraction for people is necessarily the delight in the beautiful; I believe that the question of what the source is should be investigated ethnographically as well as philosophically. In connecting the power of particular aesthetic characteristics to the alluring capacity of artworks that Walter Benjamin described as their "aura," I therefore propose an empirical approach to aesthetics that is simultaneously concerned with form and effect. People are interested in, reflect upon, and (potentially) are changed by art through an engagement with its aesthetics.

However, the effects of artworks are not limited to the immediate relations between objects and viewers, which have been described as the "art encounter." For this reason, anthropologists and sociologists have spent decades describing and analyzing the social, political, material, and discursive topographies of art worlds. Despite their similarities to other fields where expertise, access, power, and renown regulate competition and success, art worlds are fundamentally shaped by the artworks with which they are concerned: without works of art and, consequently, their aesthetic capacities, there is no art world (Born 2010). The fact that aesthetic forms have effects within these artistic social fields means that they necessarily also affect *value*, both in the broad sense of the respect and attention that we grant to someone or something and in the more specific sense of its economic worth.

I have argued in this book that the concept of "fields" of cultural production, as described by Pierre Bourdieu, can be useful for parsing exactly how aesthetics affect value. By viewing art worlds as *aesthetic spaces* rather than only sociopolitical ones, we can see how value is generated by aesthetic change. This is because any change in aesthetics (of an artist, a style of work, or a whole genre) necessarily transforms the *relative positions* of artworks and producers vis-à-vis one another and the expectations of other art-world actors. As one aesthetic mode comes to be thought of as more (or less) intriguing, authentic, or desirable, all other aesthetic positions in the art world shift in terms of their meanings and worth. Within such a schema, aura, the captivating power of artworks, is central to their legitimacy and therefore their value. In other words, I suggest that within art worlds the aura itself is a kind of "currency" or symbolic capital.

Referring to the allure or aura of artworks as currency becomes more than metaphor when discussing those works that are primarily made to be commodities. In markets for commercial art, a work's capacity to engage viewers' attention plays a large part in determining how much it can sell for. Viewers' interest in an artwork will be deeply colored by the larger beliefs

about quality, legitimacy, and authenticity in that particular market. I have argued that these ideas become especially definitive in those markets where the valued content of commodities is understood to be cultural. I have described these markets as "economies of culture": fields of economic activity that depend on a reified culture concept in order to commodify the practices of everyday life into marketable objects, places, and events.

Within all economies of culture, aesthetics work as evidence of the authenticity or veracity of the cultural content that is consumed. As William Wood (2008), Christopher Steiner (1995), Nelson Graburn (1976, 2004), and many others have shown, aesthetics are a primary way that consumers, especially those from other cultures, interpret and evaluate the meaning and worth of cultural objects. For this reason, aesthetics within economies of culture, especially those that cater to tourists and other outsiders, tend to be conservative; in fact, repetition in style and form assures outsiders that what they are purchasing is genuine and real (Steiner 1999:101). This makes the issue of competition for cultural producers rather problematic. In order to be successful, they must simultaneously meet the expectations of consumers by reproducing established aesthetic and symbolic repertoires and also distinguish their work from that of their competitors, a challenge that may be strikingly difficult to meet.

Miguel and Catalina García have found a way to do just that in Oaxaca. Drawing on their past experiences in the indigenous art world of the southwestern United States, the Garcías have managed to produce an aesthetic repertoire for their work that simultaneously satisfies the expectations and understandings of authenticity held by all three economies of culture that are at work in contemporary Oaxaca: North American collectors of indigenous art, Mexican consumers of *artesanías*, and domestic and foreign tourists who go looking for souvenirs. In connecting the ethnicized aesthetics of "indigenous art" to their Oaxacan woodcarvings, the Garcías have not only produced economic value for their own work. They have also opened up the field of Oaxacan woodcarving to an entirely new art world, with its own norms, expectations, and aesthetic and conceptual "currencies." The indigenous art market is often more lucrative than *artesanías* or souvenirs, so this shift has dramatic effects on how *all* Oaxacan woodcarvings are positioned in terms of legitimacy, allure, and value. As Oaxacan woodcarvings are increasingly viewed by customers as containing the cultural content of a specific ethnic group ("the Zapotecs"), rather than being a generalized representation of Mexican culture and tradition, the incentive for other Tileños (and indeed all other Oaxacan woodcarvers) to present their work as indigenous art becomes difficult to resist.

By exploring the connections and transformations of aesthetics, art worlds, and the production of value in markets for apparently "traditional" Oaxacan handicrafts, a number of larger anthropological themes emerge. First, the analysis shows that aesthetic authority can quite easily translate into political, economic, and social power. That aesthetics can constitute politics and vice versa is not in itself a new point, but this book shows that the mechanisms by which these translations take place are grounded in the varying social contexts in which they occur. The intimacy of the household workshop conditions the relationship between power and aesthetics in ways very different from the public spaces of the community, the ideological spaces of nation-states, and the globalized spaces of tourist and ethnic art markets. As such, the relationship between aesthetics and politics not only is important to the anthropological study of art but also should be considered an important aspect of politics in general. This is especially true in ethnographic contexts where the question of how culture, space, and public life are defined is undergoing challenge or change (cf. Winegar 2016).

Second, aesthetic practices are intimately connected to experiences of identity. Transformations in the values of such aesthetic practices may necessarily entail change in the ways that identity and belonging are articulated. In the case of Tileños, their position as producers of aesthetic, visual culture has drawn some toward a rethinking of their indigeneity, which had not been considered advantageous and certainly not valuable in earlier times. As their craft is increasingly addressed as a material representation of ethnicity through the market for ethnic arts, indigeneity has likewise offered a form through which some Tileños may elaborate their own identities, albeit in divergent ways. At the same time, as producers of *artesanías* in Mexico, they are also inexorably located at the heart of national processes of belonging. Their work, their lives, and their travails come to be issues of national importance, at least discursively, for the state, tourism, and culture industries that continue to view *artesanías* as symbols of true Mexicanness.

Finally, the connected themes of authorship and property in relation to aesthetics emerge clearly from Tileños' everyday practices of artisanship and the more unfamiliar terrains of intellectual and cultural property. The idea that aesthetics can be owned and controlled is an increasingly important issue that anthropologists of art, craft, and material culture must come to terms with. Like the relationship between aesthetics and power, the commodification of aesthetics plays out in very different ways at different social and conceptual levels. The idea of "authorship" in San Martín works to maintain inalienable connections between some artisans and their work, while detaching others from the products of their labors. The ambiguities in

local understandings of "style" show that these processes of authorship are neither consistent nor complete, as artisans struggle to define exactly what constitutes an individual's style and what is undermined when other artisans copy an artisan's work.

At the same time, culture and aesthetics are transformed into property within global economies of culture via discourses of intellectual property, as artisans and state actors attempt to draw boundaries around who can legitimately produce ethnic arts and crafts. I have argued that the uncertainties in the relationships between aesthetics and property are both generated by and in turn reproduce anxieties about the status of aesthetics and competitiveness within increasingly precarious and unpredictable markets. This encourages artisans and the state to try to control aesthetics through such "sequestering strategies" (Aragon 2011:71–73) as collective trademarks and cultural property. Consequently, these strategies have now become an integral part of the practice of aesthetics in many places around the world, especially where the aesthetics and styles of marginalized peoples are used by outsiders for their own agendas and profit.

I have suggested that the aesthetics of visual arts and other cultural goods can be approached ethnographically by considering how genres are constituted, maintained, and changed by the actors involved in art worlds. Conceptualizing aesthetics in this way allows us to connect the social relations of actors to the material and aesthetic processes that are at the heart of producing value in art. In the case of Oaxacan woodcarving, this approach allowed insight into how Miguel and Catalina García have successfully entered a new art market by aligning their aesthetics to the expectations of that market and also how their success fundamentally changed the nature of Oaxacan woodcarving itself.

By successfully drawing on an aesthetic of indigeneity that speaks to the North American ethnic art market in ways that their neighbors struggled to replicate, the Garcías appear at once more authoritative and more authentic than their competitors, some of whom have been producing carvings for much longer. This case shows that by charting the relations between aesthetic practices and social, economic, and political forms we can move beyond interests of "discourse" in our analyses to focus more firmly on the relations between people and art. Approaching aesthetics as a relational process provides us a frame through which we may connect the affective and sensory experiences of social life to more established anthropological interests of power, the economy, and society. The concept of aesthetics indeed provides a way forward to account for the "sensuous participation" of individuals as they create and construct their social worlds. The example of

Oaxacan woodcarving, however, shows that we must not assume that aesthetic practice is the antithesis to the exercise of power; often the two go hand in hand.

The carvers and painters of San Martín Tilcajete see themselves as aesthetic producers whose work has authority and value in its own right. While this authority is derived from their own practices of production in their workshops and is the product of their own creative work, thoughts, and ideas, artisans like Catalina experience the auras of their woodcarvings as a force separate from themselves. The woodcarvings have transformed San Martín from an unknown tiny village in the hinterlands of Oaxaca's Central Valleys into an important place where foreigners, state officials, and others visit, showing the power that these carvings can have. At the same time, this power or aura is not wholly knowable and appears too delicate, ephemeral, and unstable to be trusted. Many Tileños do not really understand why certain carvings seem to be more alluring than others, why certain artisans develop names, and whether their work will continue to be copied by people who are not artisans from Oaxaca's woodcarving communities. Although the woodcarvings have given Tileños an important and relatively secure source of economic stability, their desirability is somewhat mysterious, which makes people nervous. Artisans now worry that the futures of the market are uncertain. Just as the fox was in danger of losing its aura through a loss of integrity, they worry that the desirability of woodcarvings may not sustain everyone in the future.

On my young son's bookshelf sit a number of children's books featuring Oaxacan woodcarvings, which I have collected over the years. The oldest, *Margarito's Carvings* (1998), which is now out of print, was published by the journalist Shepard Barbash, who has written a number of books on Oaxacan woodcarving (see Chibnik 2003:175–183). It is a small, inexpensive softcover book with simple explanations and photographs of the carving process and was published in the educational book series Little Celebrations. The next three are bright hardcover picture books for small children: *ABeCedarios: Mexican Folk Art ABCs in English and Spanish* (2007), *Colores de la Vida: Mexican Folk Art Colors in English and Spanish* (2011), and *Mi Familia Calaca/My Skeleton Family: A Mexican Folk Art Family in English and Spanish* (2013), all by the children's author Cynthia Weill and published by Cinco Puntos. They are bilingual books of colors, the alphabet, and families, illustrated with lively photographs of Oaxacan craftwork, including many woodcarvings, which Weill commissioned especially for each project.

The final book, *Miguel and the Amazing Alebrijes* (Rivera-Ashford and Rivera-Ashford 2017), stands out from the others in a variety of ways. It does not contain photographs of original work by Oaxacan artisans but instead is illustrated with drawings. It comes with stickers and punch-out characters for children to play with. And—most significantly—it was not published by a small independent press but by Random House for Disney-Pixar as merchandise associated with the 2017 film *Coco*, in which Miguel is the protagonist.

As a collection, these books seem to mirror many of the changes that have taken place in the art world of Oaxacan woodcarving since my fieldwork ended in 2009, especially with regard to the Garcías. At that time, they were rapidly consolidating themselves as the premier workshop in the field, but their own presentation of their workshop was still a small-scale, informal venture. When I last visited San Martín Tilcajete, in the summer of 2017, the Garcías' outfit had become very professional indeed. In addition to the workshop where I conducted my research and their restaurant on the highway, they have expanded their business in Oaxaca City. In place of the two small and fairly generic shops that they had in 2009, they now have one very large, sophisticated gallery with a highly stylized and dramatic showroom. Located on the main pedestrianized street in the heart of the city's historic center, it also offers their clientele a shady courtyard café, serving traditional Oaxacan *botanas* (snacks), European-style coffees, and Italian sodas.

Their workshop in San Martín Tilcajete has also undergone further professionalization since my research there ended. Painters used to halt their work in order to guide visiting tour groups around the workshop; now the sole job of some staff members is to give demonstrations and tours and manage the gallery. The Garcías are also working on expanding the range of products that they offer. Behind a large parking lot recently built next to their compound, I was shown where new workshops and kilns for silverwork and pottery were being constructed. They had hired an expert potter from Mexico City, who was helping them formulate the right mixture of temper so that the local clay could be used for ceramics. The plan was that she could give classes on pottery-throwing to Tileños who would like to do this work for the Garcías. Their vision is that their workshop could become a "one-stop-shop" for visitors to observe, experience, and buy a whole range of Oaxacan craftwork, executed in the style of the Garcías' woodcarvings. While it might seem fantastical that one small workshop in San Martín Tilcajete could expand from a family venture to an entire industry in just twenty years, their plans may not be unrealistic. They now move within Oa-

xacan and Mexican networks that connect them to very important national elites and cultural institutions. They are frequently invited to attend high-level cultural events such as those attended by President Enrique Peña Nieto (2012–2018) and are well connected to the national funding bodies and museums in the nation's capital.

As the Garcías' business and fame has changed and grown, so too the larger market for Oaxacan woodcarvings has transformed and, along with it, artisans' lives. In a new chapter updating the current state of Oaxacan woodcarving, Michael Chibnik (2017:305) explains that stratification among artisans is more acute in San Martín Tilcajete than in the other carving communities. While he notes that the Tileño carvers with whom he had conducted his research in the 1990s have also achieved prosperity and stability through their work (ibid.:308–309), not all artisans in San Martín have been so lucky. Since my fieldwork, some Tileños have temporarily or permanently left woodcarving production, seeking other forms of livelihood in Oaxaca and abroad.

As Chibnik (2017:204) notes, the immigration policies of Donald Trump's administration in the United States have also affected migration flows and the dollar-to-peso exchange rate, which have direct and indirect consequences for Oaxacan artisans. A number of Tileños who spent many years as undocumented workers in the United States have come back to San Martín. Some of them have returned to or begun careers in Oaxacan woodcarving, putting extra pressure on a market that has been saturated for years. Furthermore, some of the returning migrants have never lived in San Martín Tilcajete in their adult lives and find it difficult to reintegrate into rural Oaxacan life. I noticed one young man that I did not recognize, sitting on the corner of the main square in San Martín, glaring and yelling at tourists who passed by. Friends explained to me that he was suffering the acute effects of drug addiction, and his family was at a loss about how to help him. Artisans are clearly concerned about the kind of image that this creates for the visitors on whom they depend for their sales. Some artisans have been able to take advantage of their work permits for the United States, however, taking on seasonal agricultural work, which currently offers more financial security, although certainly not more comfort, than making woodcarvings at home.

In 2009 it was clear that the Garcías were not going to remain the sole producers of woodcarvings that appealed to the "indigenous art" aesthetic that formed the basis for their success. As I discussed in chapters 3 and 6, some of their neighbors were already beginning to try their hands at "copying" the Garcías' profitable style. By 2017 their "Zapotec" aesthetic had be-

come a genre in itself, with many people producing carvings with geometric patterns and symbols in the earthy, natural tones of the Garcías' work. While these carvings were often not executed to the same high standard, their prices are also much more accessible to the average visitor (Chibnik 2017:308). Although artisans continue to produce the more traditional *comercial* and *rústica* styles of work, the success of the new indigenized style has caused a fundamental shift in the genre of woodcarving. It would not surprise me if, in the next decade, the Zapotec style of carving replaces the *rústica* style altogether (at least in San Martín), as the older generation retires or passes away.

The meanings of Oaxacan woodcarvings and *alebrijes* more generally are also undergoing larger symbolic shifts. Most significantly, the Disney-Pixar film *Coco* (Unkrich 2017) directly associates *alebrijes* with Día de los Muertos (Day of the Dead), a novel connection that does not have any grounding in Mexican practices or traditions. In the film *alebrijes* are spirit animals that aid the deceased in the Land of the Dead, a fantastical rendering of the central Mexican town of Guanajuato, where skeletons go about their days as if they are still alive. While the press and media surrounding *Coco* also connected the film's *alebrijes* to the papier-mâché figures from Mexico City, presenting them as spirit animals is a direct influence from Oaxacan woodcarvers, particularly the Garcías. Their assertion that *alebrijes* are Zapotec *tonas* inspired this decision. The illustrators and animators who worked on *Coco* spent months preparing in Oaxaca, researching, sketching, and painting in Oaxacan craft workshops, including the Garcías' (Ugwu 2017). The aesthetics of their work infuse the visual design, colors, and atmosphere of the film.

The film was immensely successful in Mexico, in fact the most successful movie of all time. It grossed 842 million pesos (over USD 46 million) in its first twenty days at the box office in 2017. Globally, it has grossed over 800 million USD to date. The runaway success of this film means that most people will encounter *alebrijes* as spirit guides of the dead, rather than as Oaxacan woodcarvings. What this means for the idea of *alebrijes* and the field of Oaxacan woodcarving has yet to be seen, but the artisans that I spoke to in San Martín Tilcajete were unanimous in their appraisal that any attention to their work is a good thing. For those who work within such economies of culture that place high value on authenticity and tradition, a famous film that links their work to the most famous holiday of the year is a lucrative opportunity, even if it means a significant change in what Oaxacan woodcarvings are and mean.

Indeed, as this book has illustrated, Oaxacan woodcarvings have never

really meant one thing anyway. They are a form of craft, *artesanía*, ethnic art, and souvenir that is constantly changing, as the meanings and interpretations of their genre, art worlds, and economies of culture ebb and flow through time. By honing in on how aesthetics are both a response to and an instrument of these changes, this book has shown that aesthetic forms and practices are intimately linked to the production of value. This relationship between value and aesthetics has meaningful consequences for *all* artistic and cultural producers and the larger ways that cultures become commodities in the contemporary world. As such, the relationship between value and aesthetics should also be a primary concern for anthropologists as we work to illuminate the connections of objects, power, wealth, and prestige in all the societies that we study.

A Note on Names

Apart from Manuel Jiménez, Isidoro Cruz, and Antonio Mendoza Ruiz, all personal names in this book are pseudonyms. I have retained the true names of Jiménez and Cruz because their importance in the history of Oaxacan woodcarving is very well known and they are peripheral to the stories that I tell and the analyses that I make here. Mendoza Ruiz is himself a renowned artisan in textiles; I give him credit for his provocation that frames this piece of work. However, everyone else has been given a pseudonym. While anonymization remains standard practice in anthropology—and is even a requirement of some ethics review boards and funding bodies—it is problematic in the context of this research. I have struggled with this question. First, there is the issue that many of the artisans with whom I worked did *not* want to be anonymized: in their experience, being identified in the texts of journalists and researchers is a promotional opportunity for their work and gives them legitimacy in the eyes of some of their customers. Second, by anonymizing my research participants, I risk creating a gulf between my research and research conducted by others working on the topic. In essence, I have removed my participants from the art history of Oaxacan woodcarving or at least removed the experiences that they shared with me. Finally, it is not entirely possible to anonymize all of my research participants. I am certain that readers who are familiar with the Oaxacan woodcarving market will be able to identify at least some of the artisans whose work I describe.

Be all that as it may, I remain convinced that pseudonyms are the more ethical choice in this case. As the market for ethnic arts and crafts depends on the "mystique of authenticity," my descriptions of certain artisans' deliberate transformation of aesthetic, authorial, and labor practices in San Martín Tilcajete may undermine their claims to authenticity and may even impact the economic well-being of themselves or the community in general (cf. Wood 2001b). Likewise, some of the arguments I make draw on artisans' critiques of others within a context of fierce economic competition in a small village. To report people's real names risks amplifying the animosities and jealousies that are believed by many Tileños to be increasing all the time. Perhaps I am overly preoccupied with these concerns. However, the kind

of tourist that Oaxaca attracts is rather likely to read ethnographic accounts of the region, especially as many are available in Oaxaca City's English-language bookstore. As I was once rather aggressively reminded by an "in-the-know" collector: "People want to buy the real thing, a piece made with their own hands. . . . You must be very careful what you write."

References

Aguiar, José Carlos. 2007. "Dirty CDs: Piracy, Globalisation and the Emergence of New Illegalities in the San Juan de Dios Market, Mexico." PhD diss., University of Amsterdam, Netherlands.

———. 2010. "La piratería como conflicto: Discursos sobre la propiedad intelectual en México." *Revista de Ciencias Sociales* 38:143–156.

———. 2013. "Smugglers, Fayuqueros, Piratas: Transitory Commodities and Illegality in the Trade of Pirated CDs in Mexico." *PoLAR: Political and Legal Anthropology Review* 36:249–265.

Alonso, Anna María. 2004. "Conforming Disconformity: 'Mestizaje,' Hybridity, and the Aesthetics of Mexican Nationalism." *Cultural Anthropology* 19 (4):459–490.

Anaya Muñoz, Alejandro. 2005. "The Emergence and Development of the Politics of Recognition of Cultural Diversity and Indigenous Peoples' Rights in Mexico: Chiapas and Oaxaca in Comparative Perspective." *Journal of Latin American Studies* 37 (3):585–610.

Appadurai, Arjun. 2006. "The Thing Itself." *Public Culture* 18 (1):15–21.

Aragon, Lorraine. 2011. "Where Commons Meet Commerce: Circulation and Sequestration Strategies in Indonesian Arts Economies." *Anthropology of Work Review* 32:63–76.

———. 2014. "Law versus Lore: Copyright and Conflicting Claims about Culture and Property in Indonesia." *Anthropology Today* 30 (5):15–19.

Arenas, Iván. 2011. "Rearticulating the Social: Spatial Practices, Collective Subjects, and Oaxaca's Art of Protest." PhD diss., Department of Anthropology, University of California at Berkeley.

Bakewell, Liza. 1995. "'Bellas Artes' and 'Artes Populares': The Implications of Difference in the Mexico City Art World." In *Looking High and Low: Art and Cultural Identity*, edited by Brenda Jo Bright and Liza Bakewell, 19–54. Tucson: University of Arizona Press.

Barbash, Shepard. 1993. *Oaxacan Woodcarving: The Magic in the Trees*. San Francisco: Chronicle Books.

———. 1998. *Margarito's Carvings*. Glenview, IL: Celebration.

Bargellini, Clara. 2005. "Originality and Invention in the Painting of New Spain." In

Painting a New World: Mexican Art and Life, 1521–1821, edited by Donna Pierce, Rogelio Ruiz Gomar, and Clara Bargellini, 79–91. Austin: University of Texas Press.

Bartra, Roger. 1993. *Agrarian Structure and Political Power in Mexico*. Baltimore, MD: Johns Hopkins University Press.

Bateson, Gregory. 1972. *Steps to an Ecology of Mind: Collected Essays in Anthropology, Psychiatry, Evolution, and Epistemology*. Chicago: University of Chicago Press.

Becker, Howard. 1982. *Art Worlds*. Berkeley: University of California Press.

Beezley, William H. 2008. *Mexican National Identity: Memory, Innuendo, and Popular Culture*. Tucson: University of Arizona Press.

Benjamin, Walter. 2008. *The Work of Art in the Age of Mechanical Reproduction*. Translated by J. A. Underwood. London: Penguin.

Biagioli, Mario. 2014. "Plagiarism, Kinship, and Slavery." *Theory, Culture and Society* 31 (2–3):65–91.

Born, Georgina. 2010. "The Social and the Aesthetic: For a Post-Bourdieuian Theory of Cultural Production." *Cultural Sociology* 4:171–208.

Bourdieu, Pierre. 1977. *Outline of a Theory of Practice*. Cambridge: Cambridge University Press.

———. 1984. *Distinction: A Social Critique of the Judgement of Taste*. Translated by Richard Nice. Cambridge, MA: Harvard College; Milton Park, Abingdon, UK: Routledge and Keegan Paul.

———. 1986. "The Forms of Capital." In *Handbook of Theory and Research for the Sociology of Education*, edited by John Richardson, 241–258. New York: Greenwood.

———. 1993. *The Field of Cultural Production: Essays on Art and Literature*. New York: Columbia University Press.

Bowen, Sarah. 2010. "Development from Within? The Potential for Geographical Indications in the Global South." *Journal of World Intellectual Property* 13 (2):231–252.

Bowen, Sarah, and Marie Sarita Gaytán. 2012. "The Paradox of Protection: National Identity, Global Commodity Chains, and the Tequila Industry." *Social Problems* 59 (1):70–93.

Breglia, Lisa. 2006. *Monumental Ambivalence: The Politics of Heritage*. Austin: University of Texas Press.

Brown, Denise Fay. 1999. "Mayas and Tourists in the Maya World." *Human Organization* 58 (3):295–304.

Brown, Michael. 2003. *Who Owns Native Culture?* Cambridge, MA: Harvard University Press.

Brulotte, Ronda. 2009. "'Yo Soy Nativo de Aquí': The Ambiguities of Race and Ethnicity in Oaxacan Craft Tourism." *Journal of Latin American and Caribbean Anthropology* 14 (2):457–482.

———. 2012. *Between Art and Artifact: Archaeological Replicas and Cultural Production in Oaxaca, Mexico*. Austin: University of Texas Press.

Bruner, Edward. 1996. "Tourism in the Balinese Borderzone." In *Displacement, Diaspora, and Geographies of Identity*, edited by Smadar Lavie and Ted Swedenburg, 157–179. Chapel Hill, NC: Duke University Press.

———. 2005. *Culture on Tour: Ethnographies of Travel*. Chicago: University of Chicago Press.

Bunten, Alexis Celeste. 2008. "Sharing Culture or Selling Out? Developing the Commodified Persona in the Heritage Industry." *American Ethnologist* 35 (3):380–395.

Canessa, Andrew. 2007. "Who Is Indigenous? Self-Identification, Indigeneity, and Claims to Justice in Contemporary Bolivia." *Urban Anthropology* 36 (3):195–237.

Cant, Alanna. 2015a. "The Allure of Art and Intellectual Property: Artisans and Industrial Replicas in Mexican Cultural Economies." *Journal of the Royal Anthropological Institute* 21 (4):820–837.

———. 2015b. "Persuasive Evidence: Anthropological and Touristic Images of 'Traditional' Practices." *Visual Anthropology* 28 (4):277–285.

———. 2016a. "The Art of Indigeneity: Aesthetics and Competition in Mexican Economies of Culture." *Ethnos* 81 (1):152–177.

———. 2016b. "Who Authors Crafts? Producing Woodcarvings and Authorship in Oaxaca, Mexico." In *Critical Craft: Technology, Globalization and Capitalism*, edited by Clare Wilkinson-Weber and Alicia Ory de Nicola, 19–34. London: Bloomsbury.

———. 2018. "'Making' Labour in Mexican Artisanal Workshops." *Journal of the Royal Anthropological Institute* 24 (S1):61–74.

Carpenter, Edmund. 1973. *Eskimo Realities*. New York: Holt, Rinehart and Winston.

Carrier, James. 1992. "Emerging Alienation in Production: A Maussian History." *Man*, n.s. 27 (3):539–558.

CDI [Comisión Nacional Para el Desarrollo de los Pueblos Indígenas de México]. 2010. *Indicadores sociodemográficos de la población total y la población indígena*. Mexico City: CDI.

Chan, Anita Say. 2011. "Competitive Tradition: Intellectual Property and New Millennial Craft." *Anthropology of Work Review* 32:90–102.

Chance, John. 1978. *Race and Class in Colonial Oaxaca*. Stanford, CA: Stanford University Press.

Chance, John, and William B. Taylor. 1985. "Cofradías and Cargos: An Historical Perspective on the Mesoamerican Civil-Religious Hierarchy." *American Ethnologist* 12 (1):1–26.

Chibnik, Michael. 2003. *Crafting Tradition: The Making and Marketing of Oaxacan Woodcarvings*. Austin: University of Texas Press.

———. 2006. "Oaxacan Woodcarvings in the World of Fine Art: Aesthetic Judgments of a Tourist Craft." *Journal of Anthropological Research* 62 (4):491–512.

———. 2017. *Tallando una tradición: El trabajo y el comercio de alebrijes y otras tallas en madera de Oaxaca*. Oaxaca: 1450 Ediciones.

Chugh, Shalene, and Philip Hancock. 2009. "Networks of Aestheticization: The Architecture, Artefacts and Embodiment of Hairdressing Salons." *Work, Employment and Society* 23 (3):460–476.

Clifford, James. 1988. *The Predicament of Culture: Twentieth-Century Ethnography, Literature, and Art*. Cambridge, MA: Harvard University Press.

———. 2001. "Indigenous Articulations." *Contemporary Pacific* 13 (2):468–490.

Coffey, Mary K. 2010. "Banking on Folk Art: Banamex-Citigroup and Transnational Cultural Citizenship." *Bulletin of Latin American Research* 29 (3):296–312.

———. 2012. *How a Revolutionary Art Became Official Culture.* Durham, NC: Duke University Press.

Cohen, Jeffrey. 1999. *Cooperation and Community: Economy and Society in Oaxaca.* Austin: University of Texas Press.

———. 2004. *The Culture of Migration in Southern Mexico.* Austin: University of Texas Press.

Coleman, Elizabeth. 2004. "Aboriginal Art and Identity: Crossing the Borders of Law's Imagination." *Journal of Political Philosophy* 12(1):20–40.

Colloredo-Mansfeld, Rudi. 2002. "An Ethnography of Neoliberalism: Understanding Competition in Artisan Economies." *Current Anthropology* 43 (1):113–137.

———. 2011. "Work, Cultural Resources, and Community Commodities in the Global Economy." *Anthropology of Work Review* 32:51–62.

Comaroff, John L., and Jean Comaroff. 2009. *Ethnicity, Inc.* Chicago: University of Chicago Press.

CONEVAL [Consejo Nacional de Evaluación de la Política de Desarrollo Social]. 2012. *Informe de pobreza y evaluación en el estado de Oaxaca, 2012.* Mexico City: CONEVAL.

Cook, Scott. 2004. *Understanding Commodity Cultures: Explorations in Economic Anthropology with Case Studies from Mexico.* New York: Rowman and Littlefield.

———. 2006. "Commodity Cultures, Mesoamerica and Mexico's Changing Indigenous Economy." *Critique of Anthropology* 26 (2):181–208.

Cook, Scott, and Jong-Taick Joo. 1995. "Ethnicity and Economy in Rural Mexico: A Critique of the Indigenista Approach." *Latin American Research Review* 30 (2): 33–59.

Coombe, Rosemary. 1998. *The Cultural Life of Intellectual Properties: Authorship, Appropriation, and the Law.* Durham, NC: Duke University Press.

Coote, Jeremy. 1992. "Marvels of Everyday Vision: The Anthropology of Aesthetics and the Cattle-Keeping Nilotes." In *Anthropology, Art, and Aesthetics,* edited by Jeremy Coote and Anthony Shelton, 245–273. Oxford: Clarendon.

Cross, John C. 2011. "Mexico." In *Media Piracy in Emerging Economies,* edited by Joe Karaganis, 305–325. New York: Social Science Research Council.

Danto, Arthur. 1964. "The Artworld." *Journal of Philosophy* 61 (19):571–584.

Dark, Philip J. C. 1966. "The Study of Ethno-Aesthetics: The Visual Arts." In *Essays on the Verbal and Visual Arts,* edited by June Helm, 131–148. Seattle: University of Washington Press.

Das, Veena, and Shalini Randeria. 2015. "Politics of the Urban Poor: Aesthetics, Ethics, Volatility, Precarity." Introduction to supplement 11. *Current Anthropology* 56 (S11):S3–S14.

D'Ascia, Luca. 2007. "¿Quién habla en la oreja de Einstein? Arte indígena contemporáneo en el estado de Chiapas (México)." *Boletín de Antropología* (Universidad de Antioquia, Medellín, Colombia) 21 (38):11–40.

DeHart, Monica C. 2010. *Ethnic Entrepreneurs: Identity and Development Politics in Latin America.* Stanford, CA: Stanford University Press.

de la Cadena, Marisol, and Orin Starn. 2007. Introduction. In *Indigenous Experience Today,* edited by Marisol de la Cadena and Orin Starn, 1–30. New York: Berg.

de la Fuente, Eduardo. 2013. "Why Aesthetic Patterns Matter: Art and a 'Qualitative' Social Theory." *Journal for the Theory of Social Behaviour* 44 (2):168–185.

de la Peña, Guillermo. 2005. "Social and Cultural Policies toward Indigenous Peoples: Perspectives from Latin America." *Annual Review of Anthropology* 34:717–739.

———. 2011. "Ethnographies of Indigenous Exclusion in Western Mexico." *Indiana Journal of Global Legal Studies* 18 (1):307–319.

Delpar, Helen. 1992. *The Enormous Vogue of Things Mexican: Cultural Relations between the United States and Mexico, 1920–1935.* Tuscaloosa: University of Alabama Press.

Demian, Melissa. 2000. "Longing for Completion: Toward an Aesthetics of Work in Suau." *Oceania* 71 (2):94–109.

Dennis, Philip A. 1987. *Intervillage Conflict in Oaxaca.* New Brunswick, NJ: Rutgers University Press.

Dent, Alexander S. 2012. "Piracy, Circulatory Legitimacy, and Neoliberal Subjectivity in Brazil." *Cultural Anthropology* 27 (1):28–49.

DOI [United States Department of the Interior]. 1990. *The Indian Arts and Crafts Act.* PL 101-644. Available at http://www.iacb.doi.gov/act.html.

Driscoll-Engelstad, Bernadette. 1996. "Beyond Anonymity: The Emergence of Textile Artists in the Canadian Arctic." *Museum Anthropology* 20 (3):26–38.

Dubin, Margaret D. 2001. *Native America Collected: The Culture of an Art World.* Albuquerque: University of New Mexico Press.

Durand Ponte, Víctor Manuel. 2007. Prólogo. In *Ciudades mexicanas del siglo XX: Siete estudios históricos,* edited by Jorge Hernández Díaz, 11–34. Oaxaca: Universidad Autónoma Benito Juárez de Oaxaca.

Edelman, Marc. 1994. "Landlords and the Devil: Class, Ethnic, and Gender Dimensions of Central American Peasant Narratives." *Cultural Anthropology* 9 (1):58–93.

Eisenstadt, Todd A. 2011. *Politics, Identity, and Mexico's Indigenous Rights Movements.* Cambridge: Cambridge University Press.

Elson, Christina. 2007. *Excavations at Cerro Tilcajete: A Monte Albán II Administrative Centre in the Valley of Oaxaca.* Ann Arbor: University of Michigan, Museum of Anthropology.

Errington, Frederick K. 1987. "The Rock Creek Auction: Contradiction between Competition and Community in Rural Montana." *Ethnology* 26 (4):297–311.

Errington, Shelly. 1998. *The Death of Authentic Primitive Art and Other Tales of Progress.* Berkeley: University of California Press.

Esteva, Gustavo, Mariana Ortega Breña, Jan Rus, and James Lerager. 2007. "The Asamblea Popular de los Pueblos de Oaxaca: A Chronicle of Radical Democracy." *Latin American Perspectives* 34 (1):129–144.

Fabian, Johannes. 1998. *Moments of Freedom: Anthropology and Popular Culture.* Charlottesville: University Press of Virginia.

Feinberg, Benjamin. 2003. *The Devil's Book of Culture: History, Mushrooms, and Caves in Southern Mexico.* Austin: University of Texas Press.

Field, Les W. 1999. *The Grimace of Macho Raton: Artisans, Identity, and Nation in Late-Twentieth-Century Western Nicaragua.* Durham, NC: Duke University Press.

Finney, Henry C. 1993. "Mediating Claims to Artistry: Social Stratification in a Local Visual Arts Community." *Sociological Forum* 8 (3):403–431.

Flannery, Joyce, and Kent V. Marcus. 2007. Introduction to *Excavations at Cerro Til-*

cajete: A Monte Albán II Administrative Centre in the Valley of Oaxaca, by Christina Elson, i–xii. Ann Arbor: University of Michigan, Museum of Anthropology.

FONART [Fondo Nacional para el Fomento de las Artesanías]. 2012. *Marcas colectivas artesanales.* Mexico City: Secretaría de Desarrollo Social.

———. 2016. *Registro de una marca artisanal.* Mexico City: Secretaría de Desarrollo Social.

Foster, George M. 1965. "Peasant Society and the Image of Limited Good." *American Anthropologist,* n.s. 67 (2):293–315.

Foster, Robert J. 2007. "The Work of the New Economy: Consumers, Brands, and Value Creation." *Cultural Anthropology* 22(4):707–731.

Gallagher, Kevin P., and Roberto Porzecanski. 2010. *The Dragon in the Room: China and the Future of Latin American Industrialization.* Stanford, CA: Stanford University Press.

García, Ismael. 2016. "Se va Gabino Cué y deja en Oaxaca obras a medias." *El Universal.* http://www.eluniversal.com.mx/articulo/estados/2016/11/30/se-va-gabino-cue-y-deja-en-oaxaca-obras-medias.

García Canclini, Néstor. 1993a. "Los usos sociales del patrimonio cultural." In *El patrimonio cultural de México,* edited by Enrique Florescano, 41–61. Mexico City: Fondo de Cultura Económica.

———. 1993b. *Transforming Modernity: Popular Culture in Mexico* [translation of *Las culturas populares en el capitalismo* (1983)]. Translated by Lidia Lozano. Austin: University of Texas Press.

———. 1995. *Hybrid Cultures: Strategies for Entering and Leaving Modernity.* Minneapolis: University of Minnesota Press.

Geismar, Haidy. 2001. "What's in a Price? An Ethnography of Tribal Art at Auction." *Journal of Material Culture* 6 (1):25–47.

———. 2005. "Copyright in Context: Carvings, Carvers, and Commodities in Vanuatu." *American Ethnologist* 32 (3):437–459.

———. 2013. *Treasured Possessions: Indigenous Interventions into Cultural and Intellectual Property.* Durham, NC: Duke University Press.

Gell, Alfred. 1992. "The Technology of Enchantment and the Enchantment of Technology." In *Anthropology, Art, and Aesthetics,* edited by Jeremy Coote and Anthony Shelton, 40–67. Oxford: Clarendon.

———. 1996. "Vogel's Net: Traps as Artworks and Artworks as Traps." *Journal of Material Culture* 1 (1):15–38.

———. 1998. *Art and Agency: An Anthropological Theory.* Oxford: Oxford University Press.

Gershon, Ilana. 2011. "Neoliberal Agency." *Current Anthropology* 52 (4):537–555.

Godoy, Emilio. 2010. "Mexico-China: Trade Winds from the East." IPS: Interpress Service News Agency, April 14. Available at http://www.ipsnews.net/2010/04/mexico-china-trade-winds-from-the-east/.

Gowlland, Geoffrey. 2016. "Materials, the Nation and the Self: Division of Labor in a Taiwanese Craft." In *Critical Craft: Technology, Globalization and Capitalism,* edited by Clare Wilkinson-Weber and Alicia Ory DeNicola, 199–216. London: Bloomsbury.

Graburn, Nelson. 1976. "Introduction: The Arts of the Fourth World." In *Ethnic and Tourist Arts,* edited by Nelson Graburn, 1–32. Berkeley: University of California Press.

————. 2004. "Authentic Inuit Art: Creation and Exclusion in the Canadian North." *Journal of Material Culture* 9:141–159.

————. 2005. "From Aesthetics to Prosthetics and Back: Materials, Performance and Consumers in Canadian Inuit Sculptural Arts; or, Alfred Gell in the Canadian Arctic." In *Les cultures à l'oeuvre: Rencontres en art*, edited by Brigite Derlon, Michèle Coquet, and Monique Jeudy-Ballini, 47–62. Paris: Biro Éditeur.

Greenhalgh, Paul. 1997. "The History of Craft." In *The Culture of Craft*, edited by Peter Dormer, 20–52. Manchester, UK: Manchester University Press.

Gutmann, Matthew. 1992. "Primordial Cultures and Creativity in the Origins of 'Lo Mexicano.'" *Kroeber Anthropological Society Papers* 75-76:48–61.

Hale, Charles. 2004. "Rethinking Indigenous Politics in the Era of the 'Indio Permitido.'" *NACLA Report on the Americas* 38 (2):16–21.

————. 2005. "Neoliberal Multiculturalism: The Remaking of Cultural Rights and Racial Dominance in Central America." *PoLAR* 28 (1):10–19.

Hall, Stuart 1986. "Gramsci's Relevance for the Study of Race and Ethnicity." *Journal of Communication Inquiry* 10 (2):5–27.

Hannerz, Ulf. 1990. "Cosmopolitans and Locals in World Culture." *Theory, Culture, and Society* 7:237–251.

Hansen, Miriam Bratu. 2008. "Benjamin's Aura." *Critical Inquiry* 34 (2):336–375.

Harris, Olivia. 1995. "Ethnic Identity and Market Relations: Indians and Mestizos in the Andes." In *Ethnicity, Markets, and Migration in the Andres: At the Crossroads of History and Anthropology*, edited by Brooke Larson, Olivia Harris, and Enrique Tandeter, 351–390. Durham, NC: Duke University Press.

————. 2007. "What Makes People Work?" In *Questions of Anthropology*, edited by Rita Astuti, Jonathan Parry, and Charles Stafford, 137–167. Oxford, UK: Berg.

Hart, Keith. 2001. *The Memory Bank: Money in an Unequal World*. London: Profile Books.

Hayden, Cori. 2003. *When Nature Goes Public: The Making and Unmaking of Bioprospecting in Mexico*. Princeton, NJ: Princeton University Press.

Hernández Díaz, Jorge. 2007. "Dilemas de la construcción de ciudadanías." In *Ciudades mexicanas del siglo xx: Siete estudios históricos*, edited by Jorge Hernández Díaz, 35–86. Oaxaca: Universidad Autónoma Benito Juárez de Oaxaca.

Hernández Díaz, Jorge, and Gloria Zafra. 2005. *Artesanas y artesanos: Creación, innovación y tradición en la producción de artesanías*. Mexico City: Plaza y Valdés.

Herzfeld, Michael. 2004. *The Body Impolitic: Artisans and Artifice in the Global Hierarchy of Value*. Chicago: University of Chicago Press.

Hickey, Gloria. 1997. "Craft within a Consuming Society." In *The Culture of Craft*, edited by Peter Dormer, 83–100. Manchester, UK: University of Manchester Press.

Hirsch, Eric. 2010. "Property and Persons: New Forms and Contests in the Era of Neoliberalism." *Annual Review of Anthropology* 39:347–360.

Holo, Selma. 2004. *Oaxaca at the Crossroads: Managing Memory, Negotiating Change*. Washington, DC: Smithsonian Books.

Hoopes, James. 1991. Introduction to *Peirce on Signs: Writings on the Semiotic by Charles Sanders Peirce*, edited by James Hoopes, 1–13. Durham: University of North Carolina Press.

Hoskins, Janet. 2006. "Agency, Biography and Objects." In *The Handbook of Material Culture*, edited by Christopher Tilley, Webb Keane, Susanne Kuechler, Mike Rowlands, and Patricia Spyer, 74–84. London: Sage.

Howell, Jayne. 2009. "Vocation or Vacation? Perspectives on Teachers' Union Struggles in Southern Mexico." *Anthropology of Work Review* 30 (3):87–98.

Hunt, Robert C. 1971. "Components of Relationships in the Family: A Mexican Village." In *Kinship and Culture*, edited by Francis L. K. Hsu, 106–143. Chicago: Aldine Transaction..

INEGI [Instituto Nacional de Estadística y Geografía]. 2010. *Censo de población y vivienda 2010.* Mexico City: Gobierno de México.

———. 2012. *El anuario estadístico de Oaxaca 2011.* Mexico City: Gobierno de México.

Ingold, Tim. 2000. *The Perception of the Environment: Essays on Livelihood, Dwelling and Skill.* Milton Park, Abingdon, UK: Routledge.

———. 2001. "Beyond Art and Technology: The Anthropology of Skill." In *Anthropological Perspectives on Technology*, edited by Michael Brian Schiffer, 17–31. Albuquerque: University of New Mexico Press.

Ingold, Tim, and Elizabeth Hallam. 2007. "Creativity and Cultural Improvisation: An Introduction." In *Creativity and Cultural Improvisation*, edited by Elizabeth Hallam and Tim Ingold, 1–24. Oxford, UK: Berg.

Keller, Charles M. 2001. "Thought and Production: Insights of the Practitioner." In *Anthropological Perspectives on Technology*, edited by Michael Brian Schiffer, 33–45. Albuquerque: University of New Mexico Press.

Knight, Alan. 1990. "Racism, Revolution, and *Indigenismo*: Mexico, 1910–1940." In *The Idea of Race in Latin America, 1870–1940*, edited by Richard Graham, 71–113. Austin: University of Texas Press.

Layton, Robert. 2003. "Art and Agency: A Reassessment." *Journal of the Royal Anthropological Institute* 9:447–464.

Leach, James. 2003. "Owning Creativity: Cultural Property and the Efficacy of Custom on the Rai Coast of Papua New Guinea." *Journal of Material Culture* 8 (2):123–143.

———. 2008. "An Anthropological Approach to Transactions Involving Names and Marks, Drawing on Melanesia." In *Trade Marks and Brands: An Interdisciplinary Critique*, edited by Lionel Bently, Jennifer Davis, and Jane C. Ginsburg, 319–342. Cambridge: Cambridge University Press.

Le Breton, David. 2017. *Sensing the World: An Anthropology of the Senses.* London: Bloomsbury.

Lengyel, György. 2002. "Social Capital and Entrepreneurial Success: Hungarian Small Enterprises between 1993 and 1996." In *The New Entrepreneurs of Europe and Asia: Patterns of Business Development in Russia, Eastern Europe and China*, edited by Victoria E. Bonnell and Thomas B. Gold, 256–277. New York: M. E. Sharpe.

Leuthold, Steven. 1998. *Indigenous Aesthetics: Native Art, Media, and Identity.* Austin: University of Texas Press.

Li, Tania Murray. 2000. "Articulating Indigenous Identity in Indonesia: Resource Politics and the Tribal Slot." *Comparative Studies in Society and History* 42 (1):149–179.

Lindholm, Charles. 2008. *Culture and Authenticity.* London: Blackwell.

Lira Vásquez, Carlos, and Danivia Calderón Martínez. 2009. "La identidad 'Colonial' de Oaxaca: una invención de la política turística y patrimonial." In *Ciu-*

dades mexicanas del siglo XX: Siete estudios históricos, edited by Ariel Rodríguez Kuri and Carlos Lira Vásquez, 353–412. Mexico City: Colegio de México.

Litman, Jessica. 1991. "Copyright as Myth." *University of Pittsburgh Law Review* 53:235–249.

Little, Walter. 2004. *Mayas in the Marketplace: Tourism, Globalization, and Cultural Identity.* Austin: University of Texas Press.

———. 2008. "Living within the Mundo Maya Project: Strategies of Maya Handicrafts Vendors." *Latin American Perspectives* 35 (3):87–102.

Lomnitz, Claudio. 1993. *Exits from the Labyrinth: Culture and Ideology in the Mexican National Space.* Berkeley: University of California Press.

———. 2001. *Deep Mexico, Silent Mexico: An Anthropology of Nationalism.* Minneapolis: University of Minnesota Press.

López, Rick A. 2010. *Crafting Mexico: Intellectuals, Artisans, and the State after the Revolution.* Durham, NC: Duke University Press.

MacCannell, Dean. 1976. *The Tourist: A New Theory of the Leisure Class.* New York: Schocken.

———. 1984. "Reconstructed Ethnicity: Tourism and Identity in Third World Communities." *Annals of Tourism Research* 11 (3):375–391.

Magaña, Maurice Rafael. 2017. "Spaces of Resistance, Everyday Activism, and Belonging: Youth Reimagining and Reconfiguring the City in Oaxaca, Mexico." *Journal of Latin American and Caribbean Anthropology* 22 (2):215–234.

Makovicky, Nicolette. 2010. "'Something to Talk About': Notation and Knowledge-Making among Central Slovak Lace-Makers." *Journal of the Royal Anthropological Institute* 16 (S1):S80–S99.

Mallón, Florencia. 1992. "Indian Communities, Political Cultures, and the State in Latin America, 1780–1990." *Journal of Latin American Studies* 24:35–53.

Marchand, Trevor. 2010. "Embodied Cognition and Communication: Studies with British Fine Woodworkers." *Journal of the Royal Anthropological Institute* 16 (S1):100–120.

Martin, Keir. 2018. "Wage-Labour and a Double Separation in Papua New Guinea and Beyond." *Journal of the Royal Anthropological Institute* 24 (S1):89–101.

Martín-Barbero, Jesús. 2000. "Transformations in the Map: Identities and Culture Industries." *Latin American Perspectives* 27 (4):27–48.

Martínez Gracida, C. Manuel. 1883. *Catálogo etimológico de los nombres de los pueblos, haciendas y ranchos del estado de Oaxaca.* Oaxaca: Candiani.

Maruyama, Naho, Tsu-Hong Yen, and Amanda Stronza. 2008. "Perception of Authenticity of Tourist Art among Native American Artists in Santa Fe, New Mexico." *International Journal of Tourism Research* 10:453–466.

Marx, Karl. 1970 [1844]. *Economic and Philosophic Manuscripts of 1844.* Translated by M. Milligan. London: Lawrence and Wishart Ltd.

———. 1976 [1867]. *Capital: A Critique of Political Economy.* Translated by Ben Fowkes. London: Penguin.

Mascia-Lees, Frances. 2011. "Aesthetics: Aesthetic Embodiment and Commodity Capitalism." In *A Companion to the Anthropology of the Body and Embodiment,* edited by Frances Mascia-Lees, 3–23. London: Wiley Blackwell.

———. 2016. "American Beauty: The Middle Class Arts and Crafts Revival in the United States." In *Critical Craft: Technology, Globalization, and Capitalism,* ed-

ited by Clare M. Wilkinson-Weber and Alicia Ory DeNicola, 57–77. London: Bloomsbury.

Matthews, Duncan. 2002. *Globalizing Intellectual Property Rights: The TRIPS Agreement*. London: Routledge.

May, Christopher. 2010. *The Global Political Economy of Intellectual Property Rights: The New Enclosures*. London: Routledge.

May, Christopher, and Susan K. Sell. 2006. *Intellectual Property Rights: A Critical History*. Boulder, CO: Lynne Rienner.

McCaughan, Edward. 2012. *Art and Social Movements*. Durham, NC: Duke University Press.

Meisch, Lynn. 1995. "Gringas and Otavaleños: Changing Tourist Relations." *Annals of Tourism Research* 22 (2):441–462.

Merlan, Francesca. 2005. "Indigenous Movements in Australia." *Annual Reviews in Anthropology* 34:471–494.

Merleau-Ponty, Maurice. 1964. *The Primacy of Perception*. Translated by Carleton Dallery. Evanston, IL: Northwestern University Press.

Metcalf, Bruce. 1997. "Craft and Art, Culture and Biology." In *The Culture of Craft*, edited by Peter Dormer, 67–82. Manchester, UK: University of Manchester Press.

México: ¿Cómo Vamos? 2017. *Semáforo económico estatal: Muchos Méxicos en uno*. http://mexicocomovamos.mx/?s=contenido&id=700.

"México, inconforme por restricción de China a exportaciones." 2009. *El Universal*, August 21. Available at http://www.eluniversal.com.mx/notas/621205.html.

Meyer, Birgit. 2009. *Aesthetic Formations: Media, Religion, and the Senses*. London: Palgrave Macmillan.

Milgram, B. Lynne. 2016. "Refashioning a Global Craft Commodity Flow from Aklan, Central Philippines." In *Critical Craft: Technology, Globalization, and Capitalism*, edited by Clare M. Wilkinson-Weber and Alicia Ory DeNicola, 169–186. London: Bloomsbury.

Miller, Daniel. 2005. "Materiality: An Introduction." In *Materiality*, edited by Daniel Miller, 1–50. Durham, NC: Duke University Press.

Mohsini, Mira. 2016. "Crafting Muslim Artisans: Agency and Exclusion in India's Urban Crafts Communities." In *Critical Craft: Technology, Globalization, and Capitalism*, edited by Clare M. Wilkinson-Weber and Alicia Ory DeNicola, 239–258. London: Bloomsbury.

Molotch, Harvey. 2004. "How Art Works: Form and Function in the Stuff of Life." In *Matters of Culture: Cultural Sociology in Practice*, edited by Roger Friedland and John Mohr, 341–377. Cambridge: Cambridge University Press.

Mookherjee, Nayanika. 2011. "The Aesthetics of Nations: Anthropological and Historical Approaches." *Journal of the Royal Anthropological Institute* 17 (S1):S1–S20.

Morales, Álvaro. 2017. *Oaxaca, la tercera peor economía de México*. http://www.encuentroradiotv.com/index.php/politica-estatal/item/5890-oaxaca-la-tercera-peor-economia-de-mexico.

Morisawa, Tomohiro. 2015. "Managing the Unmanageable: Emotional Labour and Creative Hierarchy in the Japanese Animation Industry." *Ethnography* 16 (2):262–284.

Morphy, Howard. 1989. "From Dull to Brilliant: The Aesthetics of Spiritual Power among the Yolngu." *Man* 24 (1):21–40.

Morphy, Howard, and Morgan Perkins. 2006. "The Anthropology of Art: Reflec-

tion on Its History and Contemporary Practice." In *The Anthropology of Art: A Reader*, edited by Howard Morphy and Morgan Perkins, 1–32. London: Blackwell.

Morphy, Howard, et al. 1996. "Debate: Aesthetics Is a Cross-Cultural Category." In *Key Debates in Anthropology*, edited by Tim Ingold, 251–293. London: Routledge.

Morris, William. 1999 [1884]. "The Art of the People." In *William Morris on Art and Socialism*, edited by Norman Kelvin, 19–34. Mineola, NY: Dover.

Mraz, John. 2009. *Looking for Mexico: Modern Visual Culture and National Identity*. Durham, NC: Duke University Press.

Muehlmann, Shaylih. 2009. "How Do Real Indians Fish? Neoliberal Multicultural-ism and Contested Indigeneities in the Colorado Delta." *American Anthropolo-gist* 111 (4):468–479.

Mullin, Molly. 2001. *Culture in the Marketplace: Gender, Art, and Value in the Amer-ican Southwest*. Durham, NC: Duke University Press.

Murphy, Arthur, and Alex Stepick. 1991. *Social Inequality in Oaxaca: A History of Resistance and Change*. Philadelphia: Temple University Press.

Myers, Fred. 2001. "Introduction: The Empire of Things." In *The Empire of Things: Regimes of Value and Material Culture*, edited by Fred Myers, 3–61. Santa Fe, NM: School of American Research Press.

———. 2002. *Painting Culture: The Making of an Aboriginal High Art*. Durham, NC: Duke University Press.

———. 2005. "Some Properties of Art and Culture: Ontologies of the Image and Economies of Exchange." In *Materiality*, edited by Daniel Miller, 88–117. Dur-ham, NC: Duke University Press.

Nájar, Alberto. 2010. "La guerra de las piñatas en México." *BBC Mundo, México*. July 3. Available at https://www.bbc.com/mundo/cultura_sociedad/2010/07/100 702_1934_mexico_pinatas_lav.

Navarro, Carlos, and Miguel Leatham. 2004. "Pentecostal Adaptations in Rural and Urban Mexico: An Anthropological Assessment." *Mexican Studies/Estudios Mexicanos* 20 (1):145–166.

Newell, Sasha. 2013. "Brands as Masks: Public Secrecy and the Counterfeit in Côte d'Ivoire." *Journal of the Royal Anthropological Institute* 19 (1):138–154.

Noble, Brian. 2007. "Justice, Transaction, Translation: Blackfoot Tipi Transfers and WIPO's Search for the Facts of Traditional Knowledge Exchange." *American An-thropologist* 109 (2):338–349.

Norget, Kristin. 2010. "A Cacophony of Autochthony: Representing Indigeneity in Oaxacan Popular Mobilization." *Journal of Latin American and Caribbean An-thropology* 15 (1):116–143.

Notar, Beth. 2008. "Producing Cosmopolitanism at the Borderlands: Lonely Plan-eteers and 'Local' Cosmopolitans in Southwest China." *Anthropological Quar-terly* 81 (3):615–650.

Novelo, Victoria. 1976. *Artesanías y capitalismo en México*. Mexico City: Instituto Nacional de Antropología e Historia.

———. 1993. "Las artesanías en Mexico." In *El patrimonio cultural de Mexico*, ed-ited by Enrique Florescano, 219–246. Mexico City: Fondo de Cultura Económica.

Nugent, David. 1996. "From Devil Pacts to Drug Deals: Commerce, Unnatural Ac-cumulation, and Moral Community in 'Modern' Peru." *American Ethnologist* 23 (2):258–290.

Nutini, Hugo. 1984. *Ritual Kinship: Ideological and Structural Integration of the*

Compadrazgo System in Rural Tlaxcala. Vol. 2. Princeton, NJ: Princeton University Press.

O'Connor, Erin. 2005. "Embodied Knowledge: The Experience of Meaning and the Struggle towards Proficiency in Glassblowing." *Ethnography* 6 (2):183–204.

Olvera, Alberto J. 2010. "The Elusive Democracy: Political Parties, Democratic Institutions, and Civil Society in Mexico." *Latin American Research Review* 45 (SI):79–103.

Overing, Joanna. 1989. "The Aesthetics of Production: The Sense of Community among the Cubeo and Piaroa." *Dialectical Anthropology* 14 (3):159–175.

Parks, Walter P. 1997. *The Miracle of Mata Ortiz: Juan Quezada and the Potters of Northern Chihuahua.* Riverside, CA: Coulter.

Paxson, Heather. 2012. *The Life of Cheese: Crafting Food and Value in America.* Berkeley: University of California Press.

Pérez Vargas, Isabel. 1993. "Cambio económico y producción artesanal en San Martín Tilcajete en Oaxaca." Undergraduate thesis, Universidad Autónomo Metropolitana, Itztapalapa, Mexico. http://tesiuami.izt.uam.mx/uam/aspuam/presentatesis.php?recno=8842&docs=UAM8842.PDF.

Pinney, Christopher. 2002. "The Indian Work of Art in the Age of Mechanical Reproduction: Or, What Happens When Peasants 'Get Hold' of Images." In *Media Worlds: Anthropology on New Terrain*, edited by Faye Ginsburg and Lila Abu-Lughod, 355–369. Berkeley: University of California Press.

———. 2004. *"Photos of the Gods": The Printed Image and Political Struggle in India.* London: Reaktion Books.

Poole, Deborah. 2004. "An Image of 'Our Indian': Type Photographs and Racial Sentiments in Oaxaca, 1920–1940." *Hispanic American Historical Review* 84 (1):37–84.

———. 2009. "Affective Distinctions: Race and Place in Oaxaca." In *Contested Histories in Public Space: Memory, Race, and Nation*, edited by Daniel J. Walkowitz and Lisa Maya Knauer, 197–225. Durham, NC: Duke University Press.

———. 2011. "Mestizaje, Distinction, and Cultural Presence: The View from Oaxaca." In *Histories of Race and Racism: The Andes and Mesoamerica from Colonial Times to the Present*, edited by Laura Gotkowitz, 179–203. Durham, NC: Duke University Press.

Portisch, Anna. 2009. "Techniques as a Window onto Learning: Kazakh Women's Domestic Textile Production in Western Mongolia." *Journal of Material Culture* 14 (4):471–493.

Prentice, Rebecca. 2012. "'No One Ever Showed Me Nothing': Skill and Self-Making among Trinidadian Garment Workers." *Anthropology and Education Quarterly* 43 (4):400–414.

Price, Sally. 1989. *Primitive Art in Civilized Places.* Chicago: University of Chicago Press.

Richard, Analiese, and Daromir Rudnyckyj. 2009. "Economies of Affect." *Journal of the Royal Anthropological Institute* 15 (1):57–77.

Rivera-Ashford, Roni Capin, and Aarón Rivera-Ashford. 2017. *Miguel and the Amazing Alebrijes.* New York: Random House.

Rodríguez, Sylvia. 1997. "The Taos Fiesta: Invented Tradition and the Infrapolitics of Symbolic Reclamation." *Journal of the Southwest* 39 (1):33–57.

Rowlands, Michael. 2011. "Of Substances, Palaces, and Museums: The Visible and the Invisible in the Constitution of Cameroon." *Journal of the Royal Anthropological Institute* 17 (S1):S23–S38.

Ruiz Gomar, Rogelio. 2005. "Unique Expressions: Painting in New Spain." In *Painting a New World: Mexican Art and Life, 1521–1821*, edited by Donna Pierce, Rogelio Ruiz Gomar, and Clara Bargellini, 47–77. Austin: University of Texas Press.

Rutherford, Danilyn. 2016. "Affect Theory and the Empirical." *Annual Review of Anthropology* 45 (1):285–300.

Salanueva Camargo, Pascual. 2007. "Alebrijes clonados." *Las Noticias: Voz e Imagen de Oaxaca*, November 2. Available at http://biodiv-mesoam.blogspot.com/2007 /11/alebrijes-clonados.html.

Salazar, Noel. 2010. "Tourism and Cosmopolitanism: A View from Below." *International Journal of Tourism Anthropology* 1 (1):55–69.

Sansi, Roger. 2015. *Art, Anthropology and the Gift.* London: Bloomsbury.

Scher, Philip W. 2010. "Heritage Tourism in the Caribbean: The Politics of Culture after Neoliberalism." *Bulletin of Latin American Research* 30 (1):7–20.

Schmal, John P. 2007. *Indigenous Identity in the Mexican Census.* Houston Institute for Culture. Available at http://www.houstonculture.org/hispanic/census.html.

Schneider, Arnd. 2006. *Appropriation as Practice: Art and Identity in Argentina.* Basingstoke, UK: Palgrave Macmillan.

Schneider, Arnd, and Christopher Wright. 2013. *Anthropology and Art Practice.* London: Bloomsbury.

SECTUR México [Secretaría de Turismo del Gobierno de México]. 2018. *Cuenta de viajeros internacionales.* Mexico City: DATATUR/Gobierno de México. Available at http://www.datatur.sectur.gob.mx/SitePages/VisitantesInternacionales .aspx.

SECTUR Oaxaca [Secretaría de Turismo del Gobierno de Oaxaca]. 2016. *Indicadores de la actividad turística 2016.* Oaxaca: Gobeierno de Oaxaca. Available at http:// www.sectur.oaxaca.gob.mx/wp-content/uploads/2017/01/indicadores-turismo -2016-Cierre.pdf.

Sennett, Richard. 2008. *The Craftsman.* New Haven, CT: Yale University Press.

Serrano Oswald, Serena Eréndira. 2010. "La construcción social y cultural de la maternidad en San Martín Tilcajete, Oaxaca." PhD diss., Instituto de Investigaciones Antropológicas–Facultad de Filosofía y Letras, Universidad Nacional Autónoma de México (UNAM), Mexico City, Mexico.

Sharman, Russell L. 2002. "Duke versus Tito: Aesthetic Conflict in East Harlem, New York." *Visual Anthropology Review* 18 (1–2):3–21.

———. 2006. "Re/Making La Negrita: Culture as an Aesthetic System in Costa Rica." *American Anthropologist* 108 (4):842–853.

Shlossberg, Pavel. 2015. *Crafting Identity: Transnational Indian Arts and Crafts and the Politics of Race in Central Mexico.* Tucson: University of Arizona Press.

Smith, Benjamin. 2009. *Pistoleros and Popular Movements: The Politics of State Formation in Postrevolutionary Oaxaca.* Lincoln: University of Nebraska Press.

Smith, Peter. 1998. "Ley Federal del Derecho de Autor." *Berkeley Technology Law Journal* 13 (1):503–516.

Soussloff, Catherine M. 1997. *The Absolute Artist: The Historiography of a Concept.* Minneapolis: University of Minnesota Press.

Steiner, Christopher. 1995. "The Art of the Trade: On the Creation of Value and Authenticity in the African Art Market." In *The Traffic in Culture: Refiguring Art and Anthropology*, edited by George E. Marcus and Fred R. Myers, 151–165. Berkeley: University of California Press.

———. 1999. "Authenticity, Repetition, and the Aesthetics of Seriality: The Work of Tourist Art in the Age of Mechanical Reproduction." In *Unpacking Culture: Art and Commodity in Colonial and Postcolonial Worlds*, edited by Ruth Phillips and Christopher Steiner, 87–103. Berkeley: University of California Press.

Stephen, Lynn. 1993. "Weaving in the Fast Lane: Class, Ethnicity, and Gender in Zapotec Craft Commercialization." In *Crafts in the World Market: The Impact of Global Exchange on Middle American Artisans*, edited by June Nash, 25–57. Albany: State University of New York Press.

———. 1997. "Pro Zapatista, Pro PRI: Resolving the Contradictions of Zapatismo in Rural Oaxaca." *Latin American Research Review* 32 (2):41–70.

———. 2005. *Zapotec Women: Gender, Class, and Ethnicity in Globalized Oaxaca.* 2nd ed. Durham, NC: Duke University Press.

Strathern, Marilyn. 1999. *Property, Substance and Effect.* London: Athlone.

———. 2001. "The Patent and the Malanggan." In *Beyond Aesthetics: Art and the Technologies of Enchantment*, edited by Christopher Pinney and Nicholas Thomas, 259–286. Oxford: Berg.

Svašek, Maruška. 2007. *Anthropology, Art and Cultural Production.* Ann Arbor, MI: Pluto.

Sylvanus, Nina. 2016. *Patterns in Circulation: Cloth, Gender, and Materiality in West Africa.* Chicago: University of Chicago Press.

Tan, Leon. 2013. "Intellectual Property Law and the Globalization of Indigenous Cultural Expressions: Maori Tattoo and the Whitmill versus Warner Bros. Case." *Theory, Culture and Society* 30 (3):61–81.

Taussig, Michael. 1980. *The Devil and Commodity Fetishism in South America.* Chapel Hill: University of North Carolina Press.

Taylor, Nora N. 1999. "'Pho' Phai and Faux Phais: The Market for Fakes and the Appropriation of a Vietnamese National Symbol." *Ethnos* 64 (2):232–248.

Terrio, Susan J. 1999. "Performing Craft for Heritage Tourists in Southwest France." *City and Society* 11 (1):125–144.

———. 2016. "Visions of Excess: Crafting Good Chocolate in France and the United States." In *Critical Craft: Technology, Globalization, and Capitalism*, edited by Clare Wilkinson-Weber and Alicia Ory DeNicola, 135–152. London: Bloomsbury.

Theodossopoulos, Dimitrios. 2013. "Laying Claim to Authenticity: Five Anthropological Dilemmas." *Anthropological Quarterly* 86 (2):337–360.

Thomas, Kedron. 2009. "Structural Adjustment, Spatial Imaginaries, and 'Piracy' in Guatemala's Apparel Industry." *Anthropology of Work Review* 30 (1):1–10.

———. 2013. "Brand 'Piracy' and Postwar Statecraft in Guatemala." *Cultural Anthropology* 28 (1):144–160.

Tiffany, Sharon. 2006. "Frame That Rug: Narratives of Zapotec Textiles as Art and Ethnic Commodity in the Global Marketplace." In *Exploring World Art*, edited by Eric Venbrux, Pamela Sheffield Rosi, and Robert L. Welsch, 135–155. Long Grove, IL: Waveland.

Townsend-Gault, Charlotte. 1998. "At the Margin or the Center? The Anthropological Study of Art." *Reviews in Anthropology* 27 (4):425–439.

———. 2001. "When the (Oven) Gloves Are Off: The Queen's Baton—Doing What to Whom?" In *Beyond Aesthetics: Art and the Technologies of Enchantment*, edited by Christopher Pinney and Nicholas Thomas, 235–258. Oxford: Berg.

———. 2004. "Circulating Aboriginality." *Journal of Material Culture* 9 (2):183–202.

Tsing, Anna. 2007. "Indigenous Voice." In *Indigenous Experience Today*, edited by Marisol de la Cadena and Orin Starn, 33–67. New York: Berg.

Ugwu, Reggie. 2017. "How Disney Made Sure 'Coco' Was Socially Conscious." *New York Times*, November 19. https://www.nytimes.com/2017/11/19/movies/coco-pixar -politics.html.

Unkrich, Lee (dir.). 2017. *Coco* [film]. Los Angeles: Disney-Pixar.

Venkatesan, Soumhya. 2009. "Rethinking Agency: Persons and Things in the Heterotopia of 'Traditional Indian Craft.'" *Journal of the Royal Anthropological Institute* 15 (1):78–95.

———. 2010. "Learning to Weave, Weaving to Learn . . . What?" *Journal of the Royal Anthropological Institute* 16(S1):158–175.

Wade, Peter. 1997. *Race and Ethnicity in Latin America*. London: Pluto.

Weill, Cynthia. 2007. *ABeCedarios: Mexican Folk Art ABCs in English and Spanish*. El Paso, TX: Cinco Puntos.

———. 2011. *Colores de la Vida: Mexican Folk Art Colors in English and Spanish*. El Paso, TX: Cinco Puntos.

———. 2013. *Mi Familia Calaca/My Skeleton Family: A Mexican Folk Art Family in English and Spanish*. El Paso, TX: Cinco Puntos.

Weiner, Annette B. 1992. *Inalienable Possessions: The Paradox of Keeping-While-Giving*. Berkeley: University of California Press.

Wilk, Richard. 1996. *Economies and Cultures: Foundations of Economic Anthropology*. Boulder, CO: Westview.

Winegar, Jessica. 2016. "A Civilized Revolution: Aesthetics and Political Action in Egypt." *American Ethnologist* 43 (4):609–622.

WIPO [World Intellectual Property Organization]. 2004. *La clave de la propiedad intelectual: Guía para pequeños y medianos exportadores*. Geneva: World Intellectual Property Organization.

Wise, Timothy A. 2011. "Mexico: The Cost of U.S. Dumping." *NACLA Report on the Americas* 44 (1):47–48.

Witz, Anne, Chris Warhurst, and Dennis Nickson. 2003. "The Labour of Aesthetics and the Aesthetics of Organization." *Organization* 10 (1):33–54.

Wood, Robert E. 1998. "Touristic Ethnicity: a Brief Itinerary." *Ethnic and Racial Studies* 21 (2):218–241.

Wood, William Warner. 2000. "Flexible Production, Households, and Fieldwork: Multisited Zapotec Weavers in the Era of Late Capitalism." *Ethnology* 39 (2):133–148.

———. 2001a. "The 'Invasion' of Zapotec Textiles: Indian Art 'Made in Mexico' and the Indian Arts and Crafts Act." In *Approaching Textiles, Varying Viewpoints: Proceedings of the Seventh Biennial Symposium of the Textile Society of America*, 272–281. Santa Fe, NM: Textile Society of America.

———. 2001b. "Rapport Is Overrated: Southwestern Ethnic Art Dealers and Ethnographers in the 'Field.'" *Qualitative Inquiry* 7 (4):484–503.

———. 2008. *Made in Mexico: Zapotec Weavers and the Global Ethnic Art Market*. Indianapolis: Indiana University Press.

Yanagisako, Sylvia. 2002. *Producing Culture and Capital: Family Firms in Italy*. Princeton, NJ: Princeton University Press.

———. 2018. "Reconfiguring Labour Value and the Capital-Labour Relation in Italian Global Fashion." *Journal of the Royal Anthropological Institute* 24 (S1):47–60.

Yarrow, Thomas, and Siân Jones. 2014. "'Stone Is Stone': Engagement and Detachment in the Craft of Conservation Masonry." *Journal of the Royal Anthropological Institute* 20 (2):256–275.

Young, Diana. 2011. "Mutable Things: Colours as Material Practice in the Northwest of South Australia." *Journal of the Royal Anthropological Institute* 17 (2):356–376.

Zavala, Juan. 2017. "Descubren desvío de 290 mdp en Centro de Convenciones de Oaxaca: Murat." *NVI Noticias*, January 29. Available at http://www.nvinoticias.com/nota/49627/desviaron-290-mdp-para-centro-de-convenciones-de-oaxaca-alejandro-murat.

Zolov, Eric. 2001. "Discovering a Land 'Mysterious and Obvious': The Renarrativizing of Postrevolutionary Mexico." In *Fragments of a Golden Age: The Politics of Culture in Mexico since 1940*, edited by Gilbert Joseph, Anne Rubenstein, and Eric Zolov, 234–272. London: Verso.

Index

aesthetic fields, 47–48, 60, 66, 89, 147–148, 152. *See also* fields of cultural production

aesthetics, 3–11, 16–18, 26–28, 28n3, 31–41, 46–62, 65–79, 86–91, 94, 97–110, 114–119, 127–128, 130–135, 145–161; changes in, 7, 17, 24–27, 48, 60, 89, 94–95, 99, 110, 119, 159; and circulation, 18, 47–48, 59, 140–142; and competition, 4, 9–10, 24, 27, 47–48, 74–78, 83–89, 94, 97–99, 101–110, 134–157, 145–148, 152–161; as practice, 3–5, 27, 40, 52–62, 66–72, 88–91, 108–109, 114–116, 130–135; as style, 5–7, 10, 16–18, 22–23, 40–42, 55–60, 68–69, 72–79, 82–84, 90–92, 97–99, 104, 137, 147, 155, 159; theories of, 10–11, 16, 18, 26, 31–40, 47–48, 50–51, 69–72, 75, 90–91, 94, 112–118, 147–149, 151–155; of work, 26, 42–44, 51–52, 65–67, 85, 88

agriculture, 20–24, 67, 116, 103, 158

alebrijes. See Oaxacan woodcarvings

alienation, 27, 64, 70–74, 77–79, 84n1, 154, 161

altars, 44–46, 49n5, 52

anthropology, 1, 4, 9–10, 15, 26, 31–39, 49n4, 54–55, 70–71, 86–91, 107, 112, 116–117, 121–127, 133–135, 152–154, 160. *See also* Oaxaca: research in

Appadurai, Arjun, 34–35, 163

apprenticeship, 47, 71, 82

appropriation, artistic practices of, 18, 41, 59–60, 78, 83–84, 96–99, 110, 145

Aragon, Lorraine, 133–136, 144, 155

archaeological sites, 11–12, 20, 41, 96–97, 110, 116–117, 128n2

ARIPO (Craftwork and Popular Industries of the State of Oaxaca), 2, 28n1, 92–94, 137–140

Arrazola, San Antonio, 2–5, 23–24, 42, 83, 96, 125

art, 1–6, 15–19, 23–28, 30–41, 43–48, 64, 69–70, 73–75, 94–102, 109–110, 118–135, 139, 141, 144–160; and agency, 9, 31, 35–38, 46, 69–71, 78, 135, 142–143, 151; circulation of, 3, 7–8, 11, 31–38, 77, 88–89, 99–101, 109, 117, 127, 143; definitions of, 33, 47–48, 69–71, 95, 143, 151–155; makers of, 1–8, 16–19, 26, 31, 35–38, 45–48, 54–62, 69–73, 86–88, 91, 100–104, 120–125, 131–139n7, 143, 150–160 (*see also* artisans); markets for, 1, 7, 11, 16, 23–26, 32, 59, 74, 97–99, 147, 154 (*see also* economies of culture); objects, 2–11, 15–18, 26–27, 31–40, 47–48, 52, 58–59, 69–72, 76–77, 91–100, 113, 131–136, 140–154; and politics/social justice, 13–16, 19, 29n11, 55, 119, 124–125; readings of, 38–40, 47, 145–151 (*see also* art encounters); viewers of, 5, 26, 35–41, 48, 59, 88, 101, 131, 144, 148, 151–152 (*see also* consumers)